George McGovern and the Democratic Insurgents

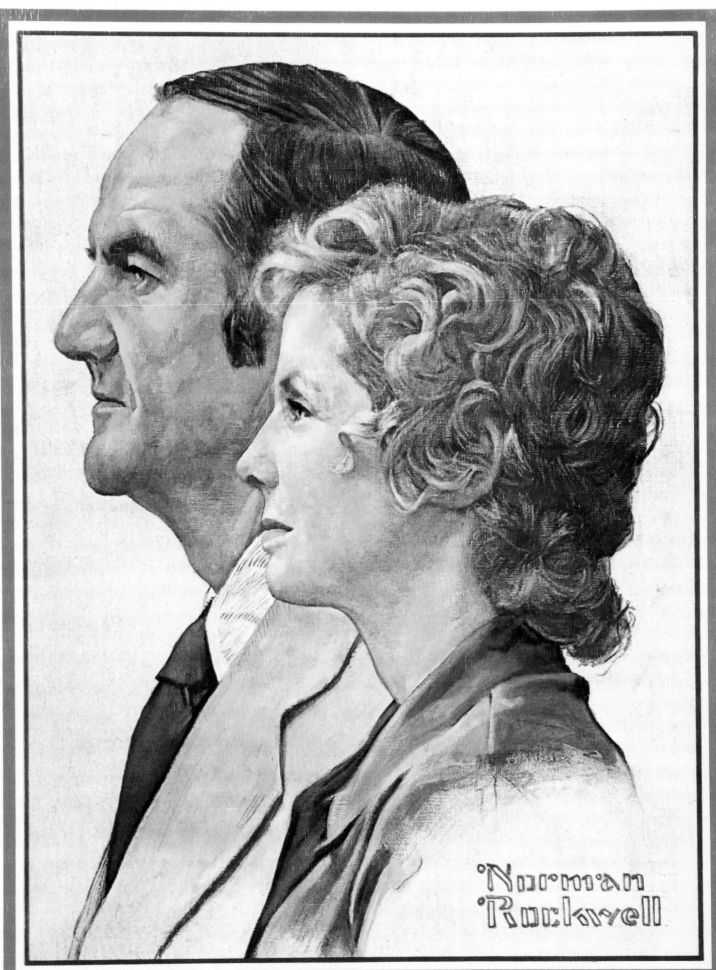

Eleanor and George McGovern

sincerely
Norman
Rockwell

George McGovern and the Democratic Insurgents

The Best Campaign and Political Posters of the Last Fifty Years

Hal Elliott Wert

Foreword by Frank Mankiewicz

Photographs by Robert Chase Heishman

University of Nebraska Press | Lincoln and London

Frontispiece: Norman Rockwell, *Eleanor and George McGovern*, printed by the permission of the Norman Rockwell Family Agency. © 1972 the Norman Rockwell Family Entities.

Library of Congress Cataloging-in-Publication Data
Wert, Hal Elliott.
George McGovern and the democratic insurgents :
the best campaign and political posters of the last
fifty years / Hal Elliott Wert ; foreword by Frank
Mankiewicz ; photographs by Robert Chase Heishman.
pages cm
ISBN 978-0-8032-7871-4 (paperback: alk. paper)
1. Political posters, American—History. 2. Political
posters, American—History—Pictorial works.
3. McGovern, George S. (George Stanley), 1922–2012
—Posters. 4. Campaign paraphernalia—United
States—History—Pictorial works. 5. Political
campaigns—United States—History—Pictorial
works. 6. Presidents—United States—Election—
History. 7. Presidential candidates—United States
—History. 8. United States—Politics and government.
I. Heishman, Robert. II. Title.
E183.3.W46 2015 324.7′30973—dc23 2015009035

Designed and set by A. Shahan

INSIDE FRONT COVER:
Unknown artist, 1972
28″ x 21″, offset lithography
The Gallery for McGovern was located in San Francisco's North Beach neighborhood, home to Italian Americans, Beatniks, and the famous City Lights Bookstore. Open throughout the fall campaign, the gallery sold a wide array of art and campaign materials and served as a gathering place for McGovern supporters. Art for McGovern galleries opened in many other cities and often hosted auctions.

For Avery East Hamlin
 Mary Katherine Wert
 Olivia May Hamlin
 Jackson Elliott Wert

Adrienne Adams — for Mc GOVERN!

Contents

Foreword by Frank Mankiewicz ix

Introduction: Art at the Heart of Politics xi

1 The Sixties Poster Awakening 1

2 The Innovative Posters of the 1968 Campaign of Eugene McCarthy 35

3 George McGovern and the Antiwar Movement from 1969 to 1972 63

4 The McGovern Poster Explosion of 1972 95

Epilogue: The Campaign Poster since 1972 211

Acknowledgments 241

Cald

Foreword

FRANK MANKIEWICZ After the assassination of Robert Kennedy, Sen. George McGovern almost threw himself into the 1968 contest for the Democratic presidential nomination. He was, after all, a leader of the group of senators strongly opposed to our war in Vietnam, and in that group the only logical presidential figure. Nevertheless, he made his announcement far too late to get a real campaign started and functioning; the race was actually between Sen. Hubert Humphrey and Sen. Eugene McCarthy. I had been Senator Kennedy's press secretary and a delegate pledged to him from California; and although I admired Senator McGovern, I was surprised to receive a telephone call from him, virtually on the eve of the convention, in which he told me he was announcing his candidacy that day and wanted me to help run his campaign.

I accepted eagerly since I had worked with Senator McGovern on antiwar issues with Robert Kennedy, and I was also aware of his strong support of civil rights issues (unlike Senator McCarthy, whose strong stand against gun control measures had won him a primary election in Oregon). McGovern was pleased I would join his campaign, he told me, since he had already announced to the press I would be running the campaign at the convention. I laughed along with him, and when he asked if I could find someone willing to put up $25,000 to guarantee our phone system, I told him I'd call a few contributors and try to line up somebody. That somebody turned out to be Stanley Kaplan—a Charlotte, North Carolina, radio station owner, and a strong RFK supporter who became a close friend of both mine and McGovern's—who only wanted to know who to talk to in order to guarantee the phones.

McGovern did well at the convention and surprised the media scoffers by winning 150 or so delegates and, I thought, establishing himself as a possible contender for the nomination four years later. It was that 1972 campaign that formed the basis—and provided the spectacular poster art of Hal Wert's book—of what McGovern rightly called a campaign "which changed American politics forever." It began with another phone call—would I join the campaign? Of course I would, even though McGovern then stood at right around 1 percent in all the national polls, which were dominated by Senator Humphrey, Sen. Edmund Muskie, Sen. Henry Jackson, and New York mayor John Lindsay, with Alabama governor George Wallace lurking as a possible third-party candidate.

Luckily, this time I was not the sole staff—far from it. A young lawyer named Gary Hart had been engaged to put together a campaign team that turned out to be an astonishingly skilled group. Rick Stearns, now a federal judge, understood the primary and delegate arrangement system better than anyone I'd ever worked with, and he was put in charge of Iowa's caucuses. There were very savvy, hardworking operators in other key states, like Joe Grandmaison in New Hampshire and Gene Pokorny in Wisconsin.

And Gary Hart and I succeeded in recruiting Patrick Caddell, a public opinion analyst who'd never been involved in politics but who did remarkable work involving wholly new analyses of public opinion. Caddell became a leader in the field until some neo-conservatives lured him into polemics and away from public opinion analysis. Gary Hart and these election specialists he'd selected, many of who remain active and leading in today's campaigns, ran the McGovern effort from the inside, while I remained the "outside" spokesman, press specialist, and strategist. And as the brilliant—in color and concept—poster brigade continues to attest in this book, the McGovern juggernaut rolled on until our first-ballot nomination truly "changed American politics forever."

Robert Kennedy once described George McGovern as "the most decent man in the Senate," and it would be nearly impossible to find anyone to disagree. Unfailingly honest in all his dealing within and outside the Senate, devoted to his family, and, with what he had frequently described to me as the values his parents had handed down to him, McGovern was unchallenged. In the time we spent together, which included the most intense days and months of his political career, I never sensed for a moment that he was going to reach a decision or take an action that was not based on the finest of motives. Not for anything was he the son of a respected minister; through the years he surrounded himself with advisors and aides who respected his ideals and rarely, if ever, thought to suggest a course that might have valued political advancement over personal ethics.

Even during the Sen. Thomas Eagleton crisis McGovern's decision of whether or not to retain his vice presidential choice on the ticket—the period of time in which his eventual defeat by Richard Nixon was enlarged beyond the possibility of return—he risked political advantage as he debated within himself, was bombarded by outside advice, and was hindered by Eagleton's failure to tell him the full truth of his past bouts with clinical depression. McGovern carefully considered the impact that dropping his running mate from the ticket would have, not only on the principal players, but also on his own family—whose welfare he cherished, I thought, more than anything. He was, indeed, the most decent man in the Senate, but also, most certainly, the most decent man we've produced in our public life.

Introduction | *Art at the Heart of Politics*

The George McGovern campaign poster explosion of 1972, a rare event in the history of American presidential elections, placed art at the heart of politics. How the poster explosion came to be is a story that begins in the early sixties.

The sixties were a flamboyant transitional age when the poster returned to prominence and played a major role in the civil rights and antiwar movements, the popularizing of the new psychedelic rock 'n' roll, and the political candidacies of Eugene McCarthy and George McGovern. Kerry James Marshall's 2003 painting, *What a Time. What a Time. Memento #5* (fig. 1), serves well to capture the decade's topsy-turvy social revolution, a time he maintains was characterized by "peaceful civil disobedience, courageous marches, visionary speeches, righteous legislation, explosive riots, and tragic deaths."

For many idealistic, young activists the sixties were a time when the burgeoning counterculture seemed certain of a future. Thousands of college-aged youth dared to imagine life beyond conformity. Malcolm Bradbury in *No, Not Bloomsbury* wrote that "the mood of the Sixties, liberationist, radical and provisionalised, was a revolt against the moralism and apoliticism, and the aesthetic caution, of the previous decade." For older generations it was a time when America was cut loose from its traditional moorings, a nation that seemed perched on the eve of destruction. The rules-based culture of the fifties forcefully resisted the in-your-face, radical, nonconformist freedom-of-expression alternative offered by a growing counterculture. Regardless of which side of the barricades a person was on, they lived through a whirlwind of social upheaval. Even today, Bradbury observes, some forty-five years later, "The dialogue and dispute between the Fifties and Sixties still seems to dominate the direction of our art and culture."

Poster books on various historical periods and topics and on specific poster makers abound; but there are surprisingly few books on American political posters, and those in existence often rely on the limited numbers of images generally familiar to viewers. No comprehensive book featuring the marvelous political posters from the 1968 or the 1972 presidential primary battles and the general election campaigns that followed has been published. A partial explanation for this historical omission is that no archive or library possesses an extensive collection, although some of the fine innovative posters from these campaigns have been preserved in a number of archives and museums in California. The best and largest collection of George McGovern posters is housed in the McGovern Library on the campus of Dakota Wesleyan University in Mitchell, South Dakota.

The dearth of political posters is also attributable to their ephemerality. Cheap slappers are put up on walls and fences and nailed to telephone poles. Slowly these paper artifacts succumb to the elements while others are torn down or pasted over. A few

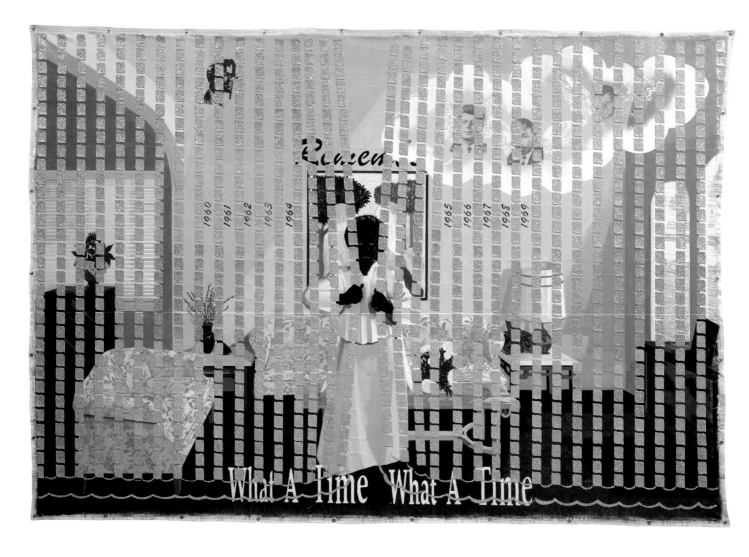

**1. Kerry James Marshall, *What a Time.
What a Time. Memento #5,* 2003**
108" × 156", acrylic on paper
*The Nelson-Atkins Museum of Art, Kansas
City, Missouri. Purchase acquired through
the generosity of the William T. Kemper
Foundation—Commerce Bank, Trustee,
3003.24. © Kerry James Marshall. Photo by
Jamison Miller.*
Kerry James Marshall, a well-known Ameri-
can artist, was born in Birmingham, Ala-
bama, in 1955. His work is heavily influenced
by his childhood years in the Watts section
of Los Angeles and the area's connection to
the civil rights and Black Power movements.
The subject of his work is the history of
African American life, which he captures in
large paintings and sculptures. This painting
well illustrates the turbulent and exciting
years that led to the McGovern poster
explosion of 1972.

staffers who are firmly committed to their candidate may tuck away a couple posters
as mementos; but at the end of campaigns, having served their purpose, many posters
are simply thrown away. Over the years what were once treasured souvenirs are often
lost, left behind, given to friends, stored in the basement, or sold at garage sales. The
life of the American political poster is a perilous one. But despite these significant haz-
ards, political posters from all eras continue to pop up and end up in private collections,
archives, and museums. Only occasionally is it possible to know how many posters were
produced, where they were printed, their various sizes, and the identities of the art-
ists, illustrators, or designers who created them. By chance, the political poster prevails.

Historians who write about politics sometimes use posters as illustrations, but they
often see them as adding only color rather than as something central to the political
campaign or to the candidate they are studying. Posters are often undervalued and are
not given the credit due in respect to visual language. Effective, well-designed posters,
however, employ visual language to bypass the rational thought process and evoke an
immediate emotional response. What better way could candidates sell themselves to
the voter or get out their message?

The majority of posters in this volume are from the campaigns of Eugene McCarthy
and George McGovern. Other candidates also fielded excellent posters, though in more
limited numbers. A few of the posters included in this book were created by famous
American artists, stars like Ben Shahn, Alexander Calder, Larry Rivers, Sam Francis, Ed
Ruscha, Peter Max, Jasper Johns, Richard Avedon, and Andy Warhol. A number of well-
known illustrators, designers, and regional artists contributed to the political art scene,

as did a large number of unknown grassroots poster makers or first-time enthusiasts. To make the case for the wide-ranging talents and styles of the McGovern poster explosion, it was necessary to include some of the best civil rights, psychedelic, and antiwar posters. The poster styles of the sixties are eclectic and owe a debt to a number of traditions that include art nouveau, art deco, American social realism, cartoon expressionism, abstract expressionism, neorealism, caricature, pop art, California psychedelic, and the popular Bauhaus-inspired international style that prevailed in the fifties.

Not surprisingly, the predominant influence on McCarthy and McGovern posters came from California psychedelic posters that in turn were heavily influenced by art nouveau. To create these different posters, artists used or mimicked a wide array of printing techniques: letterpress, screen print, and offset. As an expression of political commitment, some of the posters from this period were hand drawn and hand lettered, printed, and then hand colored. A few were created using spray can paint and stencils. Experimentation and artistic exploration are a rare phenomenon in the political poster world as the poster makers' choices are controlled by their targeted audience. The bottom line is that the poster must communicate a political message to be effective, and the viewer must understand the symbolic visual language employed. As a result, political campaigns tend to avoid artistic experimentation and play it safe by relying on formulaic, tired solutions designed by committees at large advertising firms—what one contemporary poster maker called "graphic power outages." The campaigns of 1968 and 1972, though, are an exception. The viewers of these posters were open to exciting new styles and printing techniques, creating a two-way street in which the youth revolt fed artists' imaginations, and the art they produced reaffirmed the commitment of the antiwar and counterculture activists helping to grow the movement.

After completing my book *Hope: A Collection of Obama Posters and Prints* in 2009, I decided to redouble my effort to find as many of these outstanding political posters—which were tucked away in archives, museums, private collections; for sale online; or offered in auctions—and make them available to the wider audience they deserve. One of the first stops on this search was a trip my research assistant, Robert Heishman, and I made to Mitchell, South Dakota, to photograph posters in the McGovern Library. While there we were fortunate enough to be invited by Senator McGovern to photograph campaign posters in his home. Robert and I spent an afternoon with the senator, who was in a jovial mood. Our conversation was not a probing interview but was relaxed, informal, and enjoyable. Robert and I felt privileged to be a part of this conversation in which we were given the opportunity to better know the man. Open to my questions, McGovern shared stories of his time in the Senate and his presidential campaign. He greatly admired Adlai Stevenson and modeled himself after him. Wayne Morris of Oregon was the smartest senator he ever knew. Yes, he liked Hunter S. Thompson, and no, he did not kick him off the campaign plane, but with a warm smile and a twinkle in his eye, he said, "But I should have."

Sitting at his kitchen table, he looked at the disc on which we had loaded all of the posters we had so far collected. He liked what he saw, and I asked him if he would consider writing a foreword to the book. He agreed immediately and then showed us his painting collection and pointed out posters we might wish to photograph. We set up our camera gear and lighting equipment in his living room, and while we took framed posters off the wall to photograph, he regaled us with stories of how he obtained each of his paintings, prints, or posters. I am grateful to have heard these stories and to have had this conversation with the senator as that winter he fell, became ill, and his health rapidly declined.

Just over a year after our visit, on October 21, 2012, the senator died peacefully in hospice in Sioux Falls, South Dakota, in the state he loved and represented for two terms in the House of Representatives and three terms in the U.S. Senate. Throughout his productive life he had carried the liberal flag, convinced that government was the instrument of progressive change and the protector of the less fortunate, and that war was never an acceptable answer. Both his admirers and his critics agreed that McGovern was an honorable, religious man who stayed true to his deeply held convictions.

After leaving South Dakota, the poster hunt continued through archives and libraries across America, and I was able to secure more than one hundred posters that I had never seen before. Throughout this search, I also found photos or learned of several dozen well-done posters that, unfortunately, I was unable to locate or could not obtain images of in a high enough resolution to include in this volume. I also located and contacted artists from the sixties who created these political, civil rights, antiwar, and gig posters to see what they had saved and what they might say about their works and the time in which they lived. All were supportive of the project, and several loaned posters to be photographed or sent digital files. One of the greatest rewards in writing this book came in locating and talking with the poster makers themselves.

The great political poster explosion of 1972 happened due to elements of the civil rights movement, the nationwide youth rebellion, and the antiwar movement that coalesced behind the presidential campaigns, first of McCarthy in 1968 and then of McGovern in 1972. The result, expressed in numerous styles and techniques, was the creation of a large number of bold, eye-popping posters. This book, however, is not a comprehensive catalog of political posters from the last half century but rather posters that were carefully chosen in an effort to present only the best. This volume covers all aspects of this creative explosion and attempts to fully capture this exciting era and its impact on the posters that came after in later presidential campaigns. I hope this comprehensive collection of images brought together for the first time will grab your attention, delight your eye, give you hours of pleasure, and broaden your understanding of the importance of the poster at the heart of politics at a pivotal and trying time in our nation's history. As George Stranahan accurately observed in his foreword to *Thomas W. Benton: Artist/Activist*: "Movements always find expression of their anger and dreams in the arts." Between 1963 and 1972 they did so in a very exciting way.

George McGovern and the Democratic Insurgents

CORE presents

Bob Dylan

AT UNIVERSITY REGENT THEATRE

680 E. GENESEE STREET

SUNDAY NOV. 3rd AT 4:00 P.M.

Tickets: University Regent Theatre Box office; Corner Store Box
Office and for information or reservations call 476-0770 or write
Core, 609 E. Adams St., Syracuse, N. Y.

Columbia Records

The Sixties Poster Awakening

1

Civil Rights

By 1964 the growing civil rights movement, the burgeoning antiwar protests, the stirrings of a renewed feminist movement, the sexual revolution—thanks to the widespread use of the birth control pill—and the rapidly spreading drug culture attracted a growing number of America's youth who passionately picked up the cudgel of rebellion. "Never trust anyone over thirty" became a deeply held conviction. The radical shift in music and the arts, a message of rebellion, was carried across the country on America's radio stations and in a growing alternative press. The poster, an art form in decline since the Second World War, reemerged with a renewed force beginning with the civil rights movement of the early sixties.

Graphically, the hardest-hitting civil rights posters in the mid-sixties were produced by the Student Nonviolent Coordinating Committee (SNCC), a radical activist group headed by John Lewis. SNCC more fully recognized the power of visual language, especially posters and photographs, than did other civil rights groups and created powerful graphic materials that were designed to convince the public of the justice of their cause. These posters helped to overcome decades of negative stereotypes embedded in American society that depicted blacks as inferior human beings. SNCC, dedicated to African American voter registration and active nonviolent resistance, contributed mightily to redefining how black Americans saw themselves. Lewis's organization printed captivating, simple, uncluttered posters that incorporated the stunning black-and-white photographs of then nineteen-year-old Danny Lyons, a self-taught photographer out of Brooklyn. SNCC relied almost exclusively on Lyons's photos for its posters, which were widely disseminated through a network of southern black churches, both urban and rural, and through SNCC organizations on most college campuses in the north. The great American offset poster was back, as hard at work as it had been in the forties during World War II.

2. Congress of Racial Equality (CORE), 1963
14" × 20", offset lithography
Courtesy Joe R. Armstrong.
In 1963 Bob Dylan, the hero of the folk music crowd, performed two benefit concerts for CORE, the first in Philadelphia on October 23 and later at Syracuse University on November 3. Along with Joan Baez and Pete Seeger, he played in the East Village and at various other venues around New York City. Both of the posters from these two concerts are extremely rare. Posters likely exist for some of the New York appearances and may eventually turn up.

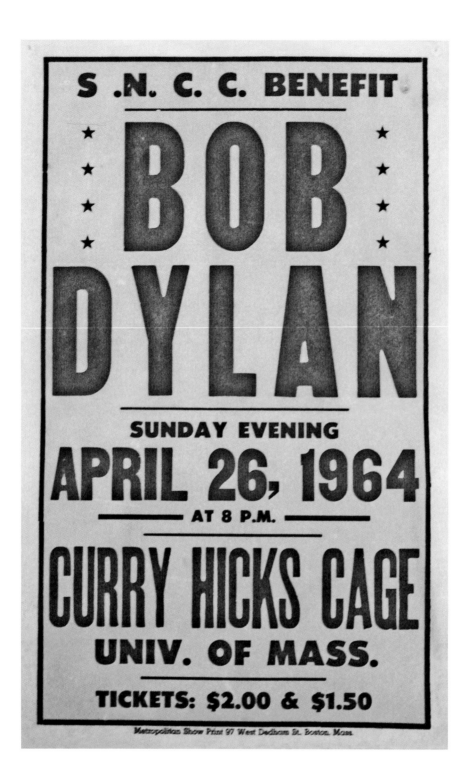

3. Student Nonviolent Coordinating Committee (SNCC), 1964
17" × 11", offset lithography
Courtesy of Joe R. Armstrong.
This yellow-and-black poster is extremely rare and is in the letterpress boxing-event style that was about to go out of fashion but had been used for decades to promote events of all types. The UMass benefit concert is one of Dylan's last performances for civil rights groups before giving up his activism in favor of his music. To Dylan's credit, he and Pete Seeger ventured to the dangerous heart of the segregated South during Freedom Summer to perform at a voter registration drive gathering on July 2, 1964, for black farmers on the outskirts of Greenwood, Mississippi. That same summer civil rights workers James Chaney, Andrew Goodman, and Michael Schwerner went missing, were presumed dead, and were later found buried in an earthen dam.

4. Louis LoMonaco, 1963
10¾" × 8⅞", offset lithography
Courtesy of the Library of Congress.
This outstanding poster of the August 28, 1963, March on Washington for Jobs and Freedom, where Dr. Martin Luther King Jr. gave his "I Have a Dream Speech," was commissioned by the New York National Urban League and was actually the front cover of a souvenir program that included five other Louis LoMonaco prints. LoMonaco's striking photomontages were influenced by the great photomontage movie posters created by Saul Bass (for example, *Man with the Golden Arm*). Here, the finger on a hand points toward three silhouetted figures holding hands and moving forward beyond the chaos behind them. The photograph was taken (probably by Charles Moore) on May 2, 1963, in Birmingham, Alabama, during the Children's Crusade, when demonstrating young blacks were sprayed with fire hoses. The poster has become an iconic image of the civil rights movement.

MARCH ON WASHINGTON FOR JOBS AND FREEDOM AUGUST 28, 1963

We Shall

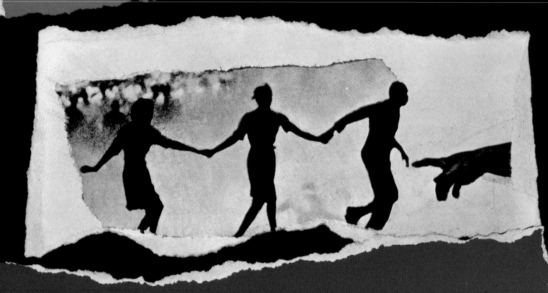

Overcome

lomonaco

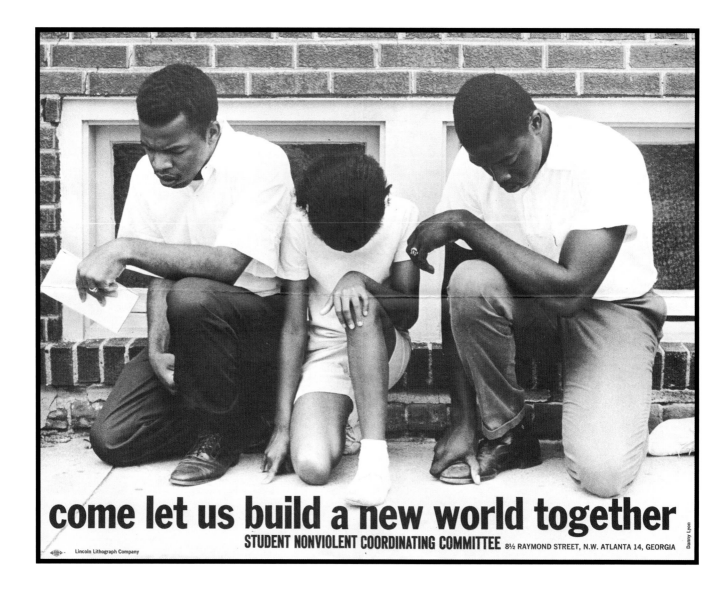

come let us build a new world together
STUDENT NONVIOLENT COORDINATING COMMITTEE 8½ RAYMOND STREET, N.W. ATLANTA 14, GEORGIA

Lincoln Lithograph Company

Danny Lyon

5. Student Nonviolent Coordinating Committee (SNCC),
Danny Lyons photo, 1963

14" × 22", offset lithography

Courtesy of the McCain Library and Archives, University
of Southern Mississippi.

Danny Lyons took his first photographs of civil rights
protests when he was nineteen, during the summer of
1962, in Cairo, Illinois. Over the next few years he was
always at the center of the most important confronta-
tions throughout the South and took enduring photos
that captured the heart and soul of SNCC's nonviolent
struggle for civil rights. The unerring SNCC design team
often cropped Lyons's photos and added pertinacious
captions. *Come let us build a new world together* was
issued as a poster in 1963 in a run of ten thousand and
sold for a dollar each. SNCC made five posters using
Lyons's photos, and the three best are included here.

6. Student Nonviolent Coordinating Committee (SNCC),
Danny Lyons photo, 1963

22" × 14", offset lithography

Courtesy of the McCain Library and Archives, University
of Southern Mississippi.

Lyons took this photo at the March on Washington for
Jobs and Freedom in August 1963, *NOW* is one of the
top photos and posters from the entire sixties civil
rights struggle.

NOW

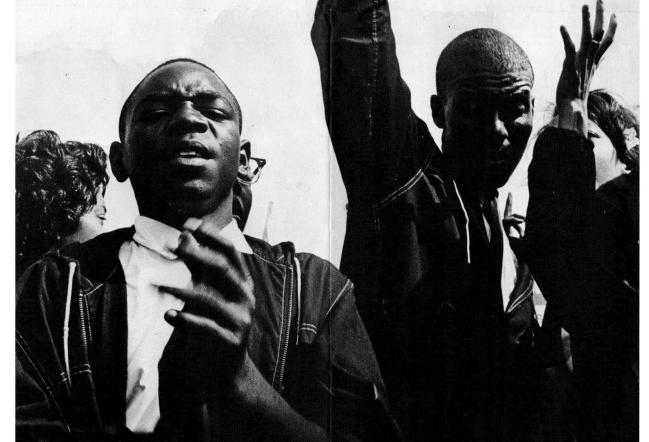

STUDENT NONVIOLENT COORDINATING COMMITTEE

8½ RAYMOND STREET, N.W. ATLANTA 14, GEORGIA

Lincoln Lithograph Company

Danny Lyon

One Man One Vote

STUDENT NONVIOLENT COORDINATING COMMITTEE
8½ RAYMOND STREET, N.W. ATLANTA 14, GEORGIA

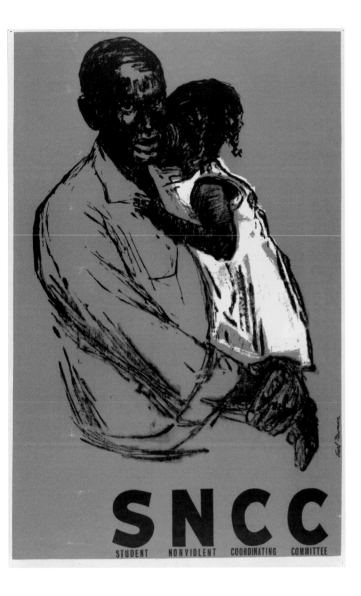

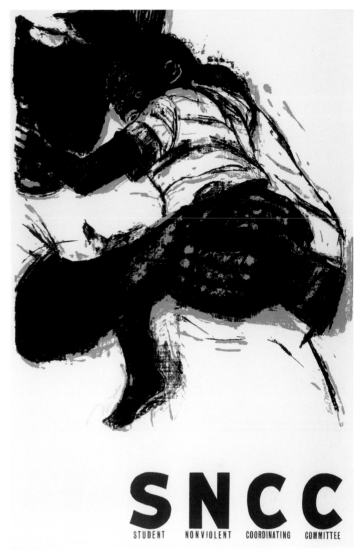

7. Student Nonviolent Coordinating Committee (SNCC), Danny Lyons photo, 1963
22" × 14", offset lithography
Courtesy of the McCain Library and Archives, University of Southern Mississippi.
This historic SNCC poster was widely distributed and captured the poverty and exploitation of the southern black sharecropper. Importantly, information at the bottom of the SNCC posters did not interfere with the hard-hitting combination of image and text.

8. Student Nonviolent Coordinating Committee (SNCC), Earl Newman, 1962
35" × 22½", screen print
Courtesy of Earl Newman.
Earl Newman moved to Venice, California, in 1960 and set up shop in an effort to make a living from his prints. He committed to screen printing: "It is like having one hundred canvases on which to experiment, using different colors of paper and inks, varying the color blends as I go along. Thus, no two prints are alike. Unlike mass-produced machine prints, each silk-screen print is made step by step, each color a separate printing." A political activist, Newman brought the screen print into the civil rights movement. This SNCC print was originally done in a run of one hundred and sold for ten dollars each.

9. Student Nonviolent Coordinating Committee (SNCC), Earl Newman, 1963
35" × 23", screen print
Courtesy of Earl Newman.
The second SNCC fund-raising poster was also printed in a run of approximately one hundred. Neither of the SNCC prints is numbered. Newman has also created all of the Monterey Jazz Festival posters since 1963, and all are signed and numbered editions. A look at his wide array of posters shows a strong influence from the belle époque posters of Henri de Toulouse-Lautrec and Jules Chéret. The limited edition screen print was a style of printing readily adopted by artists in support of McCarthy in '68 and McGovern in '72 and became a way of raising money for the campaigns.

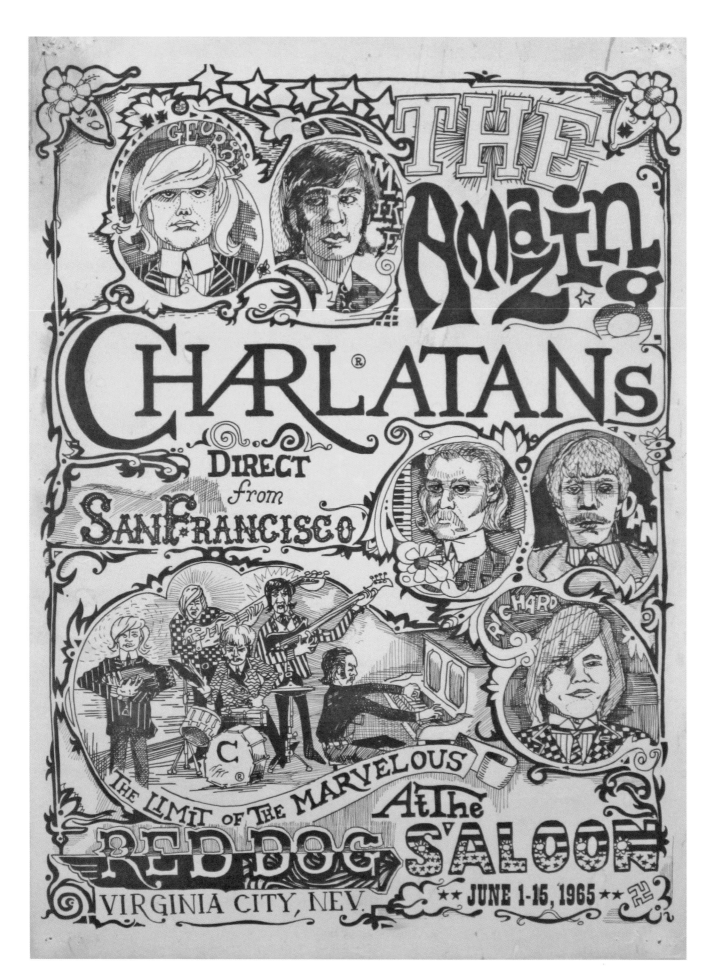

Psychedelic

In the great poster revival of the sixties and early seventies, civil rights posters led the way, but a different art form celebrating a new style of rock 'n' roll was emerging in San Francisco. The psychedelic poster style would have a profound effect on the McGovern political poster explosion in 1972. Historically, in the American mind, California had always symbolized opportunity, a chance to escape and start over, a place to create something different. The state had experienced periodic waves of growth beginning with the gold rush of the 1840s. In many ways California wasn't a place, it was a dream. Beginning in 1963, disenchanted, alienated youth from all parts of the United States started to "turn on, tune in, and drop out," as Marshall McLuhan coined it. They heeded the advice of Horace Greeley to "Go West" and moved to San Francisco. The old beatniks were still ensconced in North Beach, living a bohemian existence; but a new breed, the emerging hippie, found refuge in Haight-Ashbury.

The magic carpet ride, according to Paul D. Grushkin in *The Art of Rock,* actually began in Virginia City, Nevada, in the Red Dog Saloon, where the Amazing Charlatans, a folksy jug band that auditioned while tripping on acid and dressed like characters out of the nineteenth-century American West—outlaws, gunfighters, gamblers, ramblers, and pimps—were hired to play through the summer of 1965. That same summer Charlatans' band members George Hunter and Michael Ferguson hand drew the first psychedelic poster, producing a funky retro-western look. The hand-drawn, low-budget offset posters that began with the Charlatans would later become a favorite of the grassroots supporters of Eugene McCarthy and George McGovern. After printing, these posters were then often hand colored.

In San Francisco a commune of four people that would become known as the Family Dog put on a series of very successful dances that were promoted by handbills drawn by Alton Kelley. Kelley dressed in Bat Masterson mode and in time became one of the leading creators of psychedelic posters. These dance hall extravaganzas, or "happenings," included music, dancing, light shows, drugs, and revelers in costume and produced an exciting visual and auditory experience. From these humble beginnings an avalanche of posters would emerge in daring new colorful designs advertising a hot music scene in which garage bands blossomed into major attractions signed by big record labels. Promoters Bill Graham and the Family Dog, who both booked bands for the Fillmore Auditorium, shared the facility at first. A young artist named Wes Wilson created the first eleven out of twelve posters for Family Dog concerts and all of the posters for Graham's shows through 1967. Graham and Wilson fell out over money in 1967, and Bonnie MacLean, Graham's business partner and later his wife, designed the Fillmore posters for a number of years thereafter. Her posters were in the Wilson style, but she also created several considered to be innovative classics.

Of the hundreds of psychedelic posters, only a handful ended up being screen printed. The vast majority were printed on offset presses, and the artists and printers worked closely to render high-quality prints, sometimes mixing inks to produce desired colors. To print such colorful posters, however, was difficult. The paper had to be run through the press two or three times, one sheet at a time, and was dried for about an hour between runs. The final drying process took approximately twelve hours, and the finished posters had a screen print–like quality. When the posters arrived at various venues, there would sometimes be a long line of enthusiastic collectors waiting to grab the new release.

The modern poster owes much to the pioneers in the art of poster making, like Jules Chéret and Henri de Toulouse-Lautrec during the belle époque in France from 1871 to

10. George Hunter and Michael Ferguson of the Amazing Charlatans, 1965
14" × 10", offset lithography
Courtesy of Joe R. Armstrong.
This hand-drawn poster is known as *The Seed* and was printed in blue- and black-ink versions and occasionally hand colored. Later posters differ in date, details, and color of paper. This Red Dog Saloon poster was the first of an original cool funky style that celebrated a new type of music and birthed the psychedelic poster that would soon take the growing hippie community in San Francisco by storm.

1914. But Wes Wilson and the early creators of the psychedelic poster—Alton Kelley, Stanley Mouse, Victor Moscoso, Bonnie MacLean, Rick Griffin, Bob Fried, John Van Hamersveld, and Gary Grimshaw—owe far more to art nouveau artists like Alphonse Mucha and Vienna Secession artists like Gustav Klimt, Oskar Kokoschka, and Alfred Roller, especially in the techniques of lettering. Psychedelic posters were in many respects art nouveau on acid. Hippies claimed that to be able to read the lettering on the posters you had to be either stoned or tripping or both. Contemporary and historical images were frequently incorporated into the posters as had been done by the art nouveau artists before them. This technique of appropriation would become the stock and trade of psychedelic poster makers, who treated the past as a toy chest in which to rummage, looking for cool images—a process they referred to as going to the "image bank" or to the "graphic flea market." By using familiar images in radical new formats of contrasting bright colors and lettering, often employing figure-ground reversal, these art pirates, almost M. C. Escher–like, played with the viewer's perception and, importantly, created a kind of historical revisionist critique that infused new meanings dependent on irony, parody, and lampoon.

Between 1965 and 1969 the music and the posters from the Fillmore and the Avalon Ballroom spread throughout California. In Los Angeles, John Van Hamersveld and Gary Grimshaw (who started his poster career in Detroit) created especially outstanding posters. Gilbert Shelton, who drew the underground comix strips *The Fabulous Furry Freak Brothers, Fat Freddy's Cat,* and *Wonder Wart-Hog,* started his career in Austin, Texas, working with Jim Franklin to produce psychedelic posters for the rock venue The Vulcan Gas Company. Shelton too ended up in LA. The psychedelic posters' influence on the political posters of the presidential campaigns of Eugene McCarthy in 1968 and George McGovern in 1972 were profound, especially in the style of lettering.

11. Wes Wilson, Fillmore Auditorium, 1966
18 3/8" × 13 13/16", screen print
Family Dog Poster artwork by Wes Wilson and Chet Helms. © Rhino Entertainment Company. All rights reserved.
One of Wes Wilson's first posters, numbered Family Dog FD 1, this screen print was printed in black and white and then hand colored by Wilson himself—a technique reminiscent of that used to color the early lithographic prints of Currier and Ives in the 1840s. Wilson, who now maintains a studio in southern Missouri, was one of the most prolific psychedelic poster makers of the sixties, creating dozens that are considered classics of design. Unfortunately, Wilson made very little money from the outstanding posters he created.

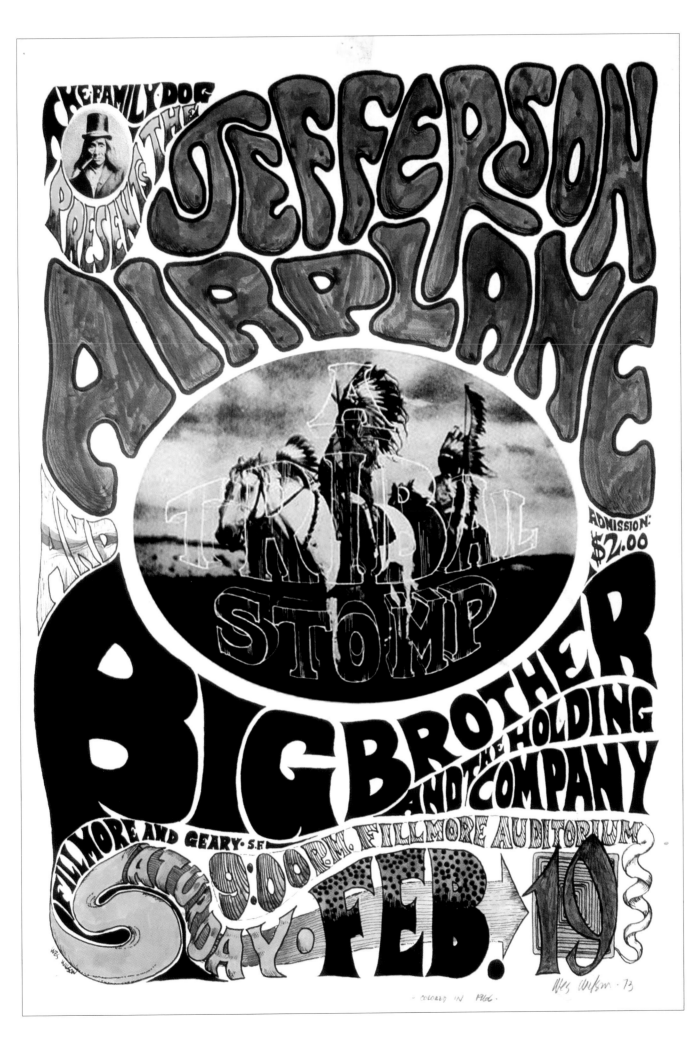

12. Stanley Mouse and Alton Kelley, Avalon Ballroom, 1966

19 3/16" × 13 3/16", screen print

Courtesy of Mouse Studios.

This is one of the few Family Dog screen print posters, FD 27, in an edition of thirty in a larger-than-usual size, created by two of the best poster makers of the era. The concert was cancelled, but the poster has achieved lasting fame.

13. Bonnie MacLean, Fillmore Auditorium, 1967

21" × 14", offset lithography

© Wolfgang's Vault. All rights reserved.

Bonnie MacLean, who married Fillmore operator and promoter Bill Graham, created a run of posters that followed those produced by Wes Wilson and very much in his style. She is considered one of the top poster makers of the era, and BG 89, pictured here, is an innovative classic. She was also famous for her psychedelic chalkboard drawings in the lobby of the Fillmore; one board promoted the current headliners and the other pitched the next concert.

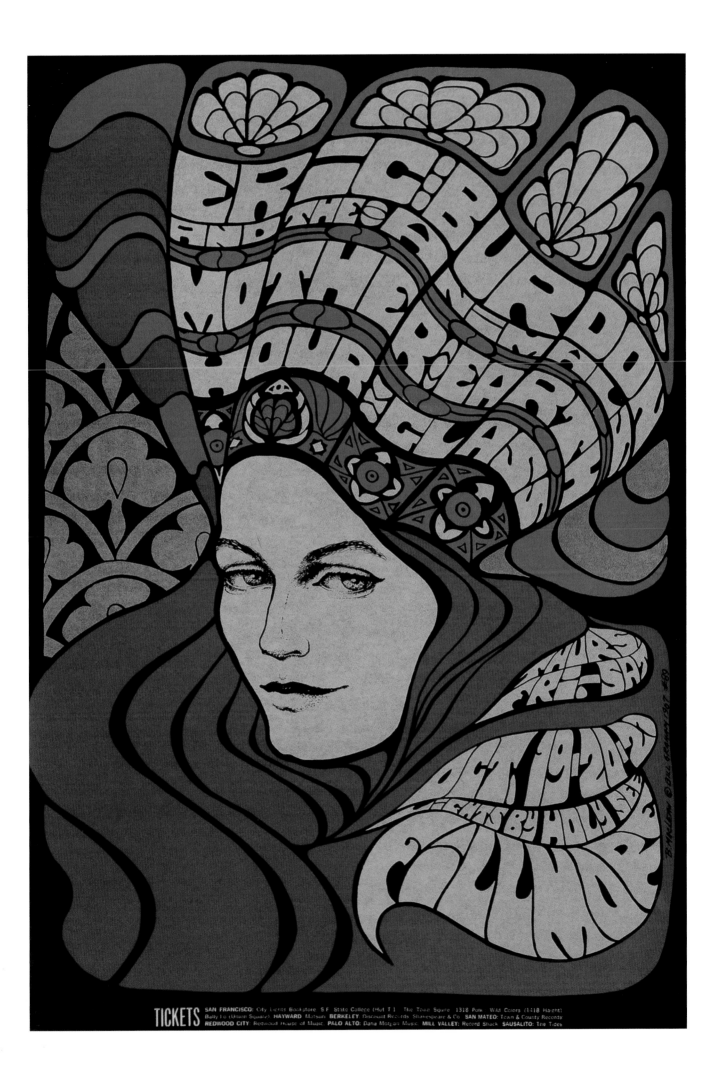

ERIC BURDON AND THE ANIMALS
MOTHER EARTH
YOUR CLASS

THURS-FRI-SAT
OCT 19-20-21
LIGHTS BY HOLY SEE
FILLMORE

TICKETS SAN FRANCISCO: City Lights Bookstore S F State College (Hut T 1) The Town Squire 1318 Polk Wild Colors (1418 Haight)
Bally Lo (Union Square) HAYWARD: Matsun BERKELEY: Discount Records Shakespeare & Co SAN MATEO: Town & County Records
REDWOOD CITY: Redwood House of Music PALO ALTO: Dana Morgan Music MILL VALLEY: Record Shack SAUSALITO: The Tides

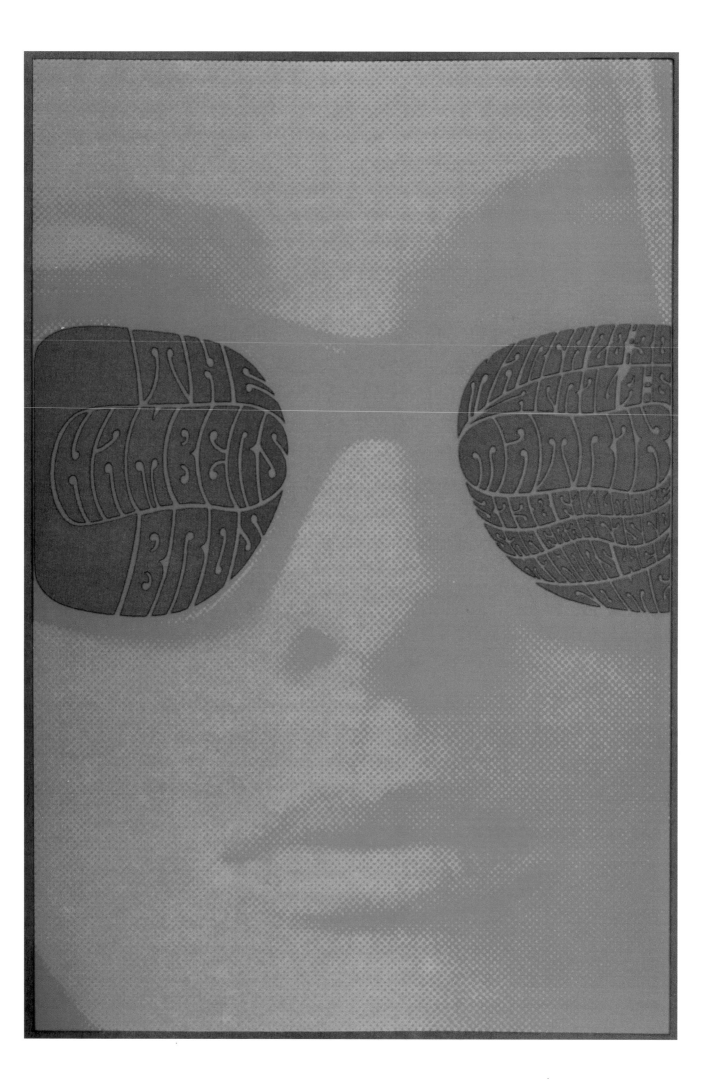

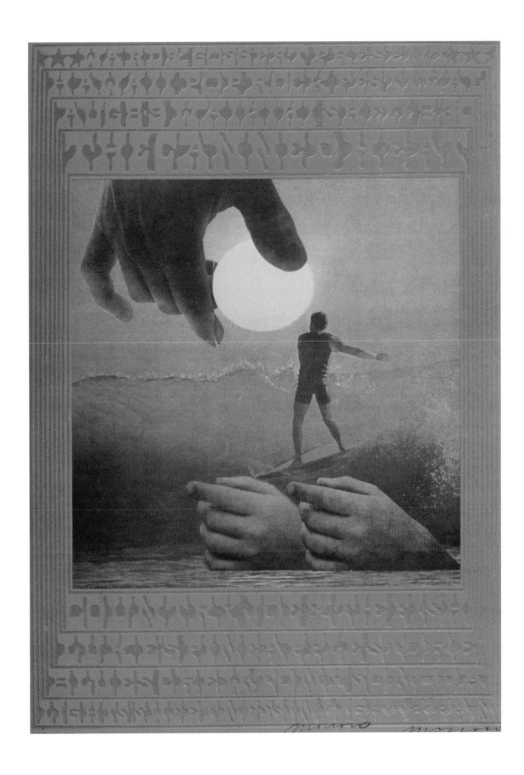

14. Victor Moscoso, Matrix Club, 1967
21" × 14", offset lithography
Courtesy of Victor Moscoso.
Neon Rose 12 is one of the most iconic psychedelic posters. In fact, the Neon Rose series epitomizes the colorful, eye-popping, electric acid posters of the hippie era. The colors are not Day-Glo, but they are bright and bring together combinations from the opposite ends of the color spectrum to produce a sense of optical vibration in the image. Victor Moscoso exclaimed, "The musicians were turning up their amplifiers to the point where they were blowing out your eardrums. I did the equivalent with the eyeballs." Artists were paid a small commission per poster and usually gave up copyright, so Moscoso formed his own company and produced the Neon Rose series, twenty-seven posters, for the Matrix Club in order to maintain control of his art and produce income.

15. Victor Moscoso, Hawaii Pop Rock Festival, 1967
20" × 14", offset lithography
Courtesy of Victor Moscoso.
Trained at Yale, Victor Moscoso pioneered the use of photographic montage in the California world of the psychedelic poster. In this poster, Neon Rose 16, he used a photo by Ron Stoner from a then current issue of *Surfer Magazine*. This poster shows the influence of Josef Albers's color studies; László Moholy-Nagy, Albers's teacher, who painted the breakfast nook in his Dessau Masters House bright orange; the Bauhaus love of photomontage; and the lettering style of the Vienna Secession.

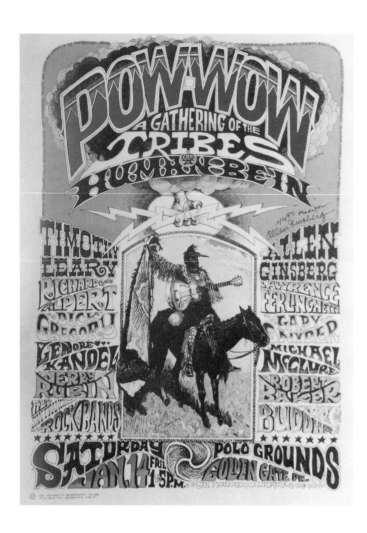

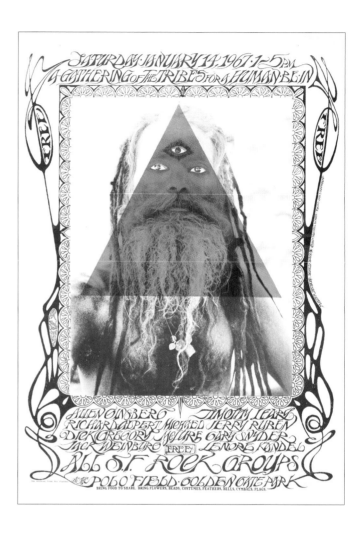

16. Rick Griffin, Human Be-In, 1967
20½" × 14½", offset lithography
Courtesy of Lincoln Cushing/Docs Populi.
On January 14, 1967, at the Polo Grounds in San Francisco's Golden Gate Park, the hippie tribes converged, a kind of bar mitzvah that ushered in the counterculture Age of Aquarius that carried over into the infamous Summer of Love. Rick Griffin's poster was printed in several different inks and on different-colored paper and because of its popularity gave him a chance to create posters for the Avalon Ballroom. Griffin, who had created posters for the surfing movement, went on to become one of the best-known California psychedelic poster makers.

17. Stanley Mouse, Alton Kelley, and Michael Bowen, Human Be-In, 1967
19¹¹⁄₁₆" × 14³⁄₁₆", offset lithography
Courtesy of Mouse Studios.
Printed in several color variants as posters and handbills, this weird, funky poster captured the counterculture fascination with Indian spiritualism in combination with drugs and is a graphic entry point into the world of Haight-Ashbury and psychedelia. Timothy Leary, the mystical high priest of the Brotherhood of Eternal Love, advocated the use of LSD and the magic mushroom, claiming it would help you break on through to the other side.

18. John Van Hamersveld, Shrine Auditorium, 1968
27¼" × 19", offset lithography
Courtesy of John Van Hamersveld.
John Van Hamersveld, who created the famous poster for the film *The Endless Summer*, moved from the surfer world into the burgeoning Los Angeles psychedelic scene in the mid-sixties. His company, Pinnacle Productions, staged rock concerts and dances and produced promotional posters and handbills. The unabashed use of color and lettering made *Indian* an instant classic of the psychedelic poster genre.

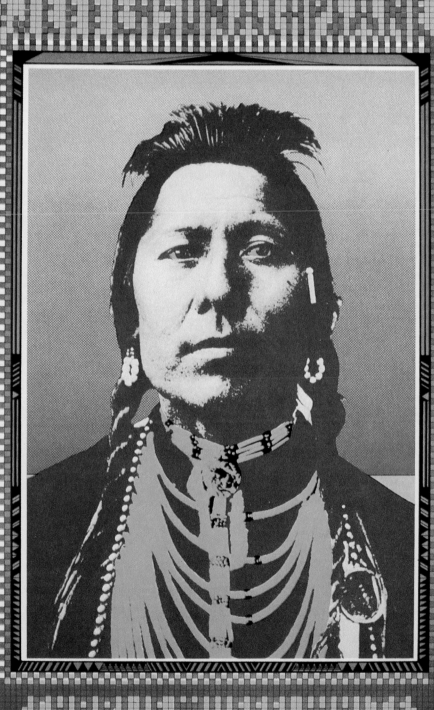

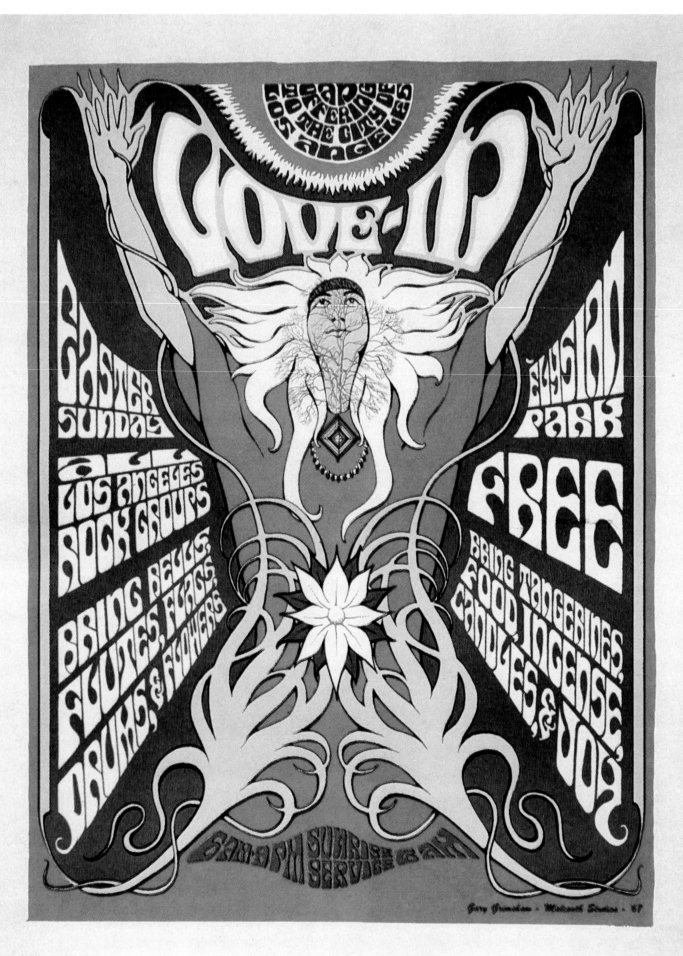

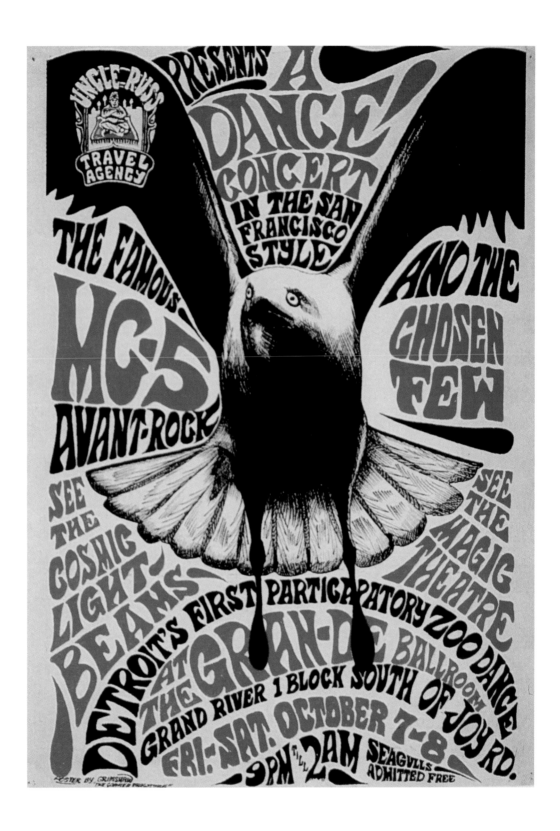

19. Gary Grimshaw, Elysian Park Love-In, 1967
22⅜ × 17⅜", offset lithography
© *Gary Grimshaw Estate.*
In *The Art of Rock*, Paul D. Grushkin claims that "Detroit is the only city that rivaled San Francisco in poster design during the psychedelic years." The Detroit psychedelic poster was heavily dependent on the independent and original artistic talents of Gary Grimshaw and was not an outgrowth of the California poster happening, though this poster is for an event in Los Angeles after Grimshaw and his unique style migrated to the City of Angels.

20. Gary Grimshaw, Grande Ballroom, 1966
19" × 13", offset lithography
© *Gary Grimshaw Estate.*
This seagull poster pitching a Detroit happening is one of Gary Grimshaw's top creations. A tight budget forced Grimshaw to work in two or three colors to cut printing costs. Most runs were of five hundred or a thousand. The Grande Ballroom—the city's famous concert and dance venue that hosted small crowds of the city's hippies gravitating to the groovy new lifestyle—commissioned Grimshaw to create posters and handbills, but due to a lack of advertising funds often only handbills were printed. Several of Grimshaw's creations are among the very best of all the psychedelic posters.

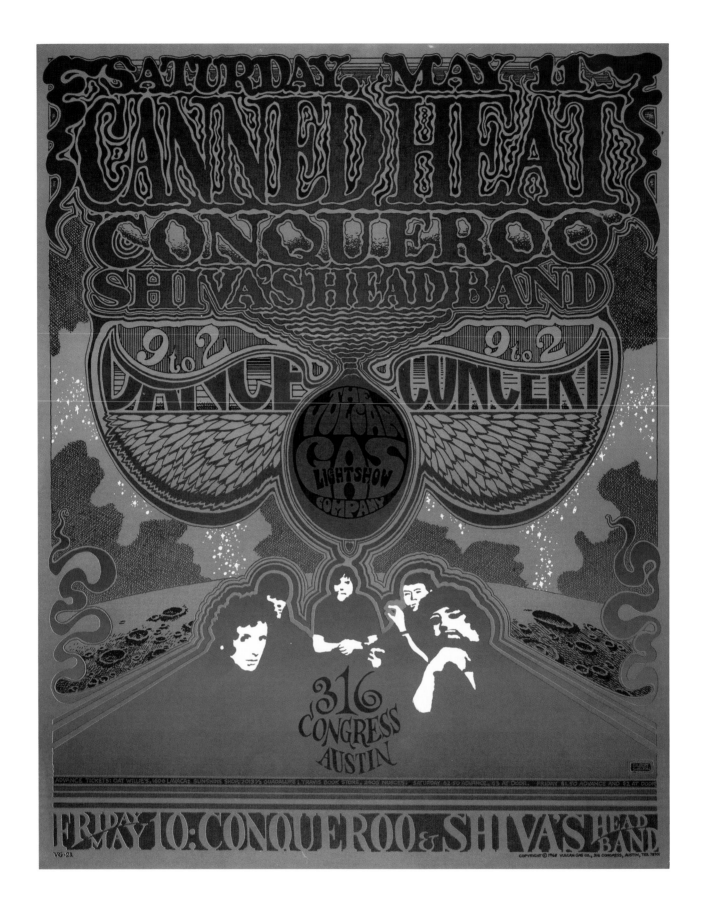

21. Gilbert Shelton, Vulcan Gas Company, 1968
29" × 23", offset lithography
Courtesy Gilbert Shelton and the Texas Poster Art Collection, TPA_0140. The Dolph Briscoe Center for American History, University of Texas at Austin.
Austin, Texas, and its university students became the center of a satellite counterculture movement that went whole hog for drugs, rock 'n' roll, the new hippie lifestyle, and antiwar activism. LSD slowly made its way to Austin, whose hippie denizens had for years survived on mescaline, peyote, and cannabis. Gilbert Shelton, who later moved to LA and became one of the kings of underground comix, created a number of fine posters for the local rock venue, the Vulcan Gas Company.

22. Gilbert Shelton, Vulcan Gas Company, 1967
29" × 23", offset lithography
Courtesy of Gilbert Shelton and the Texas Poster Art Collection, TPA_0132. The Dolph Briscoe Center for American History, University of Texas at Austin.
White Girl is one of Shelton's classic posters. The Vulcan Gas Company opened in the fall of 1967 to an enthusiastic crowd of just under a thousand. The venue never made money and lasted only three years, but it produced fabulous posters in runs of approximately one hundred in a much larger size than their San Francisco cousins.

23. Jim Franklin, Vulcan Gas Company, 1968
9" × 11", offset lithography
Courtesy of Jim Franklin and the Texas Poster Art Collection, TPA_00184. The Dolph Briscoe Center for American History, University of Texas at Austin.
The San Antonio concert was cancelled, but the poster and handbill survived. *Janis*, created by Jim Franklin, captures the rock star in fascinating color gradients. Janis Joplin, a native of Texas, began her career playing autoharp and belting out "Railroad Bill" and "Cripple Creek" in Austin in the early sixties with the Waller Creek Boys, a folk blues band. Franklin created a number of the Vulcan Gas Company's best posters.

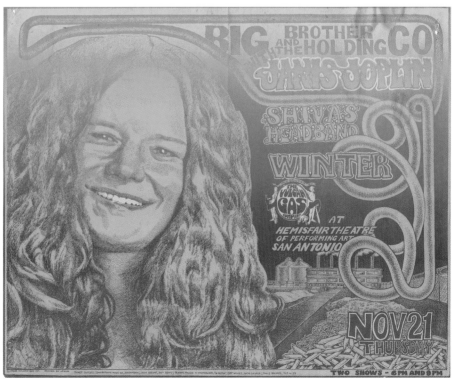

ROCK & ROLL
BENEFIT DANCE

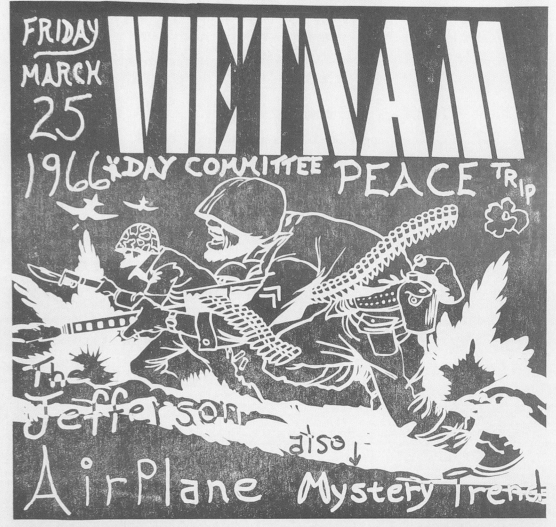

FRIDAY MARCH 25 **VIETNAM**

1966 DAY COMMITTEE PEACE TRIP

Jefferson Airplane also→ Mystery Trend

UNIVERSITY *of* CALIFORNIA
BERKELEY
HARMON GYM
DONATION $1.50

VDC FLICKS - MAGIC LIGHTS - FOG (461)

Antiwar

On March 8, 1965, the first combat troops arrived in Vietnam, and antiwar reaction was swift. As the war escalated, the growing opposition became the cause célèbre of a youth rebellion that encompassed hundreds of thousands. Many of the posters created to promote marches, demonstrations, hippie fairs, and antiwar benefit concerts were made by the best psychedelic poster makers—people like Wes Wilson. Added to this mix was an important new element as some of America's leading artists—Christos Gianakos, Rudolph Baranik, and Tomi Ungerer—joined the protests and created powerful posters that helped fuel the growing dissent. Poster styles of civil rights groups that depended heavily on contemporary photographs and the madcap psychedelic posters of the West Coast came together to produce a wide range of exciting eclectic graphics for the antiwar movement. On occasion, Bauhaus-inspired posters employing photomontage or collage would appear. War protest posters were nearly all offset runs. A partial explanation for the move away from the hand-drawn and letterpress posters was that bands were making more money and the audience for both music and antiwar gatherings was rapidly expanding. To meet this growing need for publicity posters, only offset printing could produce the range of color as well as print runs as large as five thousand or more at affordable prices.

Antiwar groups and coalitions were fragile and fraught with infighting, but despite these problems they were able to create mobilization committees, or Mobes, that patched together a number of hugely successful demonstrations—especially in the nation's capital. Marchers carried placards, signs, and posters demanding that President Lyndon Johnson end the U.S. involvement in Vietnam. Left elements in the antiwar movement, frustrated by their lack of effectiveness through nonviolence, began participating in demonstrations bent on militancy. Outsized roles were played in the Mobes by front organizations of the Communist Party USA and the Trotskyite Socialist Workers Party (SWP), groups that had a different agenda and were committed to ending the war "by any means necessary." The SWP produced some of the most effective posters of the era, often using the theme of "Bring the GIs Home Now / The Enemy Is at Home." Like SNCC, the SWP favored photomontage but often added vibrant color to their designs, having been influenced by posters created in the USSR, China, and Cuba.

By 1967 the antiwar movement reached a fever pitch. The success of the spring mobilization marches induced the Mobes to plan a major demonstration in Washington DC on October 21, 1967. One hundred thousand people crowded the Washington Mall, while thirty-five thousand crossed the Potomac and marched to the steps of the Pentagon. Posters, placards, and buttons were in abundance. The antiwar movement was poised to go mainstream.

24. Vietnam Day Committee, 1966
22" × 14", offset lithography
An example of an early Berkeley-area antiwar happening sponsored by the Vietnam Day Committee, which was founded a year earlier by political activists Jerry Rubin and Abbie Hoffman. Later both were part of the notorious Chicago Eight that went on trial for instigating the riot in Grant Park during the Democratic National Convention in August 1968.

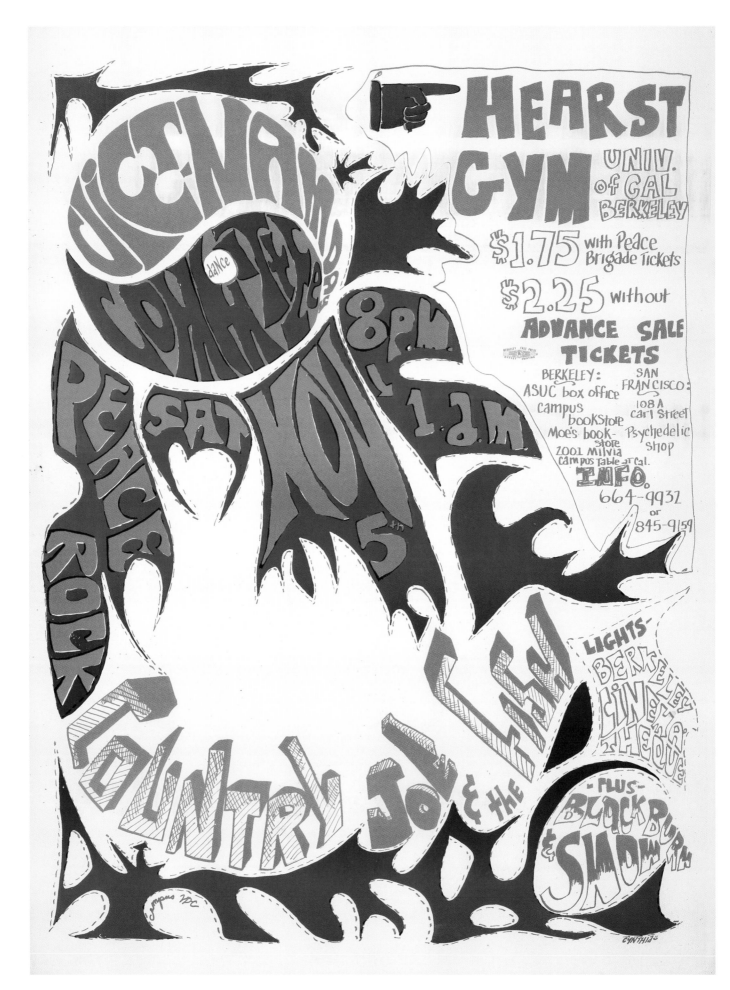

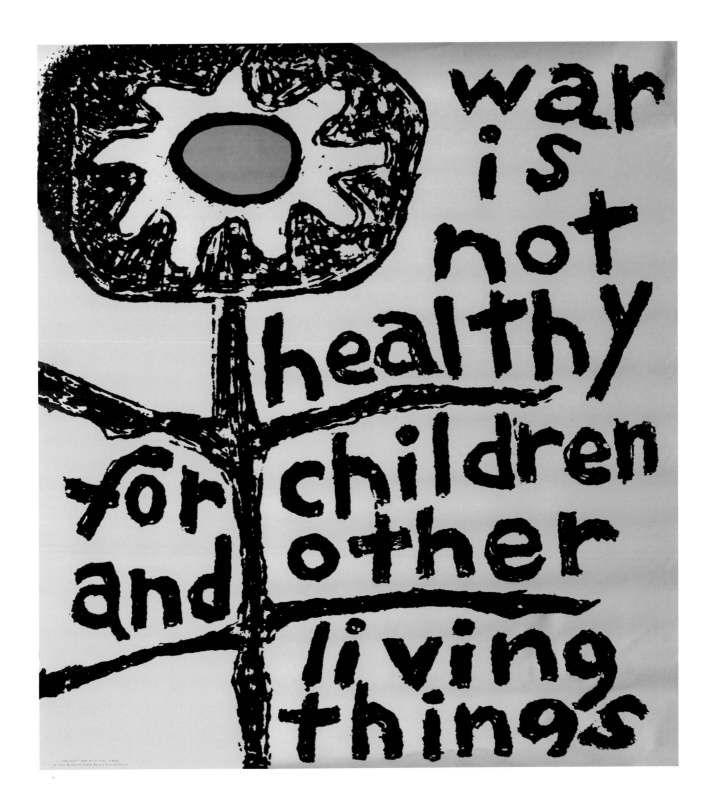

25. Vietnam Day Committee, 1966

22½" × 16¾", offset lithography

Courtesy of Lincoln Cushing / Docs Populi.

Like the Charlatans poster, referred to as *The Seed* (fig. 10), this classic early psychedelic poster was printed in an offset edition and in a very small run. Violating the design rules of the time, the poster's clutter of images and its busyness are hallmark features of the rebellious psychedelic style. An accompanying handbill is in the same design.

26. Lorraine Schneider, 1966

28" × 26 ½", offset lithography

The poster pictured here is an offset print from the late sixties, but the design was originally a 4" × 4" etching done in an edition of two hundred in 1965. Schneider, a printmaker, created the image to help end the war in Vietnam and to protect her son from being drafted. In 1969 her etching became the logo of the newly founded antiwar organization Another Mother for Peace. Schneider died in 1972 and did not live long enough to know that her etching had become iconic—second only to the ubiquitous peace sign. The poster is now widely available in an array of colors.

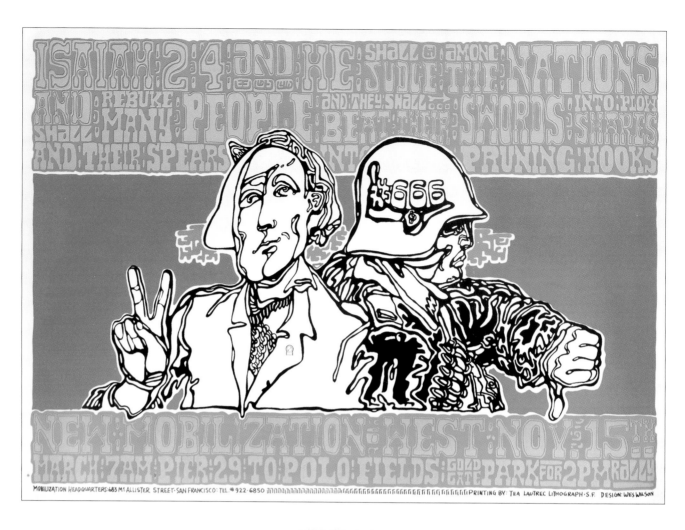

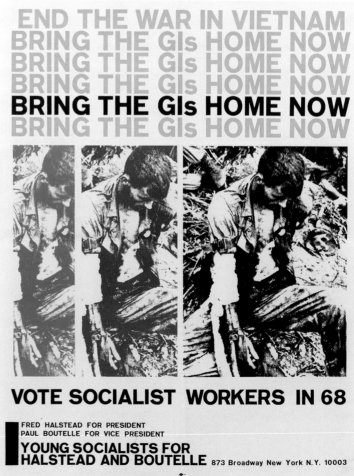

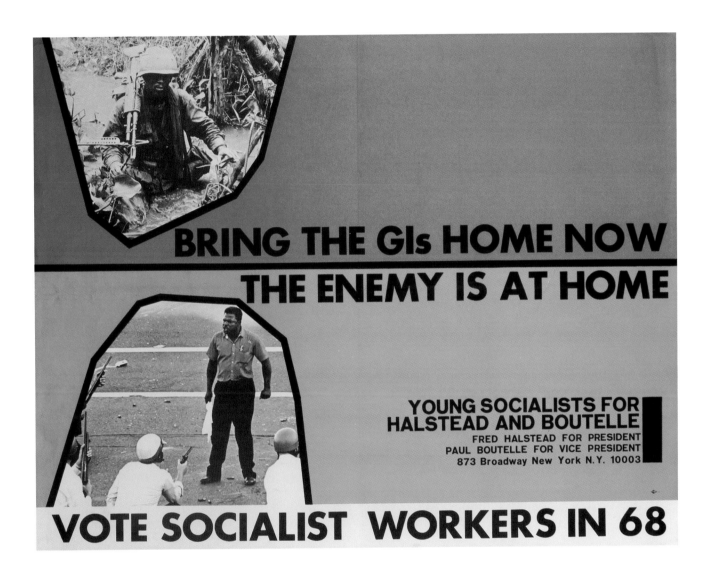

27. Wes Wilson, 1966

17⅛" × 22 ¼", offset lithography

No poster better illustrates the influence of the psychedelic poster on its antiwar cousin than this standout poster created by Wes Wilson for the New Mobilization West protest march in San Francisco on November 15. The well-known biblical quotation from Isaiah 2:4 musters history, tradition, and God on the side of peace.

28. Socialist Workers Party (SWP), 1968

22¼" × 17¼", offset lithography

Active in the antiwar movement, the SWP, headquartered in New York City, advocated complete withdrawal from Vietnam and was influential in pushing other antiwar groups in a similar direction. The party created powerful images throughout the sixties, but 1968 was the high point of SWP graphics. The SWP favored more formal poster designs using photomontage and was little influenced by the psychedelic style emanating from California.

29. Socialist Workers Party (SWP), 1968

17⅛" × 22¼", offset lithography

The SWP worked hard at forming a coalition between black power advocates and white antiwar radicals and was very active in Mobes, the coalitions of antiwar groups that organized marches and demonstrations. Malcolm X often spoke at SWP-sponsored events, but after his assassination the party's efforts fizzled. There are two versions of this poster, which use different photos at the bottom of blacks confronting the police. Nearly all SWP posters were printed in a smaller handbill size as well.

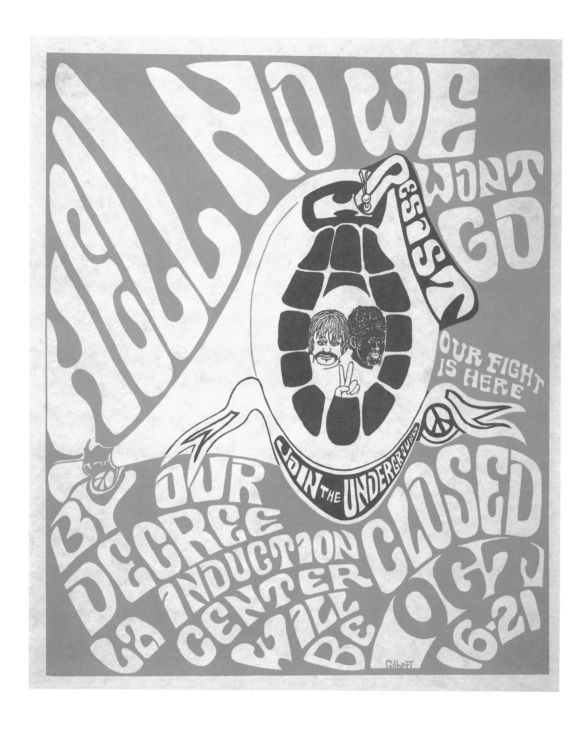

30. Gilbert, 1967

17⁵⁄₁₆" × 14⁹⁄₁₆", screen print

Courtesy of Lincoln Cushing/Docs Populi.

All that is known about this print, *Hell No We Won't Go*, is that it was made by a person named Gilbert. It is a design that clearly demonstrates the influence of the psychedelic-style poster on antiwar movement posters. Like the SWP posters, this one pitches black-white solidarity in militant draft resistance actions and encourages the viewer to join the underground and pull the pin on the hand grenade.

31. Chas Flash (Charles Fleischman), 1967

17" × 11", offset lithography

Collection of the Oakland Museum of California, All Of Us Or None Archive, fractional and promised gift of the Rossman Family. 2010.54.42.

Chas Fleischman created a number of psychedelic-style posters for events at the wild Muir Beach Tavern, a satellite of the Haight. The tavern, demolished in 1969 by the National Park Service, took on the aura of a kind of treasured shrine to the excesses of the youth rebellion. Rumors persist that after Janis Joplin's heroin- and alcohol-induced death in 1970, her ashes were spread on Muir Beach. Benefit Vietnam Summer, a coalition of antiwar groups that sponsored concerts to raise funds for their activities, occurred at various venues in and around San Francisco. Chas Flash was not only a poster maker and cartoonist but played music and made a number of films in what he describes as a "funky" genre.

BENEFIT! VIETNAM SUMMER

CHARLATANS PULLICE
TRANSATLANTIC RAILROAD
SONS OF MAGENTA RAINDROP
CHAMPLIN MORNING GLORY
SAT JULY 29 8PM $2 MUIR BEACH TAVERN

CHAS FLEISCHMAN

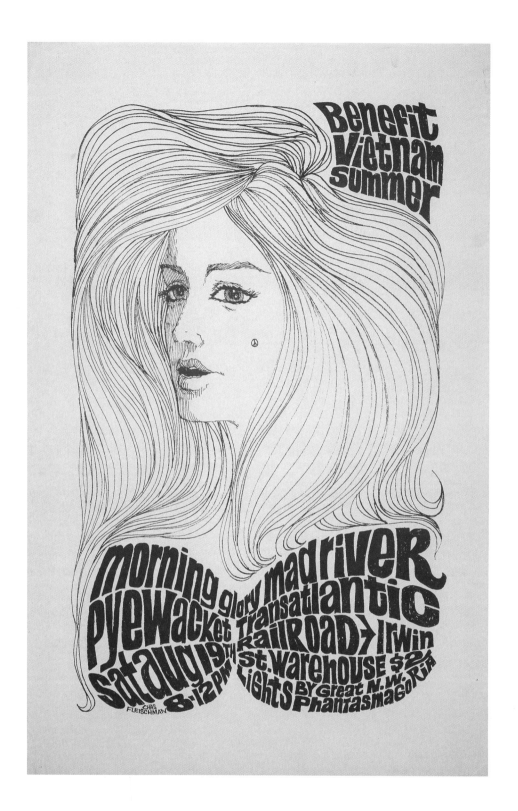

32. Chas Flash (Charles Fleischman), 1967
20" × 13", offset lithography
Collection of the Oakland Museum of California, All Of Us Or None Archive, fractional and promised gift of the Rossman Family. 2010.54.41.
Another innovative Fleischman poster for Benefit Vietnam Summer reflects the large number of rarely seen posters for events held outside San Francisco. Notice the peace sign on the woman's cheek.

33. Chas Flash (Charles Fleischman), 1968
11" × 8½", offset lithography
Courtesy of Charles Fleischman.
The Peace and Freedom Party was founded on June 23, 1967, and in 1968 nominated Eldridge Cleaver for president and Judith Mage for vice president. In some states different presidential and vice presidential candidates appeared on the Peace and Freedom Party ballot as ballot status in many states demanded candidates' names be submitted prior to the party's nominating convention held in Ann Arbor, Michigan, August 17–18, 1968. On thirteen state ballots, the party polled just over 111,000 votes nationally. Peace and Freedom Party posters were regularly in a psychedelic style.

34. Chas Flash (Charles Fleischman), 1967
13" × 10", offset lithography
Courtesy of Charles Fleischman.
Antiwar speakers toured college campuses showing films and garnering support for the mushrooming movement. Of special interest are the two groups who sponsored the film but proposed different agendas: the students are against the war, and the faculty seek a negotiated ending to the conflict.

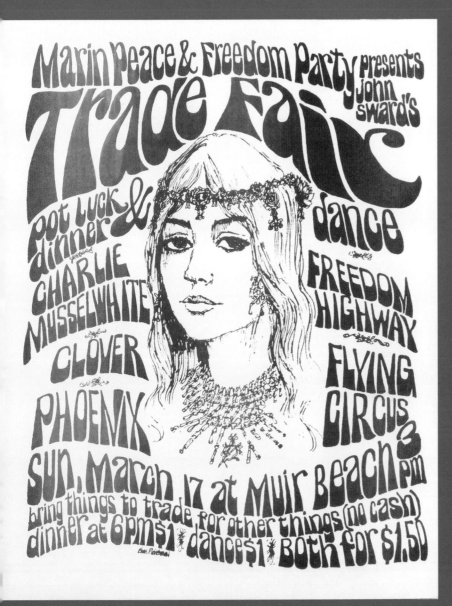

Marin Peace & Freedom Party presents John Sward's
TRADE FAIR

pot luck dinner & CHARLIE MUSSELWHITE CLOVER PHOENIX

dance FREEDOM HIGHWAY FLYING CIRCUS

Sun. March 17 at Muir Beach 3 PM
bring things to trade for other things (no cash)
dinner at 6 PM $1 dance $1 both for $1.50

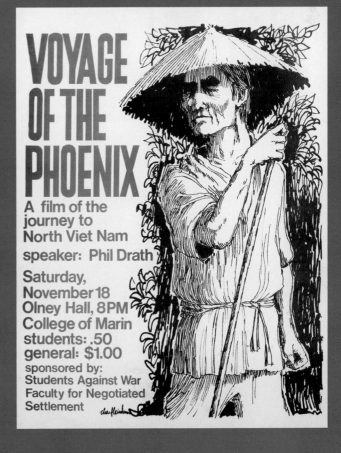

VOYAGE OF THE PHOENIX

A film of the journey to North Viet Nam

speaker: Phil Drath

Saturday, November 18
Olney Hall, 8 PM
College of Marin
students: .50
general: $1.00

sponsored by:
Students Against War
Faculty for Negotiated Settlement

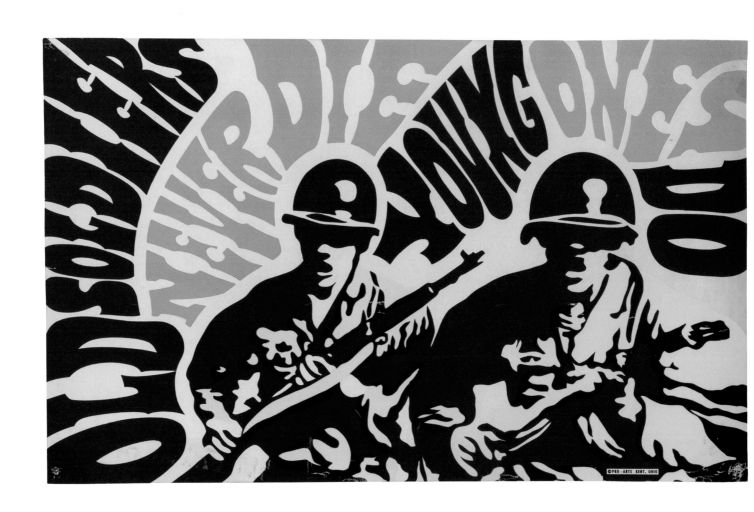

35. Unknown artist, ca. 1967–68

19⅜" × 32¾", screen print

A well-done psychedelic print in vibrant eye-catching color that ironically and effectively amends a famous line taken from an army barracks ballad, "old soldiers never die, they just fade away," used by Gen. Douglas MacArthur in his farewell speech delivered to a joint session of Congress on April 19, 1951.

36. Nancy Coner, ca. 1967

22⅓" × 17½", offset lithography

Nancy Coner employed one of the most often used slogans of the antiwar movement and used a mixed bag of potent symbols: a ranting LBJ in a vortex, slain soldiers, and marchers with placards. She created this montage for the Student Mobilization Committee.

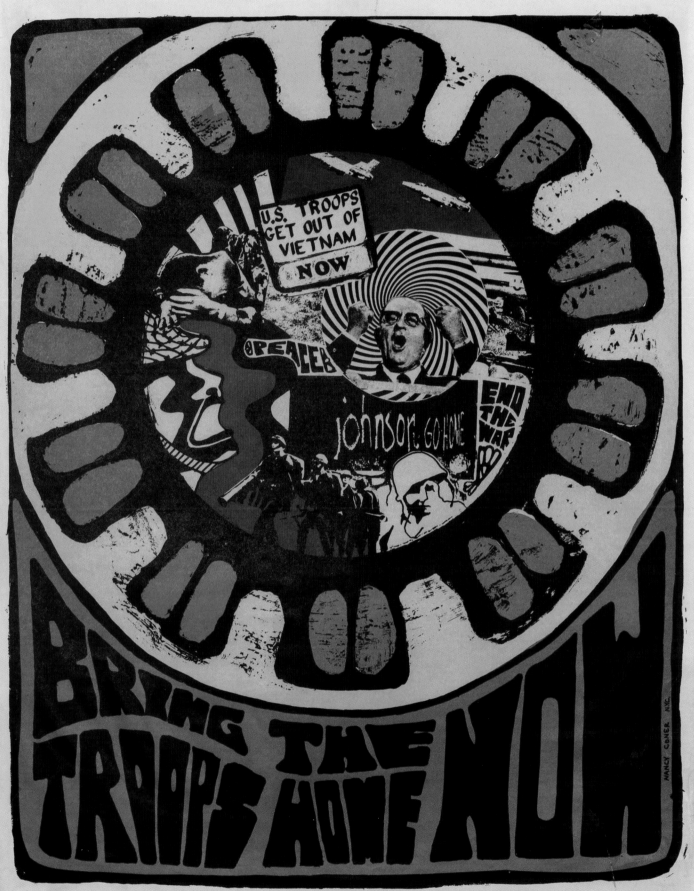

U.S. TROOPS GET OUT OF VIETNAM NOW

PEACE

END THE WAR

johnson GO HOME

BRING THE TROOPS HOME NOW

NANCY CONER, N.Y.C.

STUDENT MOBILIZATION COMMITTEE 17 E. 17th ST. N.Y. N.Y.

A breath of fresh air.

Gene McCarthy

McCarthy For President, N.Y. 300 8th Ave., N.Y. 10019. Co-Executive Directors: Sarah Kovner, Harold Ickes. State Co-Chairmen: Eleanor Clark French and Richard Lipsitz.

The Innovative Posters of the 1968 Campaign of Eugene McCarthy

Sen. Eugene McCarthy had been speaking out against U.S. military involvement in Vietnam as early as 1966. Convinced the war should immediately be brought to an end and that the growing conflict represented a "deepening moral crisis," McCarthy stated his intention to defeat President Lyndon Johnson in the nation's first primary in New Hampshire—a goal that few thought the peace candidate had a chance of accomplishing. On January 30, 1968, just six weeks before the New Hampshire primary, the Viet Cong launched the Tet Offensive, a well-planned and coordinated attack against Vietnamese cities. Though it was a U.S. military victory, Tet was a political disaster on the home front. To the American public the offensive appeared to be further escalation of a war with no end in sight, and it became the tipping point of public support, giving McCarthy's bid to unseat Johnson a huge boost. The final primary results in New Hampshire illustrated that a growing number of voters either opposed or seriously questioned the war: LBJ with 49 percent, and McCarthy at 42 percent.

Sensing a politically wounded president, Sen. Robert Kennedy, who had pledged not to run, announced his candidacy on March 16. George McGovern privately was enthusiastic for the Kennedy candidacy, but publically he took a neutral stand as McCarthy and Vice President Hubert Humphrey, an unannounced candidate, were from his neighboring state of Minnesota. The Democratic Party, however, was devolving into acrimonious factions. McCarthy and Kennedy battled it out in primary contests across the country all the way to California, lending credence to the old saw that when Democrats are asked to form a firing squad they always form a circle. On March 31 President Johnson, guessing correctly that he would lose the Wisconsin primary, shocked the nation in a televised announcement that he would "not seek, . . . and not accept, the nomination of my party." On April 4, four days after LBJ's announcement, the revered civil rights leader Dr. Martin Luther King Jr. was gunned down in Memphis. While a stunned nation mourned, riots erupted in more than forty cities.

The McCarthy campaign garnered an unprecedented tsunami of Hollywood stars and entertainers, including Paul Newman and his wife, Joanne Woodward, Woody Allen, and Dustin Hoffman. Many holdovers from the Camelot years supported RFK, including Andy Williams, Sammy Davis Jr., Warren Beatty, Bill Cosby, Henry Fonda, Mahalia Jackson, Sonny and Cher, the Byrds, and, surprisingly, Jefferson Airplane. While Hollywood stars, writers, and intellectuals flocked to the McCarthy campaign, the candidate also inherited droves of young veterans of the civil rights struggles, committed antiwar activists, and the majority of those pursuing an anti-establishment lifestyle, all of whom brought their music, art, and culture into politics while chanting loudly at campaign rallies, "Gene, Gene, Stop the Machine." The McCarthy campaign posters of 1968 brought

37. Unknown artist, 1968
28" × 21", offset lithography
A breath of fresh air, a well-designed and clever poster, was widely distributed by McCarthy's national headquarters. It captured the allure of the candidate and the possibility of something new. Another version of the poster was printed using blue ink for Gene McCarthy's name.

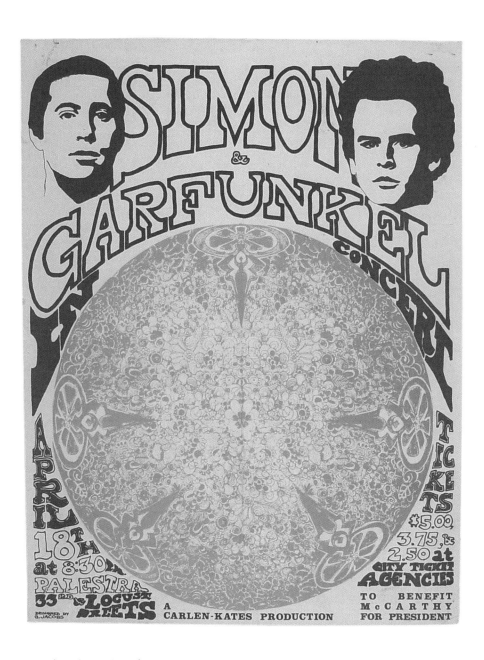

together the styles of the civil rights, psychedelic, and antiwar posters. Innovative and exciting posters at the national, state, and grassroots level proliferated, while McCarthy's graphically savvy national campaign staff produced a number of exciting and effective posters. The California psychedelic gig-poster style made its way into the presidential campaign arena for the first time with posters and handbills for three Simon and Garfunkel concerts performed in support of McCarthy.

McCarthy, campaigning hard in the cities and university towns of the Beaver State, won the Oregon primary; it was the first time a Kennedy had lost an election. The battle now focused on California. Just after midnight on June 5, after winning the hotly contested race by a few percentage points, RFK strode into the Embassy Ballroom of the Ambassador Hotel and spoke to the jubilant crowd. At the conclusion of his remarks as he was making his way through a narrow passage to waiting reporters, he and five others were shot by Sirhan Sirhan. Suffering a severe head wound, Kennedy died a day later. In the midst of this tragedy the Democratic race for the nomination was thrown into chaos. Many of Kennedy's delegates now moved to Humphrey. McCarthy stopped his campaign and retreated to Minnesota to recover from his opponent's death and decide how to proceed. An army of loyal workers waited in the field for their marching orders.

In July, fully back in the race, Clean Gene wooed delegates and planned a huge surge

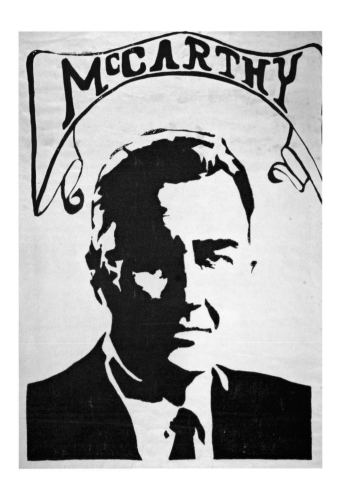

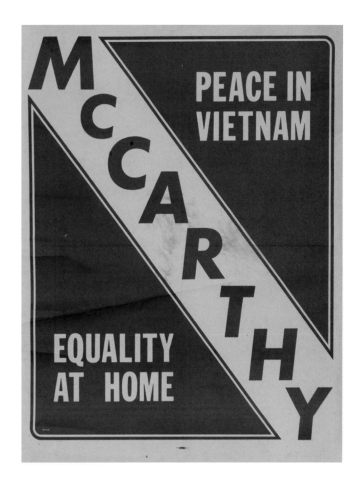

in campaign activities for later that month and on into August. Two days before the Democratic National Convention convened on August 26, the McCarthy forces held huge rallies in twenty-four American cites that resulted in a plethora of posters. The political picture was further complicated as Sen. George McGovern entered the fray in an attempt to rally the remaining Kennedy forces and deny the nomination to both McCarthy and Humphrey. But this late effort bore no fruit and weakened the forces opposed to the war. The raucous convention inside the hall showcased on national television a deeply divided Democratic Party. As expected, Humphrey received the nomination on the first ballot. Eugene McCarthy refused to support the Democratic nominee, and he and his followers vowed to take the issue of the war directly to the American people. George McGovern supported the Democratic ticket, but he concentrated on winning the election for his Senate seat in South Dakota.

The McCarthy campaign and the artists who lent their talents to political posters broke new ground and set a precedent for any candidate who could in the future garner the support of artists, especially young activists committed to a serious platform of reform and change. For the first time, styles originating with the civil rights movement, the psychedelic counterculture, and the antiwar movement influenced the creation of a wide array of eclectic posters for a presidential campaign. Ben Shahn had done two highly original posters for LBJ in 1964, but it was his *Peace Dove* poster for McCarthy that brought the limited edition to the fore in politics as a fund-raising tool and demonstrated once again—in the tradition of Honoré Daumier, Francisco Goya, and Eugène Delacroix—how effective fine art can be as instrument of political change. The *Peace Dove* poster captured a moment in time—the antiwar rebellion of the sixties—just as Victor Moscoso's psychedelic Neon Rose posters captured the essence of the counterculture rebellion. The great American political poster was back.

39. Unknown artist, 1968

25" × 17¹³/₁₆", screen print
Courtesy of the Center for the Study of Political Graphics.
This poster is from the California primary in June 1968. Likely pulled in a very small number, the poster demonstrates the grassroots support among artists and students for McCarthy and a fondness for screen prints.

40. Unknown artist, 1968

23" × 17½", offset lithography
Peace and equality became twin themes for McCarthy, who struggled not to be a one-issue candidate only concerned with ending the war in Vietnam.

He stood up alone and something happened.

McCARTHY

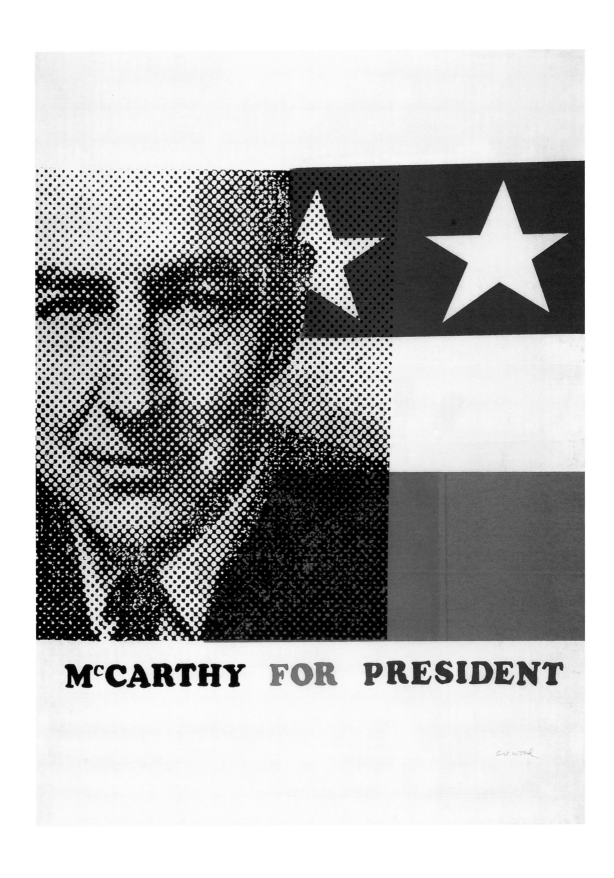

McCARTHY FOR PRESIDENT

41. Unknown artist, 1968
23" × 17" and 23" × 31", offset lithography
One of the best political posters of the sixties,
He stood up alone and something happened was
widely circulated as a window card, but larger
versions were printed, some of which left room at
the bottom to promote rallies and appearances.
The power of this poster lies in its effective use
of both text and visual language and its lack of
specificity, which allows viewers to draw their own
conclusions on the "something" that "happened."

42. Art Wood, 1968
27" × 20", offset lithography
Courtesy of Hake's Americana, Hakes.com.
A well-known political cartoonist, Art Wood utilized
a benday dot pattern in two of the posters he
created for McCarthy in this popular international
style. Wood's mastery of a wide array of design
techniques is evident in this formal design.

43. Unknown artist, 1968
12½" × 9½", offset lithography
This Pennsylvania primary poster from Philadelphia advocates ending the war, and it attempts to capture local voters by focusing on the troubled urban core of American cities.

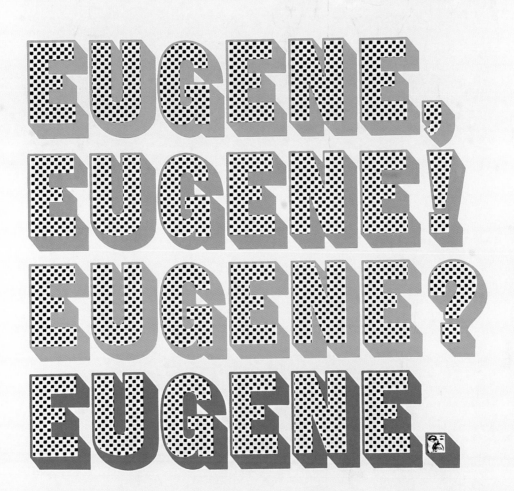

44. Samuel N. Antupit, 1968
24" × 24", offset lithography; 21" × 22¼", screen print
Courtesy of Hake's Americana, Hakes.com.
Eugene's, a political cabaret, opened in New York City on April 7, 1968, and the hostess was Mrs. Leonard Bernstein. Artists Larry Rivers and Robert Motherwell were among those attending. These tony clubs, reminiscent of Mabel Dodge Luhan's Greenwich Village salons, opened in a number of cities and appealed to various elites, mostly those in the entertainment industry, the literary world, and the arts, raising significant amounts of money for the candidate. Samuel Antupit was art director for more than one hundred magazines and newspapers, including *Art in America, Esquire, Harper's Magazine,* and *Scientific American.* A virtuoso in the use of typography, he designed books by artists like Alex Katz, Barbara Kruger, and Roy Lichtenstein. His portrait of McCarthy in the period carried the day for this well-designed and very ingenuous poster. Also available was a limited edition unnumbered screen print on heavy brown paper with "Eugene" printed in vibrant colors. This outstanding poster is quite rare.

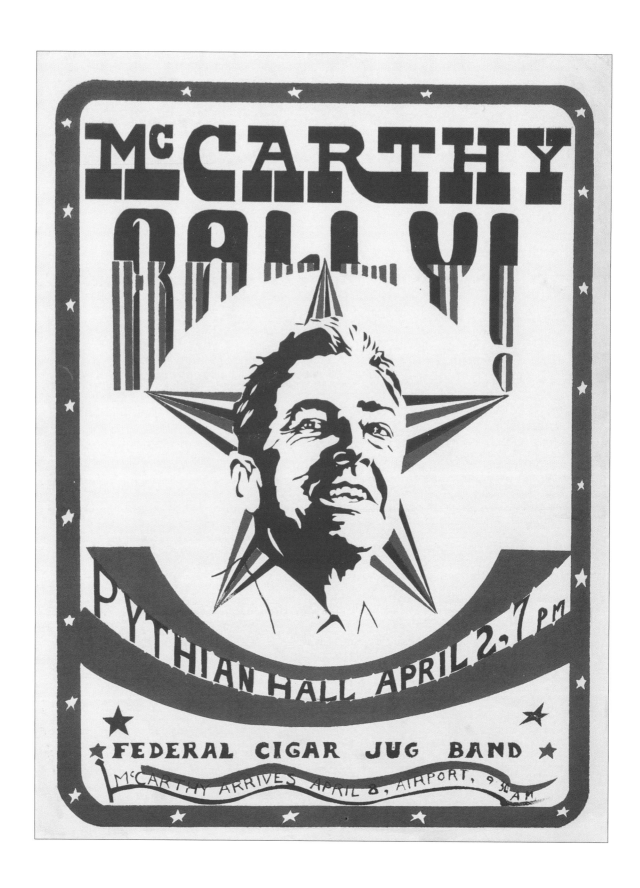

45. Bob Bailey, Pythian Hall, 1968
12" × 9", screen print
Bob Bailey, who was a jug, banjo, and guitar player, created this poster for the rally at Pythian Hall in Portland, Oregon, a place that Bailey's Federal Cigar Jug Band regularly played. McCarthy was arriving from Wisconsin, where he had just won the primary.

46. Bob Bailey, 1968
12" × 9", screen print
This small screen print representing a coalition of students and faculty is from the Oregon primary in which McCarthy defeated Robert Kennedy. McCarthy's political center of gravity was on college campuses throughout the country.

AMERICA ★ NEEDS McCARTHY McCARTHY NEEDS YOU

STUDENTS FACULTY FOR McCARTHY ★

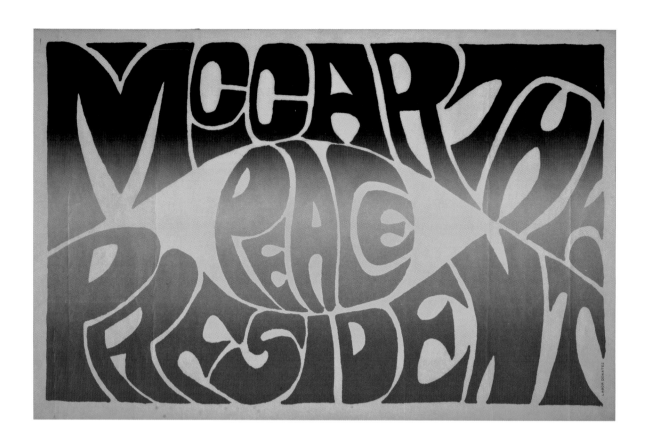

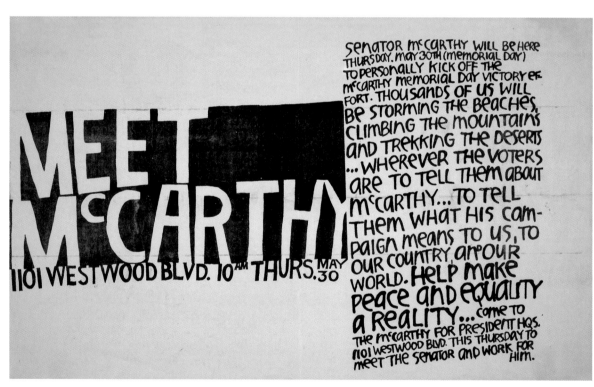

47. Unknown artist, 1969
11" × 16¹³/₁₆", screen print
Courtesy of the Center for the Study of Political Graphics.
Counterculture activists were fond of pulling screen prints in a number of colors—the spectrum-color blend being a favorite. This poster was also printed in black, blue, red, and possibly other colors such as yellow, purple, and orange.

48. Unknown artist, 1968
8½" × 14", offset lithography
Courtesy of the Center for the Study of Political Graphics.
A fine example of how counterculture artists successfully melded design and text, this poster promoting McCarthy's Memorial Day Victory Effort, a week before the California primary, is a testimony to the depth of commitment on the part of many of the senator's young, idealistic supporters.

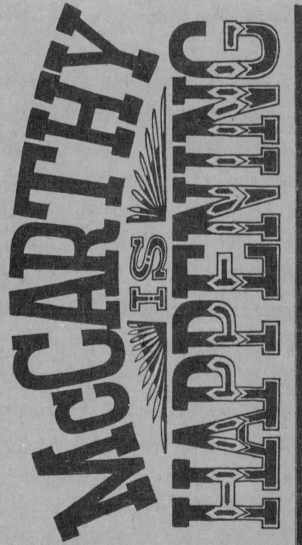

McCARTHY IS HAPPENING

EQUALITY

PEACE

TWELVE HOURS OF CONTINUOUS MUSIC

MIDNIGHT

NOON

ROCK BANDS, FOLK SINGERS, JAZZ GREEK MUSIC & DANCING, MARIACHI AND OTHER MUSICAL ATTRACTIONS

50. Elmore, 1968

29¹³/₁₆ × 12³/₈", offset lithography

The poster and handbill for this May 25 lollapalooza as well as the previous poster for the May 22 event (fig. 49) exude a whimsical ironic parody of America's past, a kind of high camp put-on. The words "happening," "music," and "arts and crafts" are in the nineteenth-century decorative wood-type style on this elongated broadside. These two posters are among the best created for McCarthy.

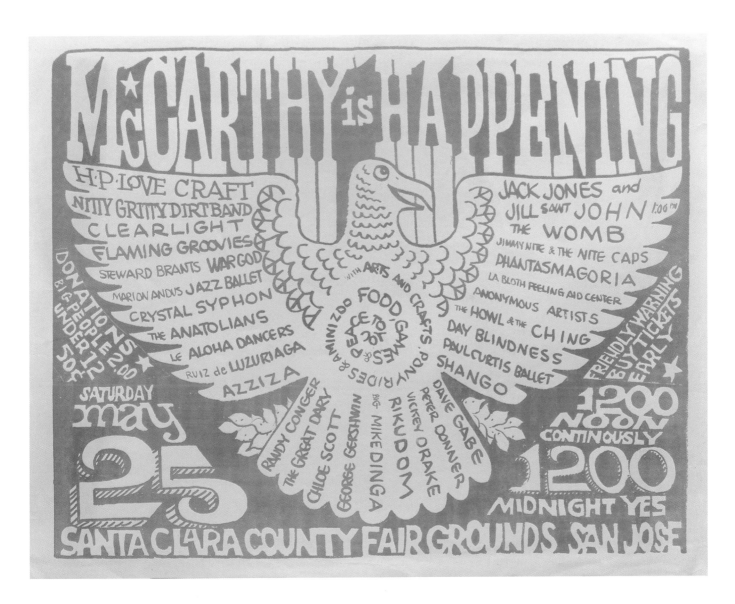

51. Unknown artist, 1968
8½" × 11", offset lithography
Courtesy of Wolfgang's Vault.
The May 25 extravaganza, *McCarthy is Happening*, produced this fine handbill in the busiest San Francisco retro style. Reading the list of bands and acts scheduled for twelve continuous hours is like a trip on LSD as you swing between H. P.

Lovecraft, a psychedelic band; the Nitty Gritty Dirt Band, a folk-rock jug band; and Jack Jones, who performed for the supper club set with songs like "Lollipops and Roses." But the "Happening" had performances in different buildings on the fairgrounds, and like a fair it promised something for everyone. Apparently no poster in this design was printed.

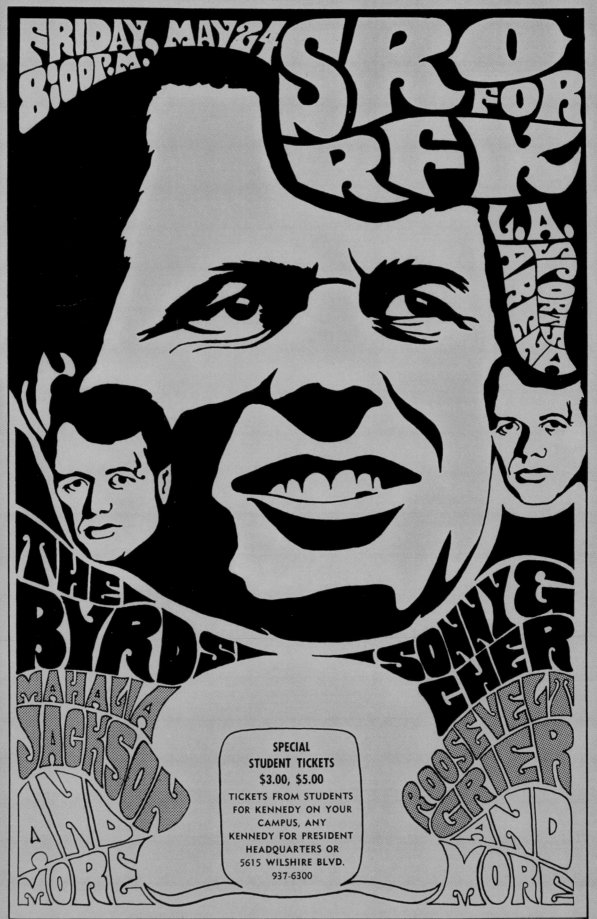

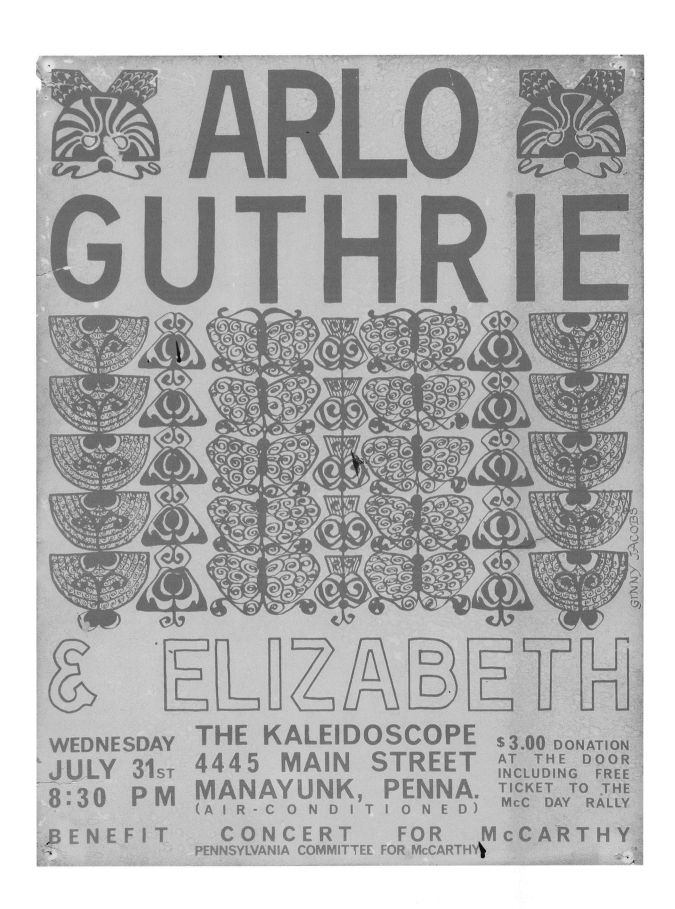

52. Mortimer, 1968

12" × 11", offset lithography

SRO for RFK, in the California psychedelic style, was printed on goldenrod paper in a window card format to promote a huge rally ten days before the California primary. A handbill in the same color was also widely circulated. This exciting poster is an exception to the standard advertising firm graphics issued by the Kennedy campaign throughout the primary battles, but RFK knew his voters were largely outside the counterculture community. RFK defeated Eugene McCarthy in the primary by 4 percentage points but was assassinated the night of his victory, which threw the antiwar faction of the Democratic Party into a tailspin.

53. Ginny Jacobs, 1968

22½" × 17 ½", offset lithography

Courtesy of Hake's Americana, Hakes.com.

This art nouveau–influenced butterfly motif gig benefit poster is a prime example of the psychedelic poster design slipping over into the political arena.

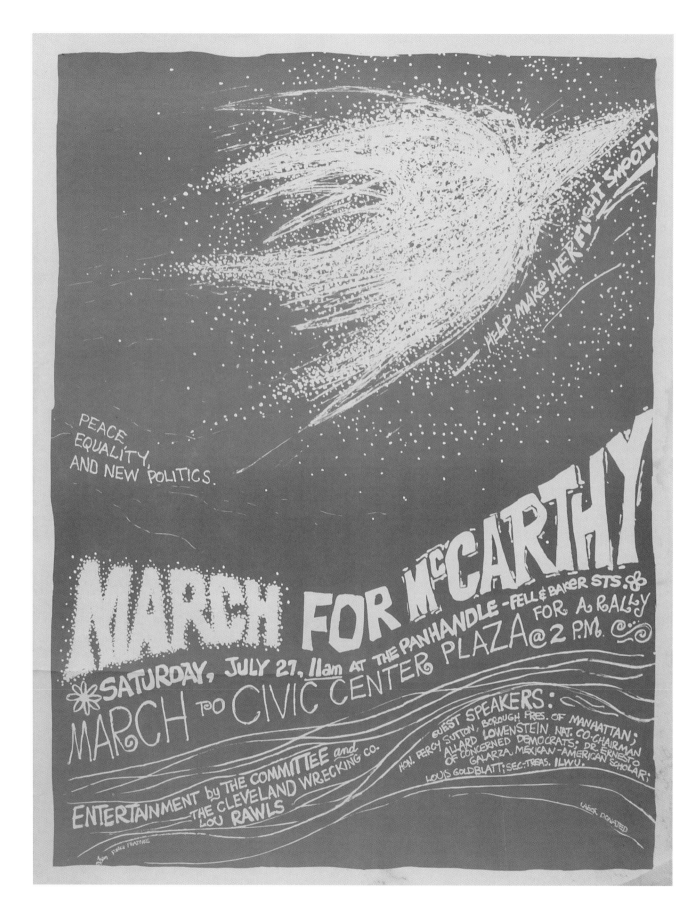

PEACE,
EQUALITY,
AND NEW POLITICS.

HELP MAKE HER FLIGHT SMOOTH

MARCH FOR McCARTHY
SATURDAY, JULY 27, 11am AT THE PANHANDLE-FELL & BAKER STS.
MARCH TO CIVIC CENTER PLAZA @ 2 P.M. FOR A RALLY

ENTERTAINMENT by THE COMMITTEE and
THE CLEVELAND WRECKING CO.
LOU RAWLS

GUEST SPEAKERS:
HON. PERCY SUTTON, BOROUGH PRES. OF MANHATTAN;
ALLARD LOWENSTEIN, NAT. CO-CHAIRMAN
OF CONCERNED DEMOCRATS; DR. ERNESTO
GALARZA, MEXICAN-AMERICAN SCHOLAR;
LOUIS GOLDBLATT, SEC-TREAS. ILWU.

54. Unknown artist, 1968
22⅞" × 17¼", offset lithography
Another dandy San Francisco psychedelic-style poster, this was created to promote a July 27 *March for McCarthy* to rally supporters for the coming Democratic convention and to pressure Kennedy delegates to switch to Clean Gene. New Yorkers Allard Lowenstein and Percy Sutton were on hand to convince those in attendance that Democrats across the country wanted McCarthy to receive the nomination.

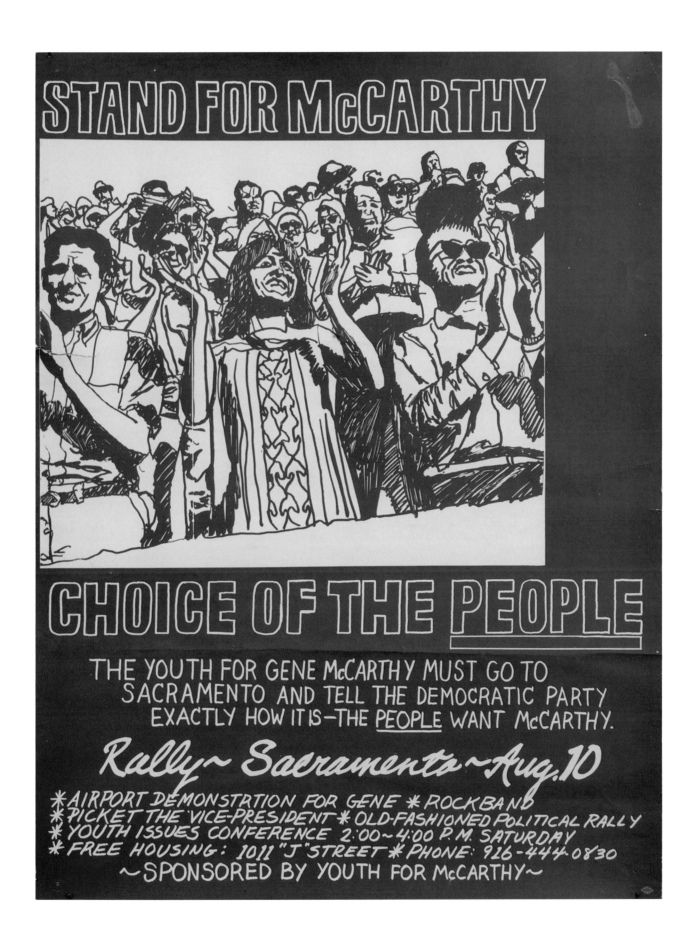

55. Unknown artist, 1968
22½" × 17", screen print
This Sacramento screen print was
timed to help McCarthy push the nomi-
nation his way at the upcoming Demo-
cratic National Convention.

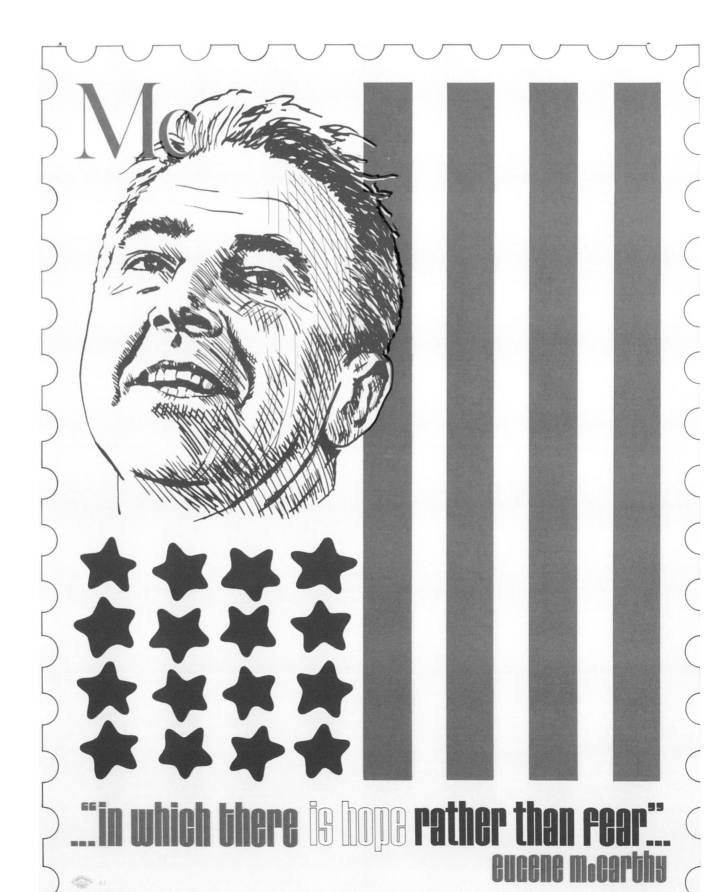

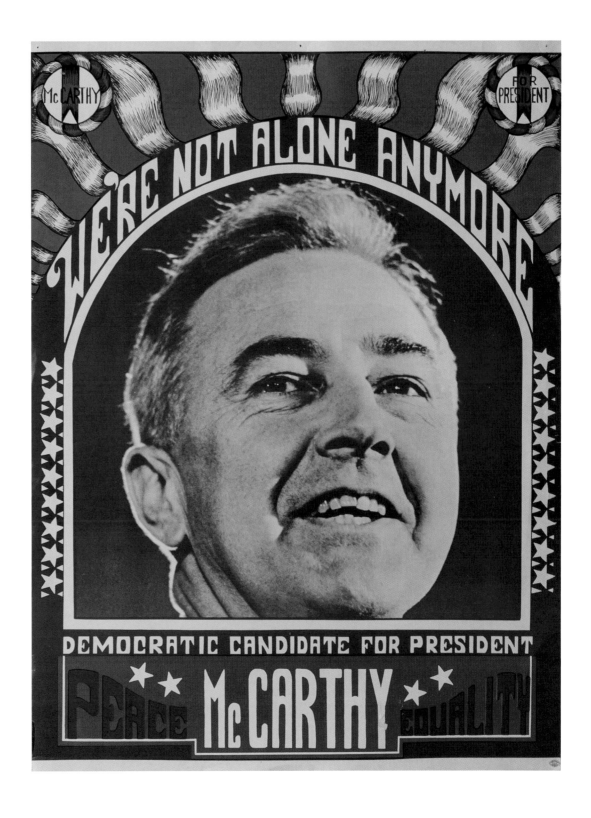

56. Unknown artist, 1968
20⅛" × 17¼" and 14¼" × 11⅛", offset lithography
The McCarthy quote, "In which there is hope rather than fear," in this eye-catching flag motif poster would have been much more effective if the main message—hope—was clearly discernable. The poster was widely distributed by the McCarthy campaign.

57. Unknown artist, 1968
15⅞" × 12", offset lithography
Flaunting design elements of the psyche-delic poster, the message "We're not alone anymore" reassured the antiwar voter that McCarthy had taken up their cause and the movement was growing.

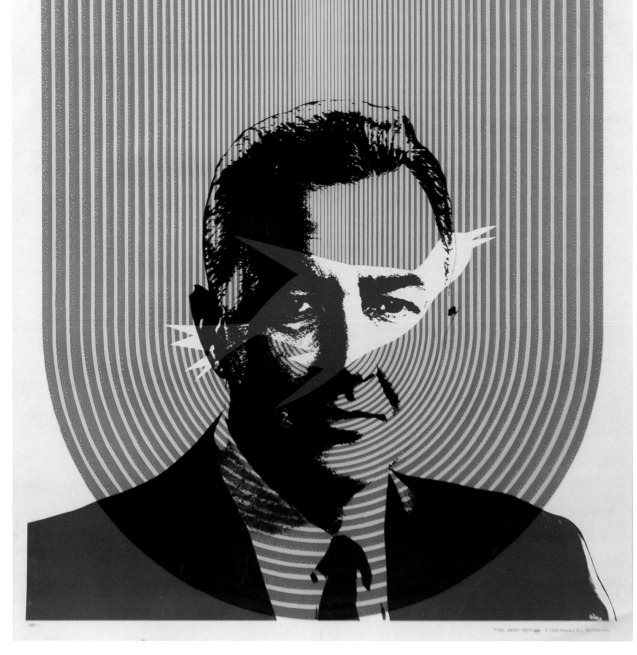

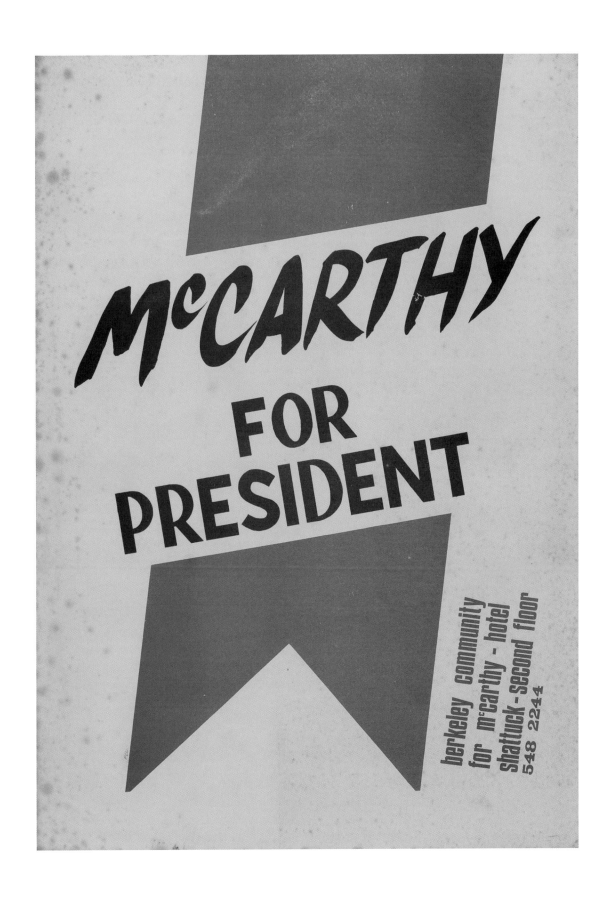

58. Wilfred Sätty (Wilfred Podreich), 1968
34½" × 23½", offset lithography
This effective, well-designed poster
by California artist Wilfred Sätty relied on
visual communication to convey McCarthy's
political message.

59. Unknown artist, 1968
14" × 9⅞", offset lithography
A California primary poster produced by the
Berkeley Community for McCarthy used
the candidate's recognized logo in a novel
way by tilting the ribbon and the "McCarthy
for President" slogan at opposite angles.

mc carthy

peace

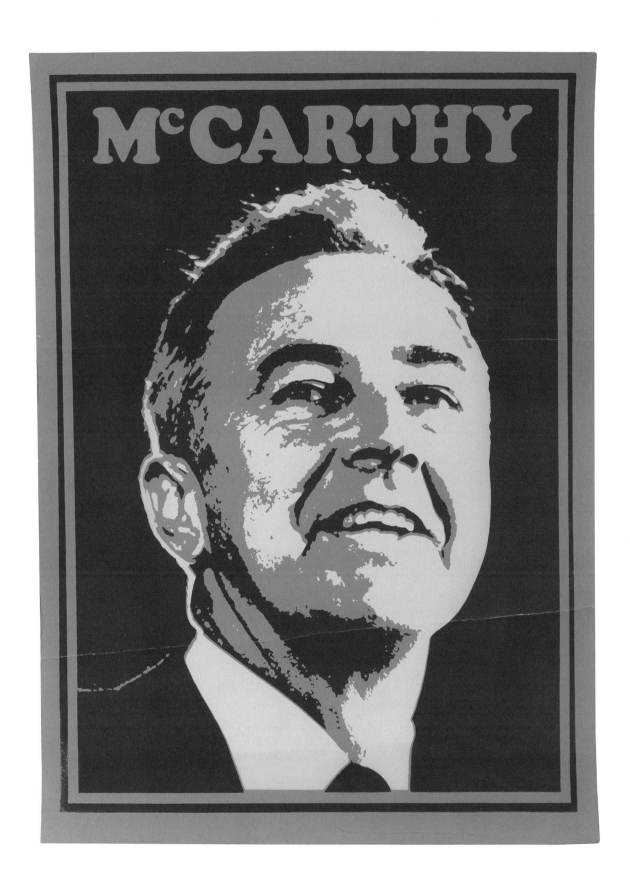

60. Thomas W. Benton, 1968
26" × 20", screen print
Courtesy Daniel Joseph Watkins.
Simple and to the point, this Thomas W. Benton poster has only recently been unearthed, and he may or may not have signed some of them. Benton later achieved a degree of fame by partnering with Hunter S. Thompson to create the Aspen Wall Posters and limited edition screen print posters for presidential candidates George McGovern, Gary Hart, and Jesse Jackson. Benton embraced bright primary colors and worked in a more formal style, an unusual choice among activist artists.

61. Unknown artist, 1968
20⁷/₁₆" × 14⁷/₈", offset lithography
Done in psychedelic style colors, this poster is likely from the Oregon primary.

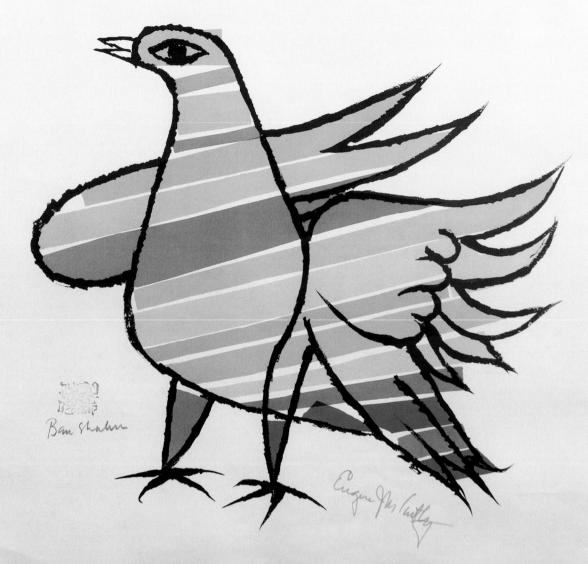

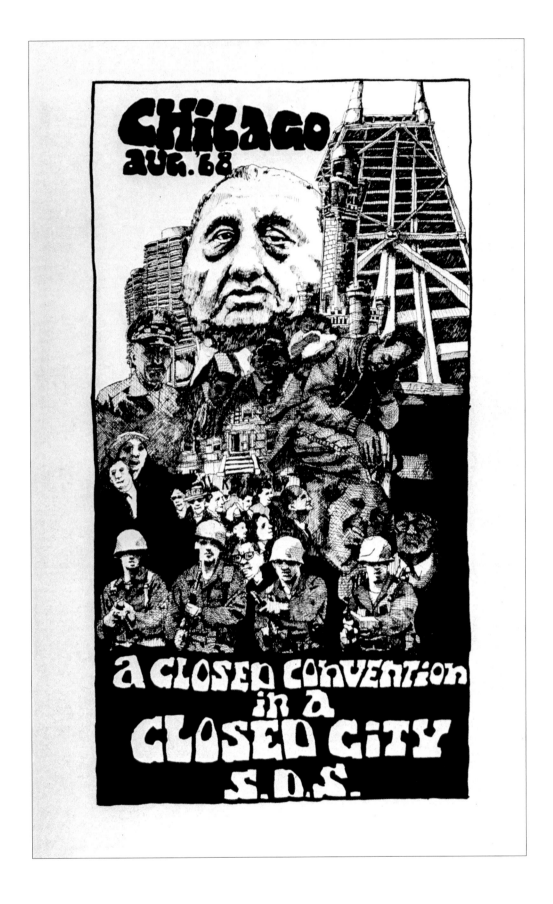

62. Ben Shahn, 1968

37¾" × 25", offset lithography

Art © Estate of Ben Shahn / Licensed by VAGA, New York NY.

One of the most popular and best designed McCarthy posters, *Peace Dove* was printed in an open edition and in a signed run of two hundred; posters signed by Ben Shahn and McCarthy are quite scarce. This is one of Shahn's last works as he passed away in March 1969. *Peace Dove* is undoubtedly one of the best political posters Shahn created. Earlier outstanding political Shahn posters include two anti-Goldwater posters, his famous 1948 Henry Wallace poster *Tweedle Dee and Tweedle Dum*, and his 1944 FDR poster *Our Friend*.

63. A. J. Epstein, 1968

25" × 15½", offset lithography

A. J. Epstein's montage graphically captures the calamity that overtook the protesters in Grant Park during the Democratic National Convention in Chicago in 1968.

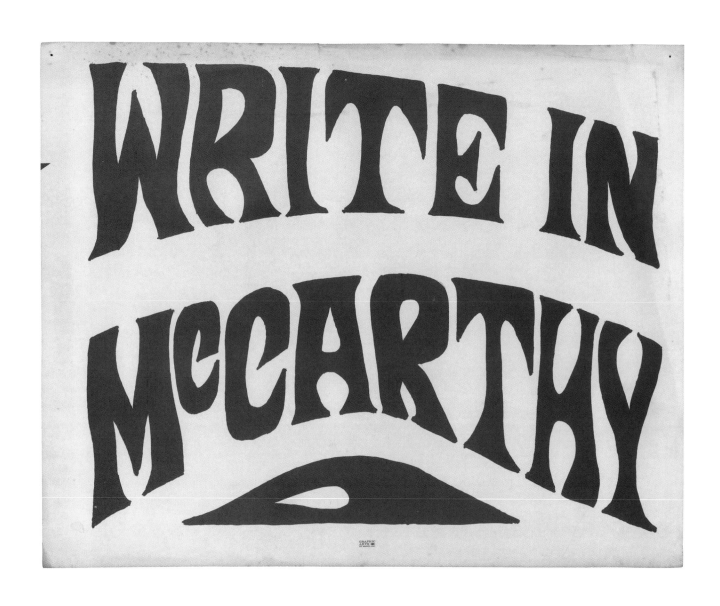

64. Unknown artist, 1968
11¼" × 14¼", screen print
Supporters in Oregon and California were bitter that their candidate had not received the Democratic nomination and, following the lead of McCarthy, refused to support the Humphrey-Muskie ticket. Write-in movements for McCarthy blossomed around the country, especially on the West Coast.

65. Unknown artist, 1968
22" × 14", screen print
This extremely interesting psychedelic-style window card features McCarthy speaking for unnamed peace candidates, who, in fact, were the firebrand opponents of the war, Paul O'Dwyer, candidate for the U.S. Senate, and Allard Lowenstein, the Democratic peace candidate for Congress in New York's fifth district. Both were allies of Senator McCarthy, and Lowenstein, like McCarthy, refused to support the Humphrey-Muskie ticket. McCarthy spoke up for peace candidates running in various parts of the country.

EUGENE McCARTHY

SPEAKS OUT
FOR
PEACE
CANDIDATES
AT

Madison Sq. Garden

Monday October 28th
FOR
INFORMATION & TICKETS
CALL 757-8715

LABOR DONATED

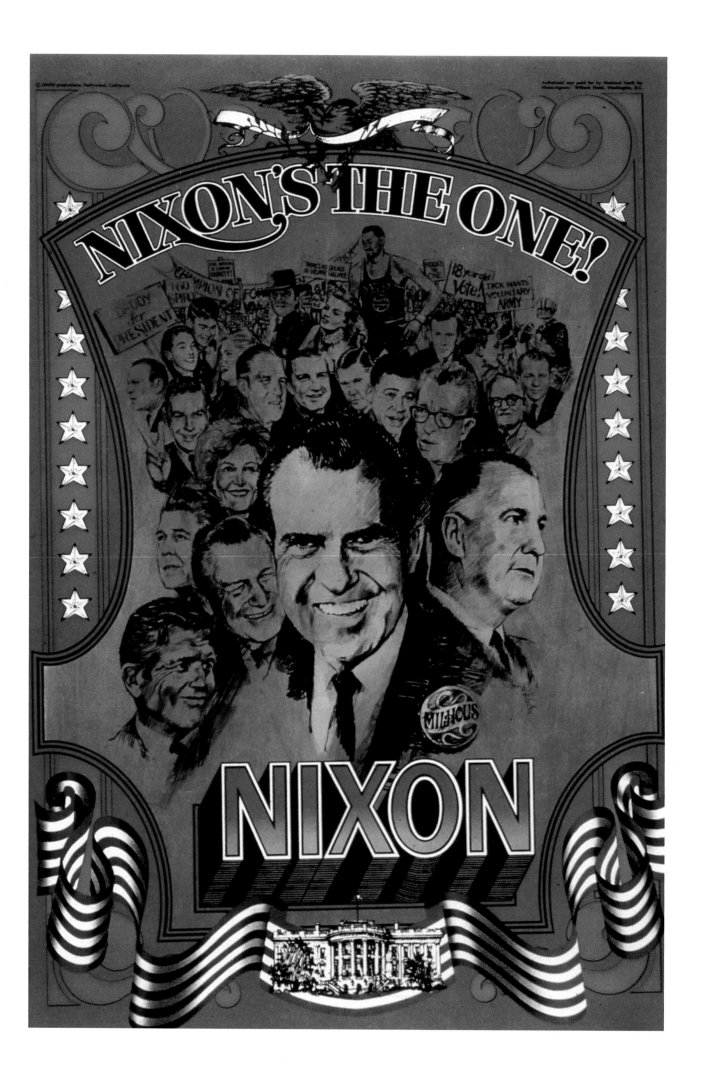

Richard Nixon received the Republican nod after defeating Nelson Rockefeller and a number of other hopefuls in the primaries and went on to win the 1968 presidential election by a half million votes, defeating Hubert Humphrey and the insurgency campaign of George C. Wallace, who carried five southern states and received almost ten million votes. The radical Peace and Freedom Party nominated Black Panther leader Eldridge Cleaver but attracted few voters. George McGovern won reelection to his Senate seat and plunged into reforming the delegate selection process in the Democratic Party as the head of the McGovern-Fraser Commission. The debate surrounding the proposed rule changes was difficult and protracted as the commission challenged the party establishment, but the reformers succeeded and the more open and inclusive rules were finally adopted. The number of primaries and caucuses were greatly increased, and delegations were assigned quotas for minorities, women, and young people, all of which enhanced McGovern's chances of securing his party's 1972 presidential nomination if he chose to run. Another seemingly huge boost to the senator's potential candidacy came with the ratification of the Twenty-Sixth Amendment to the Constitution on July 4, 1971, granting eighteen-year-olds the right to vote.

From the start, both the antiwar movement and McGovern were skeptical of President Nixon's plan to end the war by achieving a military advantage that would force the North Vietnamese to make concessions during negotiations—"Peace with Honor." The Left viewed this as nothing more than continued escalation. In response, antiwar activists created the New Mobilization Committee to End the War in Vietnam (Mobe), which organized a nationwide moratorium on October 15, 1969, and a Moratorium March on Washington on November 15. At both events George McGovern was a featured speaker. He had become the face of the antiwar movement and was convinced that it was the issue that would elect a Democratic president in 1972. With a deep sense of outrage, he characterized the conflict as "a terrible cancer eating away at the soul of our nation." The 1969 fall marches and demonstrations were hugely successful in terms of number of participants; the Washington March alone was estimated at five hundred thousand.

From 1969 to 1972 many well-designed and effective posters were created in support of the peace efforts to end the war. Antiwar poster makers often employed the revolutionary clenched fist or the peace dove clutching an olive branch or a sprig of laurel. But the symbol most used—even treasured—was the ubiquitous peace sign commissioned by Bertrand Russell and designed by British artist Gerald Holton. Few who embraced the sign with such rapturous fervor understood its meaning or its origins. Russell and Holton were both in search of a symbol that would represent their passionate support for nuclear disarmament. Holton used the semaphore signals for the letters N and D to

66. J. Michaelson, 1968
28" × 20", offset lithography
Michaelson's line drawing montage of the Republican elite is another example of effective visual communication. The poster's outstanding feature is the artist's ability to introduce a three-dimensional quality to a flat surface. Nixon's name is drop shaded so it stands out from the poster's background. With Nixon's head and shoulders in the center, the viewer's eye now pans over the other facial drawings to fix Wilt Chamberlain standing in the background.

signify nuclear disarmament. First used in 1958 at a demonstration in Great Britain, the symbol arrived in the United States in photographs taken by Larry Burrows for a *Life* magazine story on the protests. The symbol appealed to various antiwar organizations, and its use quickly spread, becoming de rigueur and showing up in every imaginable incarnation. The simple design, easily altered, was pressed into service in the women's movement and the environmental movement. The peace symbol appeared on antiwar posters and political posters, was seen occasionally on the helmets of soldiers in Vietnam, and was a pattern printed on women's panties and even painted on the naked chests and breasts of hippie protestors. Soon, the peace sign traversed the globe. Universally recognized, it is subject to endless commercialization, rivaled perhaps only by the cross and swastika. The marches and demonstrations in 1969 and 1970, with the peace sign abundantly on display, were the high point of the antiwar movement, an attempt to bring in the liberal establishment to stop the war. The last large student mobilization efforts occurred in 1971 on April 25 and May 5 and were temporarily energized by the draft lottery, the Cambodian incursions, and the National Guard shootings at Kent State. But participation in rallies and marches steadily decreased as the peace coalition descended into acrimonious self-destruction.

The civil rights and antiwar movements were not alone in their decline. The counterculture hippies in the greater San Francisco area as well as across the nation were also dwindling. Musical styles and accompanying poster styles were evolving too, and while there were still great posters being created, they just weren't the same. The original look and feel of the ebullient psychedelic poster was gone. Senator McGovern did not bemoan the decline of the antiwar movement or the counterculture as he found that the marches and demonstrations were counterproductive. He deplored the increase in violence, and his new approach was to try to end the war by congressional legislation. Working with Republican senator Mark Hatfield, the two attempted to pass an amendment that would cut off funding and force complete and immediate withdrawal from Vietnam. The legislation failed, fifty-five to thirty-nine, in the Senate in September 1970 and a revised version again failed passage in 1971. Grassroots attempts by peace activists to garner public support for the amendment and thus pressure Congress to act, although spirited, failed as well. But at last acknowledging that the legislation route was a dead end, McGovern concluded that the only way to stop the war, a war he emphatically claimed was a "criminal, immoral, senseless, undeclared, unconstitutional catastrophe," was to win the presidency.

Robert Sam Anson, McGovern's biographer, claimed that ending the war became his "magnificent obsession." But it would be an uphill battle as it had been in 1968, and the chances of a peace candidate capturing the nomination again seemed near impossible. The senator had covered his attempted legislative bets as he had been planning a possible presidential campaign since 1969. He expanded his staff, hired Gary Hart, who eventually became the campaign manager, and attempted to give three speeches a week to build his name recognition and broaden his base. Two years later, on January 18, 1971, the Prairie Statesman, as he was sometimes called, formally announced his candidacy in Sioux Falls, South Dakota.

67. D. Matin, 1968

29" × 28", offset lithography
The campaign issued this attractive *People for Rockefeller* poster in several different color variants. Representing the liberal wing of the Republican Party, Rockefeller lost the presidential nomination in 1964 to Barry Goldwater partially due to his marital problems, which touched off a national scandal. In 1968 he made only a halfhearted attempt to secure the nomination by entering the fray late and attempting to round up uncommitted delegates.

PEOPLE FOR ROCKEFELLER

People for Rockefeller, 20 W. 55th Street, New York, N.Y. 10019 — Chairman, General James L. Gavin, Treasurer, F. Randall Smith — Printed by Eureka Photo Offset Engraving, Inc., New York, N.Y.

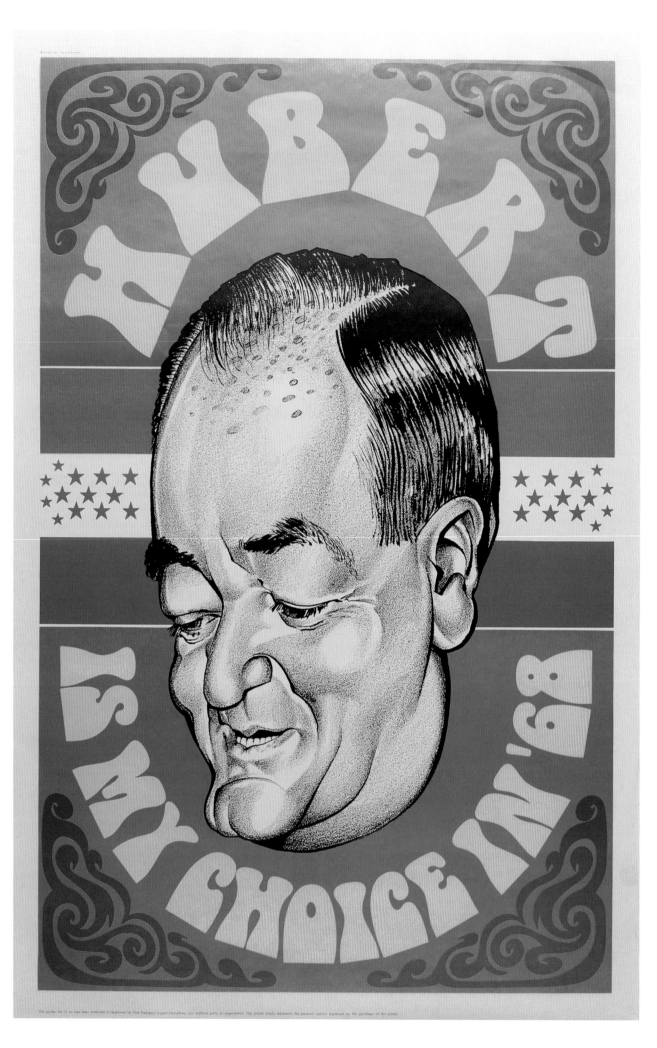

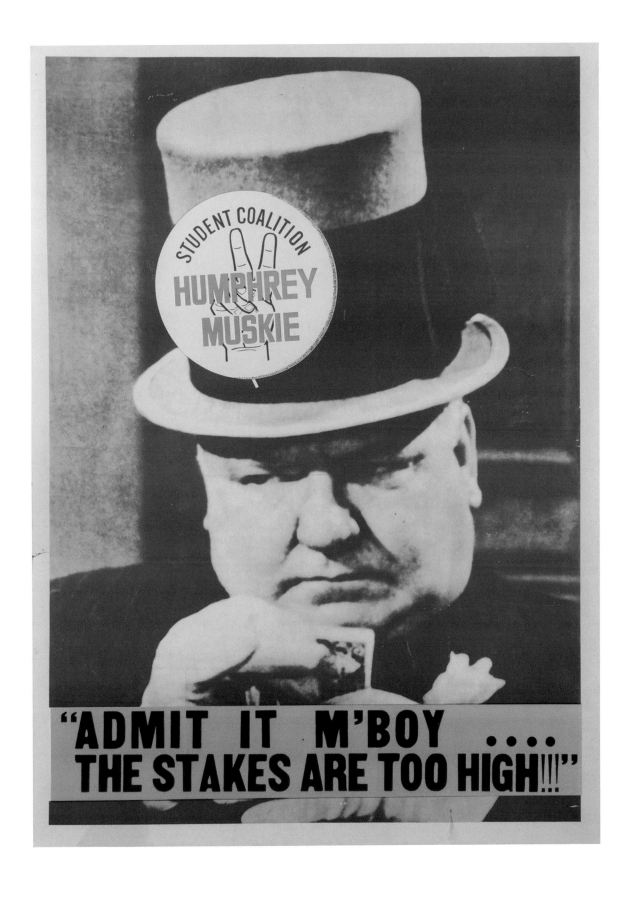

68. Jim Trelease, 1968

35³/₁₆" × 23⅛", offset lithography

An unofficial campaign poster, Jim Trelease's caricature captures the warmth of the vice president in the current hip style. Trelease created popular posters of the seven other 1968 candidates, both Democrats and Republicans.

69. Unknown artist, 1968

27⅞" × 21½", offset lithography

W. C. Fields was all the rage in the sixties, and the Student Coalition for Humphrey-Muskie issued a number of clever and well-done posters in an effort to appeal to the young antiwar activists unenthused with the party's nominees. Peter Max, the year before, lionized Fields in one of his many posters in the psychedelic style.

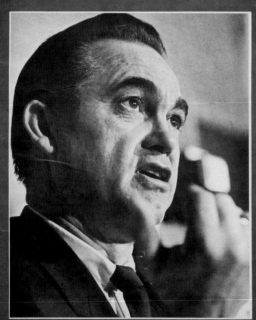

70. Unknown artist, 1968
17½" × 24½", offset lithography
The Wallace campaign issued only a few posters of artistic merit, but the candidate carried five southern states on his American Independent Party ticket and furthered the process of party realignment then underway. The American South was transformed from solid Democratic to solid Republican.

71. Unknown artist, 1968
22⅛" × 16⅜", offset lithography
The confrontational Black Panther Party and the white activists who had recently founded the Peace and Freedom Party attempted a united front that nominated the Panther's minister of information, Eldridge Cleaver, in 1968. The ticket, which included stand-in electors in some states, polled 111,607 votes but disappeared from the national scene until it amazing rebirth as a radical Left party in 2004. Several striking *Cleaver for President* posters were issued, including this one by the Bindweed Press. With the advent of the Black Panthers, the Yippies, and the Weather Underground, the fissures in American society widened and violence dramatically increased.

CLEAVER FOR PRESIDENT

BLACK PANTHER PARTY

PEACE AND FREEDOM PARTY

PEACE & FREEDOM PARTY

POWER TO THE PEOPLE

BLACK POWER TO BLACK PEOPLE

THE BINDWEED PRESS

SEE REVOLUTIONARY ART EXHIBIT

BY EMORY DOUGLAS

Minister of Culture, Black Panther Party

October 17, 18 (3 to 8) and 19 (1 to 6)

Gallery 32; 672 So. Lafayette

Park Place Los Angeles, Calif.

HEAR ELAINE BROWN

Deputy Minister of Information, Southern California, B.P.P.

Singing Revolutionary Songs from soon to be released album, "Seize the Time"

DONATION: $2.00 PER PERSON

FOR FREE BREAKFAST FOR CHILDREN, FREE HEALTH CLINIC, AND FOR POLITICAL PRISONERS

For More Information, Call 235-4127

72. Emory Douglas, 1967
19" × 11", offset lithography
© *2013 Emory Douglas / Artists Rights Society (ARS), New York.*
A large share of Emory Douglas's shocking revolutionary artwork appeared in the *Black Panther* newspaper, but he did make outstanding posters as well. The drawing for this poster was done a year before Douglas joined the Panthers. He soon became the Panthers' minister of culture, and in a prolific burst of artistic energy, he graphically illustrated the Black Panther confrontations with the "pigs" and the party's themes of "self-defense and freedom by any means necessary." Douglas maintained that drawings and cartoons were the most effective political propaganda tools.

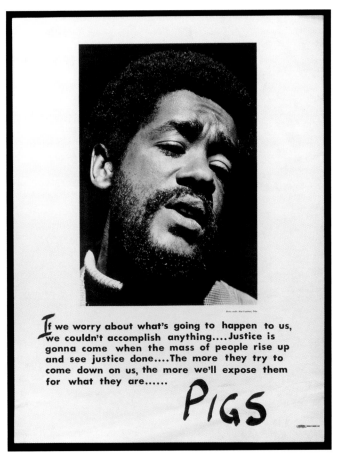

If we worry about what's going to happen to us, we couldn't accomplish anything....Justice is gonna come when the mass of people rise up and see justice done....The more they try to come down on us, the more we'll expose them for what they are......

PIGS

73. Emory Douglas, Lazaro Abreu design, ca. 1968
21" × 14", offset lithography
Emory Douglas did the drawing for this poster, but it was designed by Lazaro Abreu at the Organization of Solidarity with the People of Asia, Africa, and Latin America (OSPAAAL) and printed in and distributed from Cuba. OSPAAAL produced posters for nearly every revolutionary group in the world; though Douglas did not authorize the use of his drawing, he was influenced by the propaganda posters from Cuba and Vietnam.

74. Unknown artist, Alan Copeland photo, ca. 1968–70
23" × 17½ offset lithography
Bobby Seale and Huey Newton cofounded the Black Panther Party in an effort to "seize the time." Advocating revolution, the Black Panthers declared war on the "violent and repressive" police, the "pigs," and the police in turn declared war on them. Shootouts occurred in a number of U.S. cities between Black Panthers and "pigs" that resulted in the deaths of many party members. Over the course of a few years the Panther leadership was killed, fled the country, or was imprisoned.

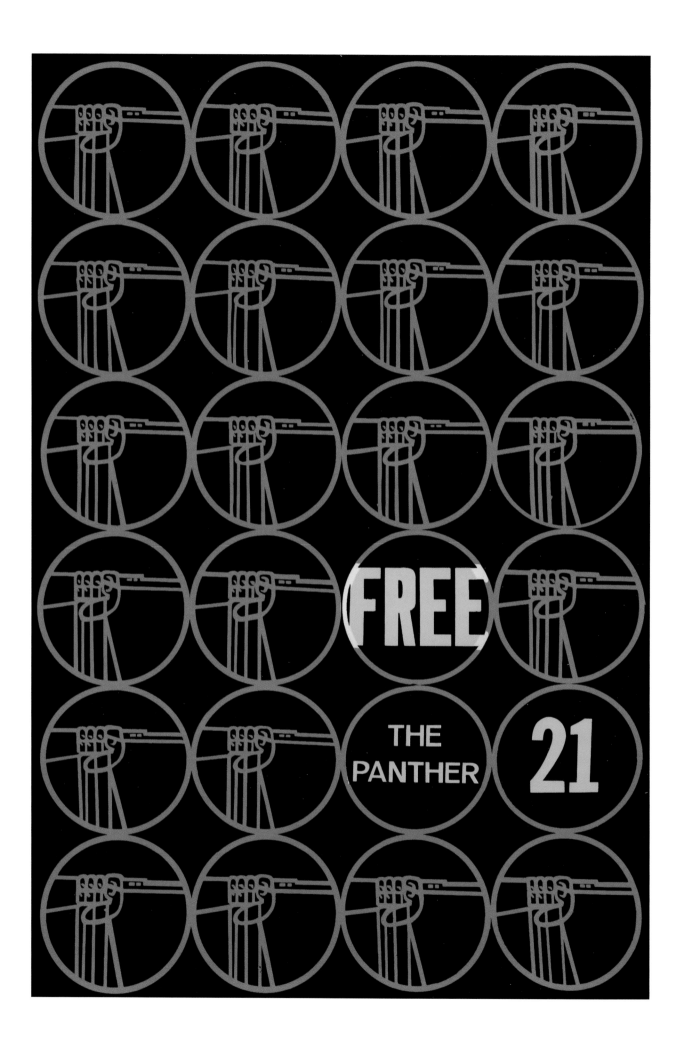

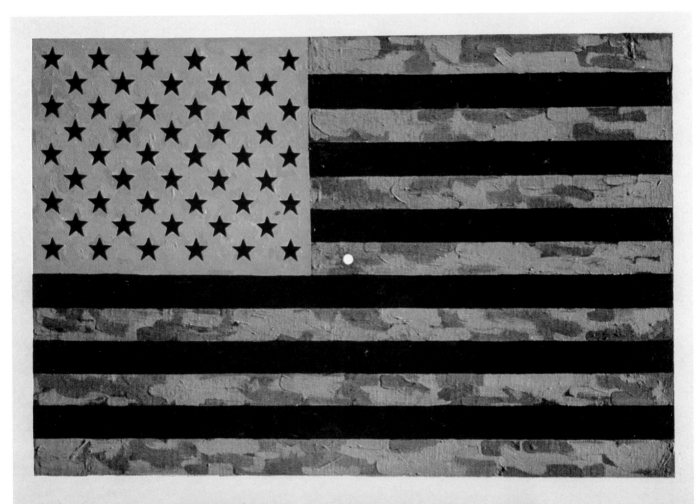

MORATORIUM

75. Unknown artist, 1970
21¼" × 16¼", offset lithography
This well-designed poster in a more formalist style is a radical departure from the majority of Black Panther graphics dominated by artists like Emory Douglas and Richard Moore.

76. Jasper Johns, 1968
22½" × 28", offset lithography
Art © Jasper Johns and ULAE/Licensed by VAGA, New York NY, published by Universal Limited Art Editions.
Jasper Johns created this downbeat pop art–style poster, commissioned by the Leo Castelli Gallery in Los Angeles, in a signed, limited edition of three hundred for the National Vietnam Moratorium Committee. Later an unsigned open offset edition was available to demonstrators. Using orange, green, and black as replacement colors on the American flag, Johns wished to convey the damage done to the nation by the continuing involvement in Vietnam. A unique feature of the poster is the white dot, which may represent a bullet hole, located in the center of the flag; regardless, it is the key to a hidden feature. Stare at the dot without blinking for at least thirty seconds, and then shut your eyes. Holding a piece of white paper an arm's length from your face, open your eyes and you should see the red, white, and blue of the U.S. flag.

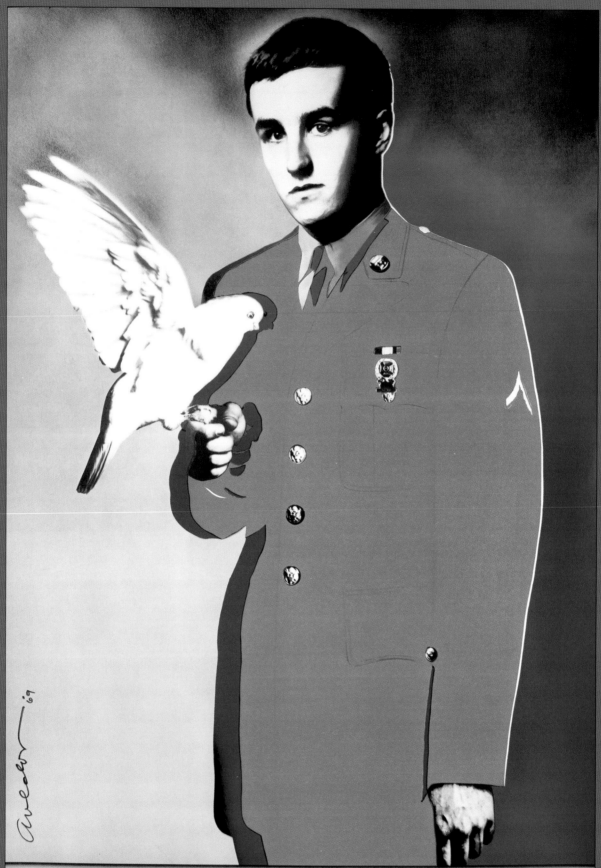

who has a better right to oppose the war?

to send contributions and for information, write
student mobilization committee to end the war in vietnam,
857 broadway, new york city 10003, (212) 675-8465

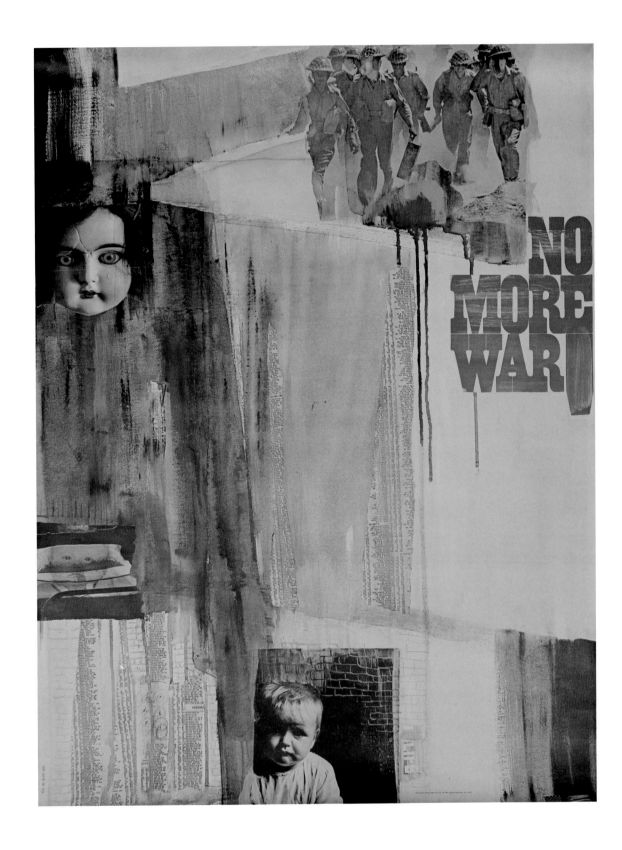

77. Richard Avedon, Marvin Israel photo, 1969

27¾" × 24", offset lithography

Working from a photograph by Marvin Israel, Richard Avedon used gradients of blue to partially outline the figure of a typical draftee, a private first class, and a peace dove in the midst of the storm of war. He then photographed the altered image and fabricated the poster. The ironic use of red, white, and blue reinforces the question, "Who has a better right to oppose the war?" The poster was created for the Student Mobilization Committee to End the War in Vietnam.

78. Marilyn Kaplan, 1970

38¾" × 23⅛", offset lithography

No More War is a fine example of photomontage in an abstract expressionist work. Marilyn Kaplan used a historic photograph of a group of soldiers—several with their faces obliterated—a drawing of a baby, a cracked doll's head, and a photograph of child, all arranged within broad vertical brush strokes, to make her case for the chaos of war

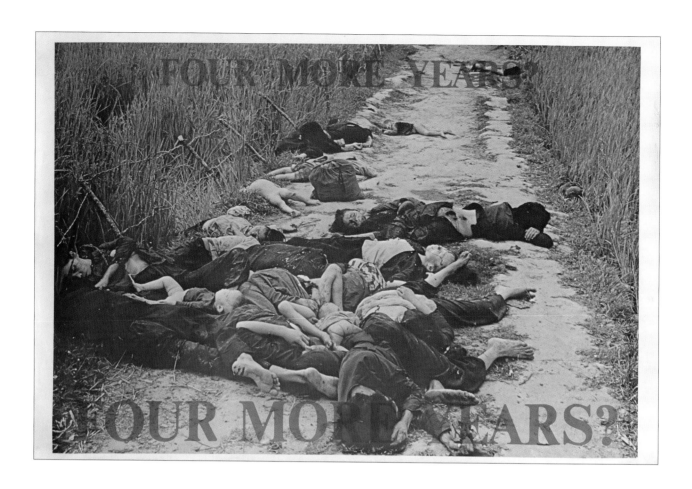

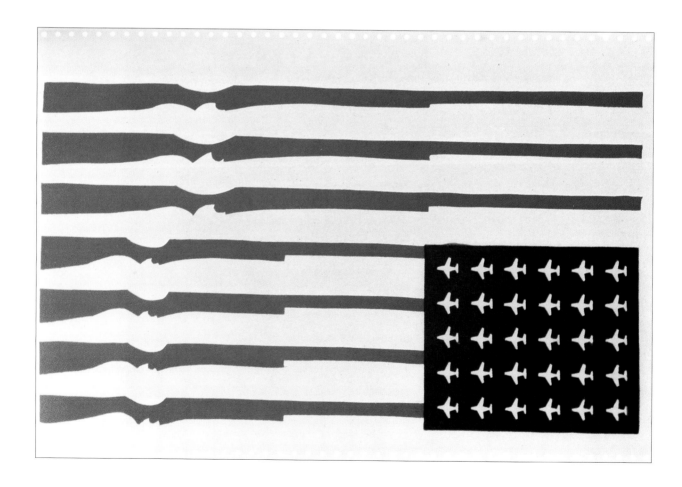

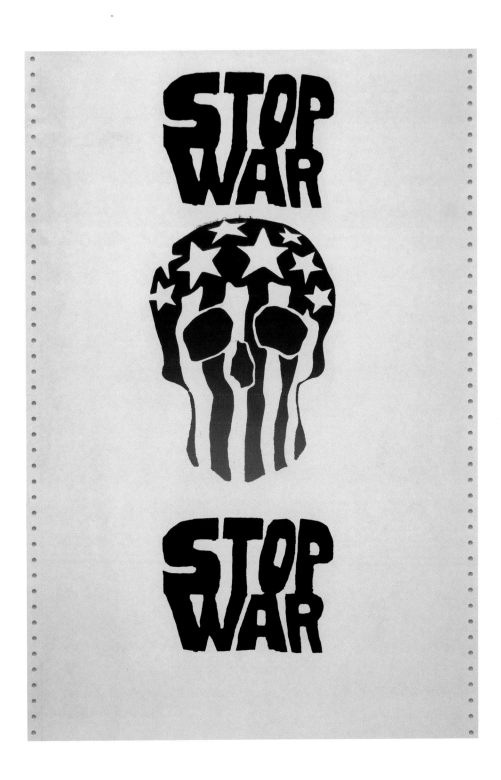

79. Artists' Poster Committee, Ron L. Haeberle photo, 1970

25" × 38", offset lithography

One of the most powerful and controversial of the antiwar posters was designed and issued by the Artists' Poster Committee (APC), comprised of Lincoln Cushing, Frazier Dougherty, and Irving Petlin, in collaboration with the Art Workers Coalition, senior staffers at the Museum of Modern Art (MoMA), and other invited artists. A decision was made to use the deeply disturbing photograph taken by Ron L. Haeberle of women and children killed during the My Lai Massacre and overprint a question and answer from the Congressional investigation. In large red print at the top was, "Q: And babies?" and at the bottom in large red print, "A: And babies." The MoMA soon withdrew its involvement, but APC distributed fifty thousand copies at no charge. The McGovern campaign issued a version in 1972 that posed the question "Four More Years?" It too quickly became contentious and distribution stopped; however, thousands of copies were already in circulation.

80. Unknown artist, 1970

14⅛" × 23", screen print

Courtesy of Lincoln Cushing / Docs Populi.

Created in the poster workshops at the University of California Berkeley in 1970, a number of printmakers labored throughout the summer to create a plethora of hard-hitting, innovative antiwar posters—perhaps as many as fifty thousand copies of more than one hundred different designs. An unusual aspect of this poster is that it is printed on tractor-feed computer paper. A controversy exists on whether the poster was to be displayed right side up or upside down. Here it is printed upside down.

81. Unknown artist, 1970

22" × 14¾", screen print

Courtesy of Lincoln Cushing / Docs Populi.

Stop War is from the UC Berkeley poster workshop and also printed on tractor-feed computer paper. Poster workshops popped up at USC in Los Angeles, the California College of Arts and Crafts, the Rhode Island School of Design, the Poster Factory in Minneapolis, and in other parts of the country, all in response to the bombing in Vietnam and the killings at Kent State and Jackson State Universities. Nationwide, hundreds of antiwar posters poured forth from these workshops.

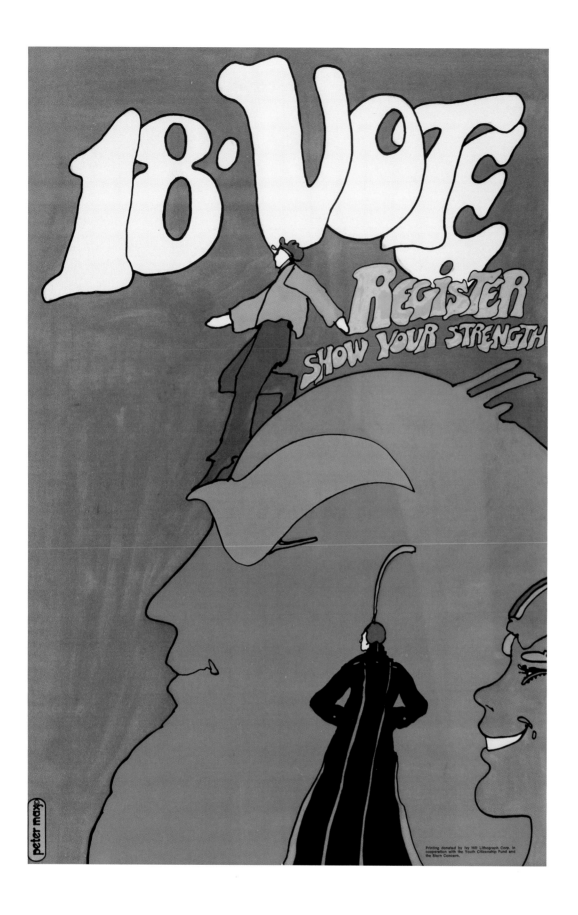

82. Peter Max, 1972

25" × 17", offset lithography

Lowering the voting age to eighteen held out tremendous
promise to peace candidates in both political parties and
especially to McGovern. Peter Max's colorful poster in his
gentle psychedelic style encourages young people to reg-
ister and get involved.

83. Peter Max, 1969

36½" × 24⅜", offset lithography

This is one of Peter Max's very best photomontage political
posters for the New York mayoral campaign of then
Republican John Lindsay in 1969. Pop artists of the sixties,
including Andy Warhol, were fond of using multiple facial
images of the famous in their paintings and prints.

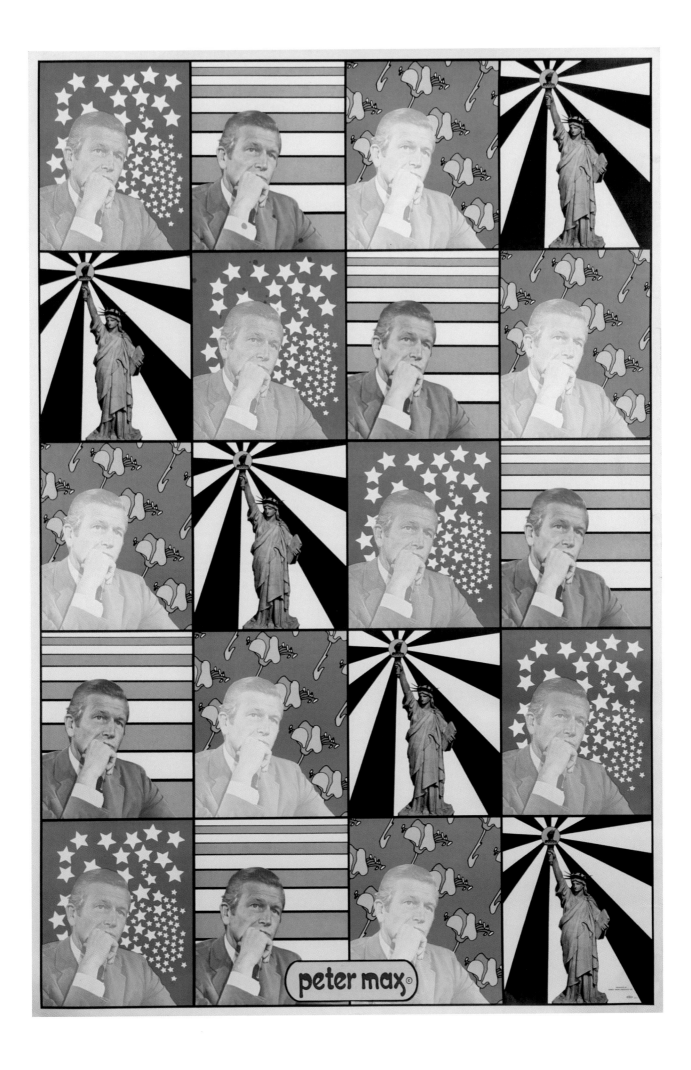

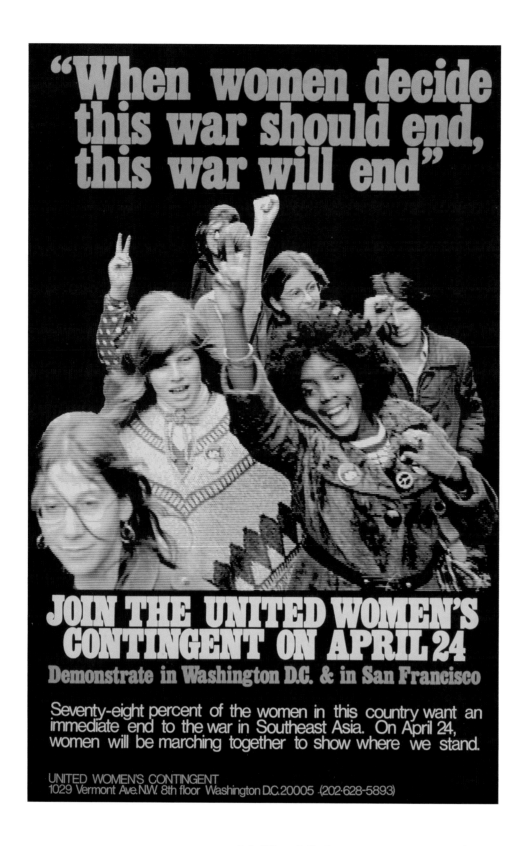

"When women decide this war should end, this war will end"

JOIN THE UNITED WOMEN'S CONTINGENT ON APRIL 24

Demonstrate in Washington D.C. & in San Francisco

Seventy-eight percent of the women in this country want an immediate end to the war in Southeast Asia. On April 24, women will be marching together to show where we stand.

UNITED WOMEN'S CONTINGENT
1029 Vermont Ave. N.W. 8th floor Washington D.C. 20005 (202-628-5893)

84. United Women's Contingent, 1971

16⅞" × 11", offset lithography

The United Women's Contingent was one of several front organizations for the Socialist Workers Party that actively worked to help organize Mobe marches around the country. The April 24, 1971, peace action was the largest of the numerous marches against the war. In Washington DC 500,000 people filled the streets, and in San Francisco 150,000 people demonstrated.

85. Unknown artist, Larry Burrows photo, 1969

17½" × 32½", screen print

This screen print uses a Larry Burrows photo taken during Operation Prairie (October 1966) to publicize the November 15, 1969, moratorium marches. The largest ones occurred in Washington DC and San Francisco, and in an effort to keep the pressure on the Nixon administration, they were held just one month after the hugely successful October marches. Communist Party USA members marched together carrying banners and placards as did a number of other left-wing organizations as well as representatives from labor unions.

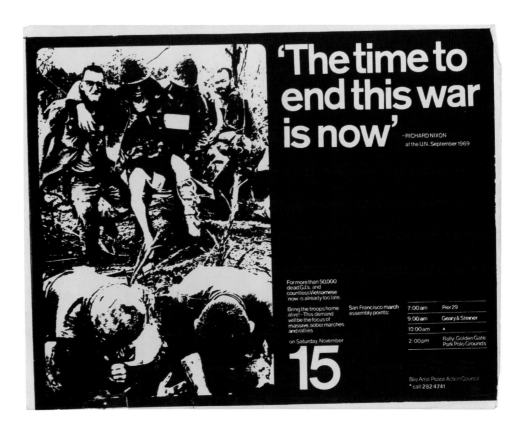

86. Mark Morris, Ben Shahn drawing, 1971

21½" × 16½", offset lithography

Mark Morris created this attractive poster of repeating images of a meditating Mahatma Gandhi drawn by Ben Shahn. The April 24, 1971, marches were the largest since November 1969. The Socialist Workers Party was one of the leading organizations in the National Peace Action Coalition (NPAC), founded in Cleveland in June 1970. The Communists, radical left pacifists, and elements of Students for a Democratic Society met in Milwaukee and founded an opposition group named the People's Coalition for Peace and Justice.

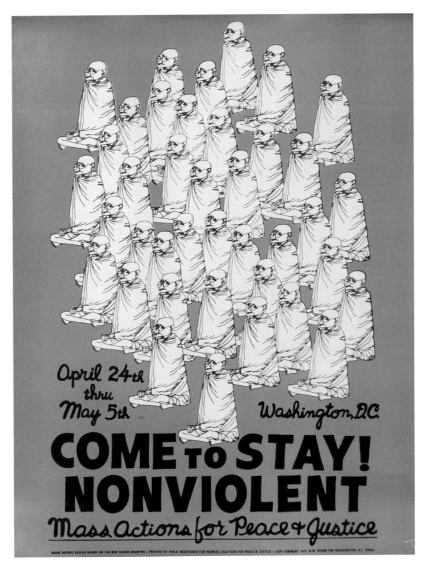

Tie his Hands
JOIN the SMC

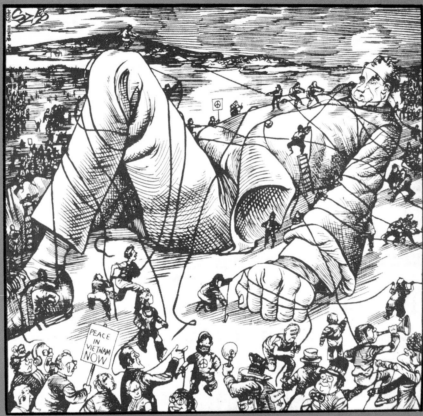

March on Washington and San Francisco	**April 24**
Commemorate Kent and Jackson murders	**May 5**

15,000 New Members by May 5th!

Student Mobilization Committee to End the War in S.E. Asia

Funds Urgently Needed!!

1029 Vermont Ave. NW 8th Fl. Washington D.C. 20005 Phone: (202) 628-5893

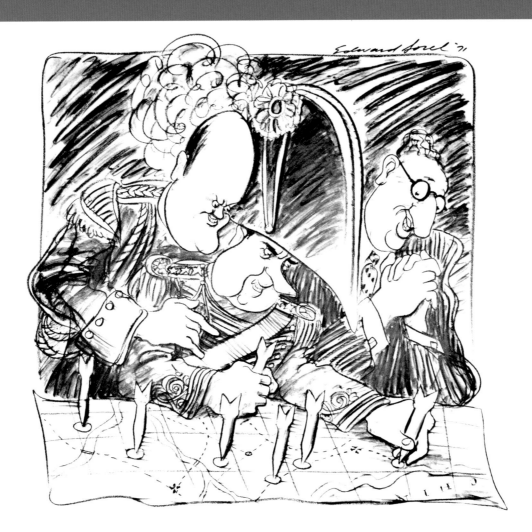

STOP THEM!
they can't stop themselves

MARCH ON WASHINGTON — SAN FRANCISCO **APRIL 24, 1971**

NATIONAL PEACE ACTION COALITION

1029 Vermont Ave. N.W. 8th floor Washington D.C. tel. 638-6225

87. Unknown Artist, 1971
17" × 11", offset lithography
The Student Mobilization Committee, though affiliated
with the National Peace Action Coalition, issued this
wonderful cartoon poster portraying Lilliputians ensnaring
a Gulliver-like Nixon to entice participation in the April 24
and May 5 moratorium mobilizations and demonstrate
that the "little people" could overcome the powerful.

88. Edward Sorel, 1971
22½" × 17½", offset lithography
Edward Sorel was an illustrator, cartoonist, caricaturist, graphic
designer, and left-wing activist; and along with Milton Glazer,
Seymour Chwast, and Reynold Ruffins, he was one of the
founders of the famous Push Pin Studios. His style, which he
described as "spontaneous direct drawing," is readily apparent
in this National Peace Action Coalition *Stop Them!* poster.

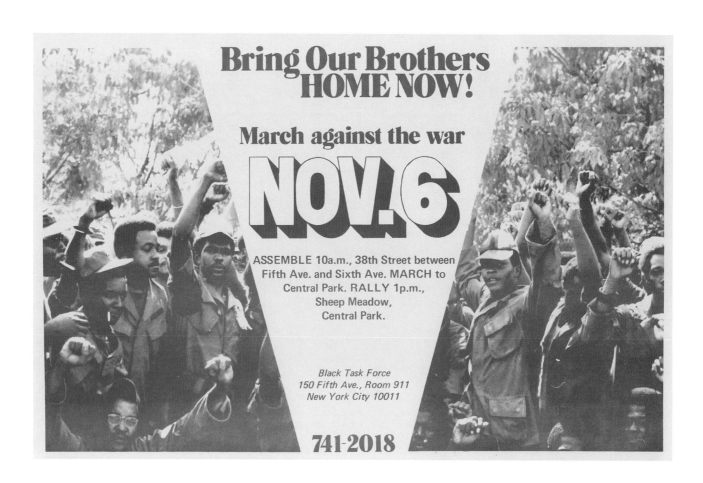

Bring Our Brothers HOME NOW!

March against the war

NOV. 6

ASSEMBLE 10a.m., 38th Street between
Fifth Ave. and Sixth Ave. MARCH to
Central Park. RALLY 1p.m.,
Sheep Meadow,
Central Park.

*Black Task Force
150 Fifth Ave., Room 911
New York City 10011*

741-2018

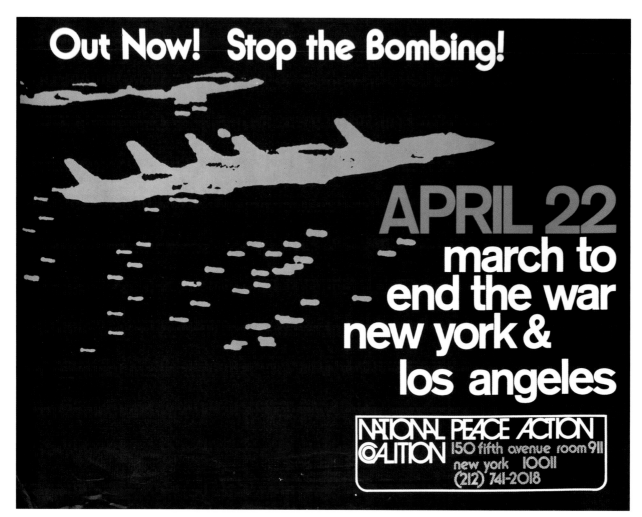

Out Now! Stop the Bombing!

APRIL 22
march to
end the war
new york &
los angeles

NATIONAL PEACE ACTION COALITION 150 fifth avenue room 911
new york 10011
(212) 741-2018

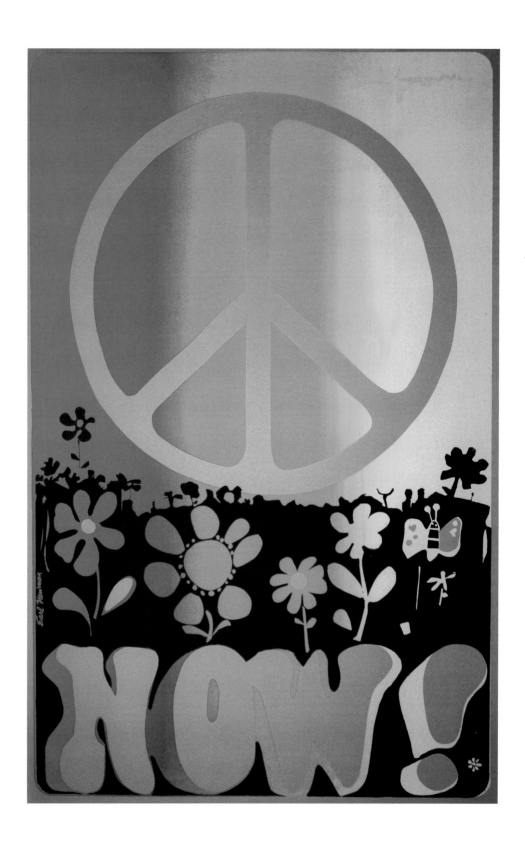

89. Unknown artist, 1971
11" × 17", offset lithography
The Black Task Force, composed
of Vietnam veterans and the Attica
Brigade, were participants in
this New York City antiwar march
on November 6, 1971.

90. Unknown artist, 1972
16¾" × 22", offset lithography
One of the last attempts at staging a mass demonstration
by the National Peace Action Coalition in the twilight of the
long antiwar crusade drew dwindling crowds. An estimate
of the New York turnout was between thirty thousand and
perhaps sixty thousand marchers, and in Los Angeles ten
to twelve thousand protesters took to the streets.

91. Earl Newman, 1967
35" × 23", screen print
Courtesy of Earl Newman.
Peace Now! captures the flower-children
aspect of the antiwar movement in
vibrant colors with the use of the omni-
present peace sign.

The majority is not silent.
The administration is deaf.

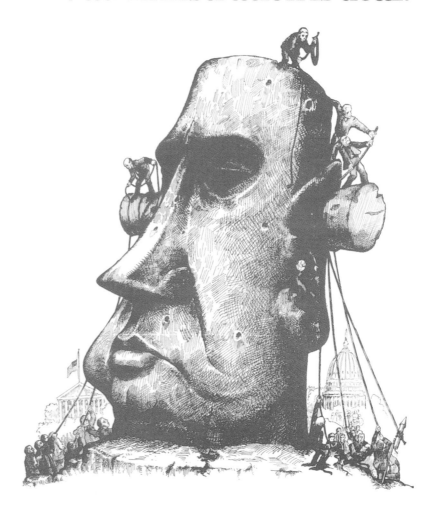

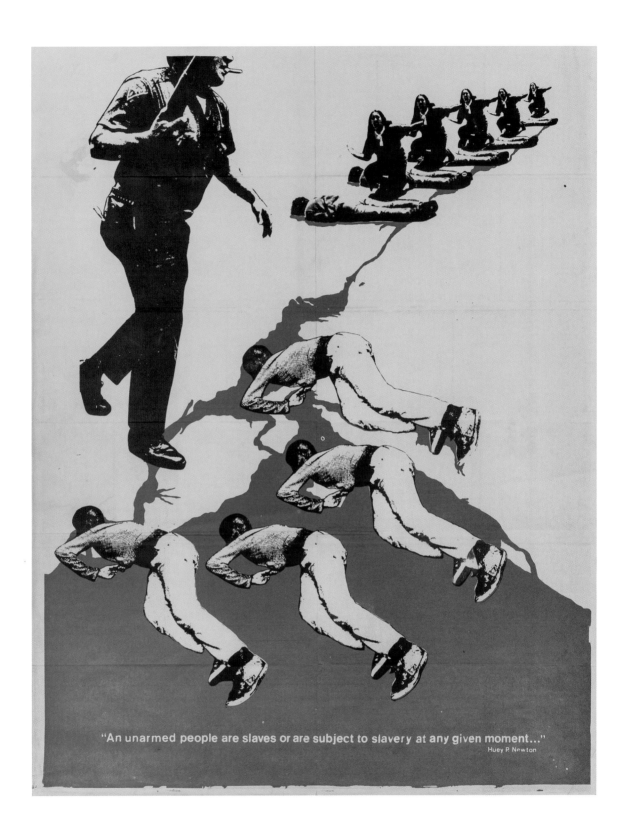

"An unarmed people are slaves or are subject to slavery at any given moment..."
Huey P. Newton

92. Unknown artist, ca. 1971

22" × 15", offset lithography

This humorous Easter Island–like image of Nixon sporting huge cork earplugs being removed by the people surely brought smiles to the faces of those who saw it.

93. Unknown artist, John Filo photo, 1971

22½" × 17½", screen print

The killing of four students at Kent State on May 4, 1970, and the killing of two students at Jackson State eleven days later on May 15 are portrayed in this hard-hitting photomontage that uses repetition very effectively. The top right photograph by John Filo, which won a Pulitzer Prize, captures fourteen-year-old runaway Mary Ann

Vecchio kneeling over the dead body of Jeffrey Miller. Immediately after the Kent State shootings, college campuses around the country, already in turmoil over the invasion of Cambodia, burst into more and larger strikes, protests, and demonstrations that often ended in violence. The killings at Jackson State further exacerbated the growing confrontation between the antiwar factions and "the establishment."

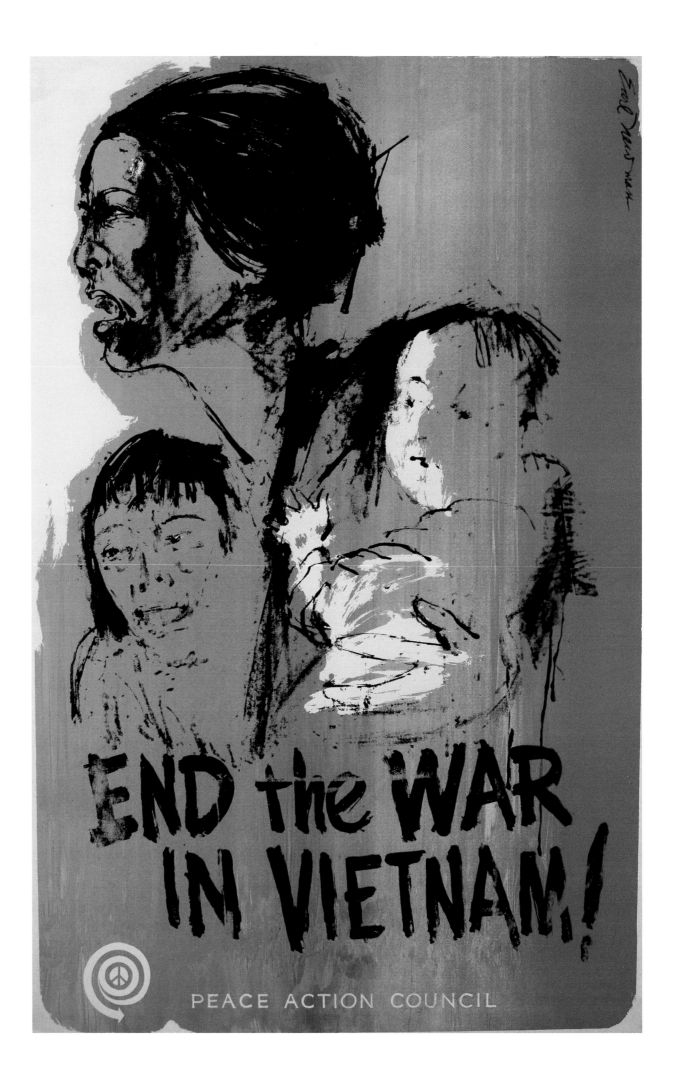

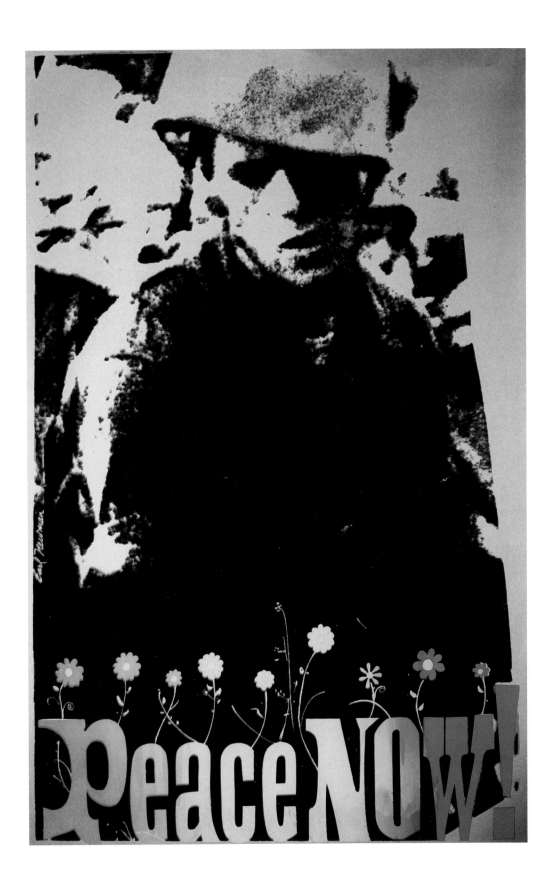

94. Earl Newman, 1969–70
35" × 23", screen print
Courtesy of Earl Newman.
The West Coast Peace Action Council commissioned this poster illustrating the suffering of the Vietnamese people at the height of the antiwar movement. A number of antiwar posters used similar images often based on actual photos of dead civilians or wounded or terrified Vietnamese fleeing the fighting.

95. Earl Newman, 1968
38" × 23", screen print
Courtesy of Earl Newman.
The image of the exhausted, perhaps shell-shocked soldier is often used in antiwar posters worldwide. Here, Newman, in a psychedelic style, uses a bright, colorful spectrum blend of flowers and lettering to convey a peaceful world contrasted with the hellish world of war.

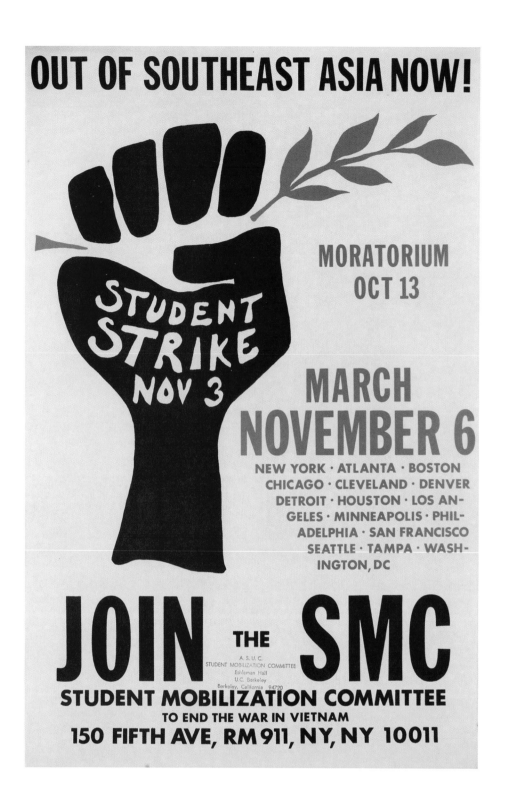

OUT OF SOUTHEAST ASIA NOW!

MORATORIUM
OCT 13

STUDENT STRIKE NOV 3

MARCH
NOVEMBER 6

NEW YORK · ATLANTA · BOSTON
CHICAGO · CLEVELAND · DENVER
DETROIT · HOUSTON · LOS AN-
GELES · MINNEAPOLIS · PHIL-
ADELPHIA · SAN FRANCISCO
SEATTLE · TAMPA · WASH-
INGTON, DC

JOIN THE **SMC**
STUDENT MOBILIZATION COMMITTEE
TO END THE WAR IN VIETNAM
150 FIFTH AVE, RM 911, NY, NY 10011

96. Unknown artist, 1971
17" × 11", offset lithography
This well-designed Student Mobilization Committee poster, featuring the ubiquitous clenched fist, promotes a number of peace actions scheduled for the fall campaign. Student strikes and teach-ins happened on many U.S. college campuses.

97. Unknown artist, ca. 1971–72
42¼" × 29½", offset lithography
Based on the World War I poster by James Montgomery Flagg, this stunning antiwar image rivals the use of the skeleton by skilled political propaganda artists like John Heartfield, Franz Masereel, and José Guadalupe Posada. The poster appeared in either 1971 or 1972 when the antiwar movement was in disarray and declining.

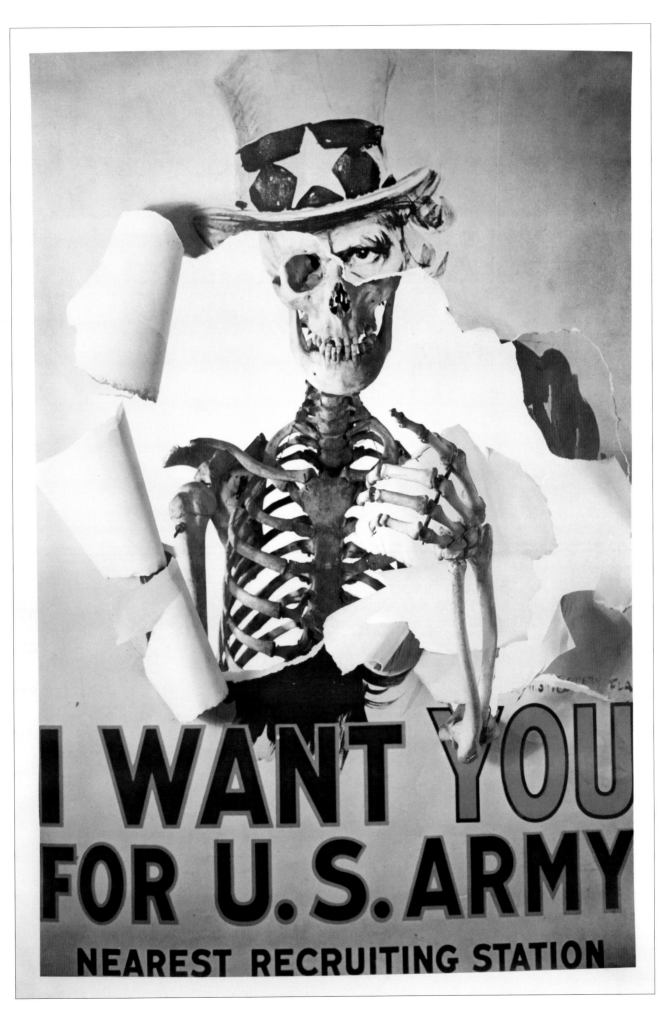

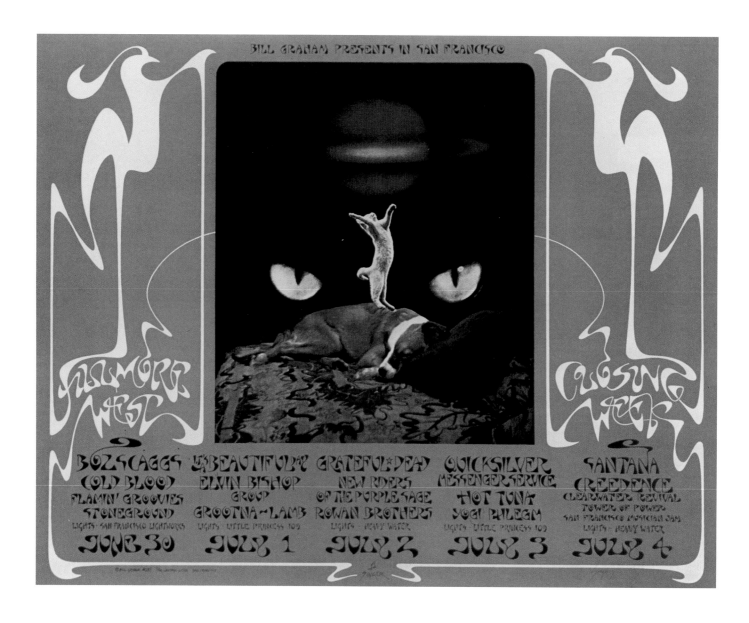

98. David Singer, 1971
16⅝" × 26¼", offset lithography
© *Wolfgang's Vault. All rights reserved.*
On July 4, 1971, Bill "Uncle Bobo" Graham closed his famous Fillmore West Auditorium. He selected his favorite bands, filmed the event, and recorded the concert. David Singer created the final mysterious poster, BG 287, in a run of psychedelic posters that

began on February 4, 1966, and featured the Jefferson Airplane. The poster is a fitting memorial capping the end of an era—"the times they are a changin'." What seemed forever in 1965—a fabulous era of music, drugs, and art—was coming to an end. Those marvelous psychedelic posters had been "trippin' on time" and time had run out.

99. Unknown artist, 1970–71
28" × 20", screen print
The McGovern-Hatfield effort to end the war by cutting off funding failed in Congress twice. Activists in various states attempted to get peace petitions on state, county, or municipal ballots through signature drives. This very rare Colorado poster is printed on heavy paper and could serve as a window card as well.

The McGovern Poster Explosion of 1972

George McGovern faced a field of formidable candidates for the Democratic presidential nomination: the Democratic establishment heir apparent, Sen. Edmund Muskie of Maine, along with Hubert Humphrey, George Wallace, Henry "Scoop" Jackson, and Shirley Chisholm. Gary Hart and Frank Mankiewicz, onetime head of the Peace Corps and RFK'S former press secretary who joined McGovern's staff and served as his alter ego and a campaign chairman, formulated a strategy that their candidate would selectively challenge Muskie in states that showed a promise of support. Iowa, the first caucuses, and New Hampshire, the first primary, were chosen as important opening rounds. Mankiewicz confidently predicted that McGovern would garner 38 percent of the votes in New Hampshire, a figure scoffed at by nearly all observers. Muskie won the Iowa caucuses and the New Hampshire primary; however, McGovern came in a close second in both contests and gained momentum and legitimacy. The day after the primary, Mankiewicz was crowned a political genius as he had missed McGovern's vote total by only a percentage point. Poor organization, a flawed strategy, and lack of enthusiasm caused the Muskie campaign to founder and then collapse.

Congresswoman Shirley Chisholm of Brooklyn, who described herself as "unbought and unbossed" was the first black women to seek the nomination of a major political party and the first women to win a primary—she won New Jersey with 65 percent of the vote. Sporting an Afro and flower-embroidered jackets, Chisholm had a magnetic charm coupled with an honest, straight-talking campaign style. Chisholm had no chance at the presidency. First, because no member of the House of Representatives had gained a major party presidential nomination since James Garfield in 1880; second, because the candidate had a very narrow base and little name recognition; and third, because America was not ready for a black female president. Chisholm, however, added to her delegate count with wins in the Mississippi and Louisiana primaries. She also survived three assassination attempts.

The Democratic Party continued to fracture, and that fact plus the new rules for delegate selection strongly favored McGovern. In Wisconsin, McGovern demonstrated his well-organized traditional ground game by widening his appeal with a significant number of blue-collar workers and farmers. After his victory in Wisconsin on April 4, Mankiewicz declared the race over; McGovern would sweep to victory in New York and the western states and be nominated in Miami on the first ballot. The political cognoscenti remained skeptical. For the counterculture and the antiwar movements, the South Dakotan's success was a renewed lease on life; perhaps the dream was not dead after all. Sensing a final political chance, the disaffected youth, the academics, the white urban elites, the Hollywood Left, and the old Left enthusiastically flocked to the McGovern

100. Di Stovall, 1972

28" × 22", screen print

Frontrunner Edmund Muskie's short-lived campaign produced a number of hip posters and prints. At a January 1972 campaign kickoff this very appealing screen print in a Peter Max–like funky style featured a peace and environmental theme and was for sale in a limited edition of 115.

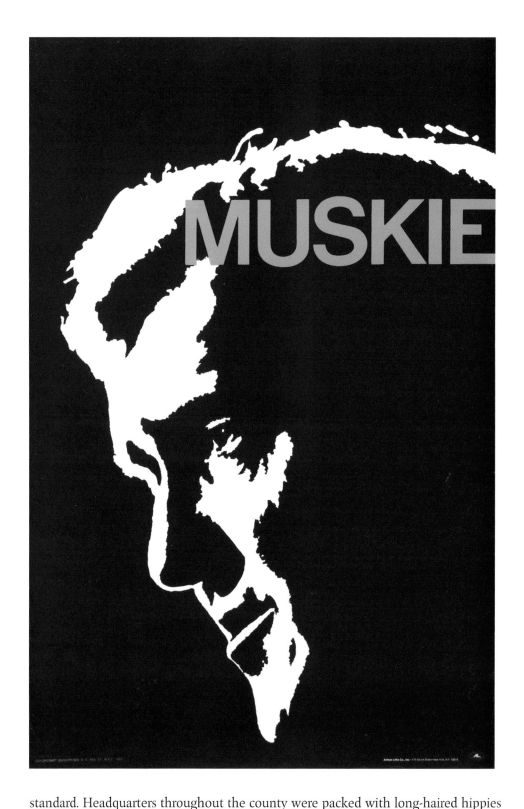

standard. Headquarters throughout the county were packed with long-haired hippies adorned with elaborate jewelry, wearing tie-dye T-shirts, bell bottoms, and Birkenstocks. More traditional Democrats were there too but seemed like poseurs, wannabes, or obviously uncomfortable aliens. This was the "New Politics."

The McCarthy campaign had seen a flowering of posters that brought the styles of the civil rights movement, the antiwar movement, and the psychedelic counterculture into the realm of politics. This combination of factors produced an avalanche of posters for George McGovern—a grassroots effort that sprang up across the country. In state after state enthusiastic artists cranked out dozens of cheap but well-designed posters, even some spray-paint stencil creations. The walls and bulletin boards of every McGovern campaign office were plastered with multiple layers of campaign posters, gig posters,

and promotions for dozens of causes—Haight-Ashbury had gone national. Establishment artists as well clambered aboard the Dakotan's bandwagon. Thousands of young volunteers from around the country worked tirelessly to secure McGovern's victory. Screen prints proliferated and the collage made an appearance. A number of rock stars jumped on the McGovern bandwagon as they had for Gene McCarthy in 1968. Shirley MacLaine and Warren Beatty sponsored a series of benefit concerts that included Joni Mitchell, Tom Rush, Carole King, James Taylor, Judy Collins, Mary Clayton, Country Joe and the Fish, Tina Turner, "Mama" Cass Elliot, Barbra Streisand, and Peter, Paul, and Mary. Simon and Garfunkel broke up in 1970, but in their enthusiasm for candidate McGovern they reunited long enough to star as headliners at a huge fund-raiser in Madison Square Garden. The rock band Chicago toured nationwide and in each venue set up voter registration booths and handed out campaign paraphernalia. On stage, McGovern stickers and posters abounded.

Mankiewicz had it right. McGovern secured enough delegates to win on the first ballot after his victory in the California primary on June 6, picking up a whopping 273. The candidate used the time between the California primary and the convention in late July to shore up support, raise money, and combat the growing "Anybody but McGovern" coalition that was gaining strength. Labor opposed his nomination as did many Democratic voters in the South and much of the Democratic establishment. For traditional centrist Democrats the fact the McGovern had been the South Dakota chairman of Henry Wallace's 1948 Progressive Party campaign was all they needed to know.

Ironically the remark that hurt McGovern the most was made by the man he would finally pick as his running mate, Missouri senator Thomas Eagleton. Shortly after the April 25 Massachusetts primary, Eagleton, demanding confidentiality, told Washington syndicated columnist Robert Novak that McGovern stood for "amnesty, abortion and the legalization of pot," and when the American people found out he would be dead in the water. McGovern opponents replaced "the legalization of pot" with "acid." Acid, Amnesty, and Abortion repeated over and over again, the three A's, none of which were true, negatively framed him as outside the mainstream. Novak finally revealed his source in his 2007 memoir *The Prince of Darkness: Fifty Years Reporting in Washington*, shortly after Senator Eagleton died. At the obstreperous Miami convention delegate credential challenges were overcome, as was a "Stop McGovern" movement led by Georgia governor Jimmy Carter. The coveted nomination was secured.

Sure that Ted Kennedy would run on the ticket, McGovern was dismayed to learn that he would not, and neither would Hubert Humphrey or any number of other prominent senators. Presumably all thought he could not possibly win and did not relish falling on the knife for the party. McGovern, by then almost desperate, turned to Eagleton on the recommendation of Sen. Gaylord Nelson of Wisconsin, who had also turned him down. In the turmoil of the search, little or no vetting occurred and Eagleton readily agreed. The nominating process for vice president on the last night of the convention took hours, with nominations for eight candidates put forward. McGovern got his running mate but delayed his acceptance speech, "Come Home America," until three o'clock in the morning—very few Americans were awake to hear the oration.

Just who was Tom Eagleton? The media was determined to find out. A few weeks' investigation revealed that the Missourian had been treated for depression and received electroshock therapy. At first McGovern stood by Eagleton and thought of using mental health as a campaign issue. To his later great regret he stated on July 26, "I am 1,000 percent for Tom Eagleton and have no intention of dropping him from the ticket." But the pressure mounted as concerns grew exponentially over a person with mental

health issues being a heartbeat from the presidency. Six days later McGovern bowed to the inevitable, dropped Eagleton, and again bore the indignity of having key Democrats spurn his request to join him on the ticket. Finally Sargent Shriver—a relative of the Kennedy clan, founder of Job Corps and Head Start, and American ambassador to France—rescued the nominee, but like Eagleton he was not well-known to the country.

Regardless, the deep divisions in the party, the convention fiasco, and the disastrous Eagleton affair made McGovern look both indecisive and opportunistic. These issues, coupled with his image of being too far Left did not bode well for defeating Nixon, whom he trailed badly in the polls. The McGovern juggernaut, so successful in the grueling primaries, looked as if it was coming unglued. The Left, however, finally had their candidate. They had worked hard to get through the state primary gauntlet and had overcome great odds to secure the nomination for their man. The civil rights movement was in turmoil, the counterculture was rapidly disintegrating, and the antiwar movement was in shambles, but this was not the time to lose heart or abandon McGovern. The thought of defeat, of accepting the dubious idea of the nobility of failure, was overcome by a belief that meaningful change was possible through the democratic process—the New Politics. Convinced, the Left set out with renewed enthusiasm on a quixotic crusade with the South Dakota senator leading this Gideon's army.

In the months that followed, a virtual explosion of innovative posters and prints in support of the peace candidate, the change candidate, appeared. Not since the color lithographic political posters of the late 1890s had the country had such a visual treat. McGovern won the heart of the art community and they repaid him in kind. Sometimes that repayment would come in the form of art auctions held in most major cities. Donated work at chichi gala events was sold to the highest bidder. The screen print that had slowly been coming back as a favored medium in political art took off. As the campaign proceeded, the number of screen prints continued to proliferate, including prints by the well-known artist Alexander Calder.

The large crowds for McGovern rallies and speeches and the deluge of posters and prints were deceptive. After the Miami convention and the Tom Eagleton affair, the air went out of the campaign; the energy spent in obtaining the nomination left the McGovern camp drained. The splits in the Democratic Party did not heal. In fact, they festered. The AFL-CIO withheld its support; the Teamsters and many in labor supported Nixon. Democrats by the tens of thousands defected from the party, particularly working-class voters—the blue-collar hardhat aristocrats. John Connelly of Texas organized Democrats for Nixon as a large number of George Wallace enthusiasts in the South drifted to the Republicans. Some said the whole effort was disorganized and lacked focus; even some of McGovern's young field workers sympathetically nicknamed their hero "Schleprock," a bad luck, pathetic cartoon character from *The Pebbles and Bamm-Bamm Show*.

Unable to raise sufficient operating funds, the campaign sputtered to the finish line in November, out of money and voters. Just after midnight on Election Day, November 7, 1972, McGovern's campaign plane, the *Dakota Queen II*, landed in Sioux Falls, the same city where it had taken off sixteen months earlier. All knew the senator would lose, especially the candidate himself in the last week. The predictions of those in the upper levels of the campaign and in the press were in the general range of 5 to 10 percentage points, but as the early returns began to come in, it was soon clear that a catastrophe was in the making. Dixville Notch, New Hampshire, voting just after midnight on Election Day, was an accurate harbinger of what was in store for the candidate nationally— Nixon 16, McGovern 3. The Prairie Statesman lost by a whopping 37 percent and carried only Massachusetts and the District of Columbia. Nixon had scored the largest landslide

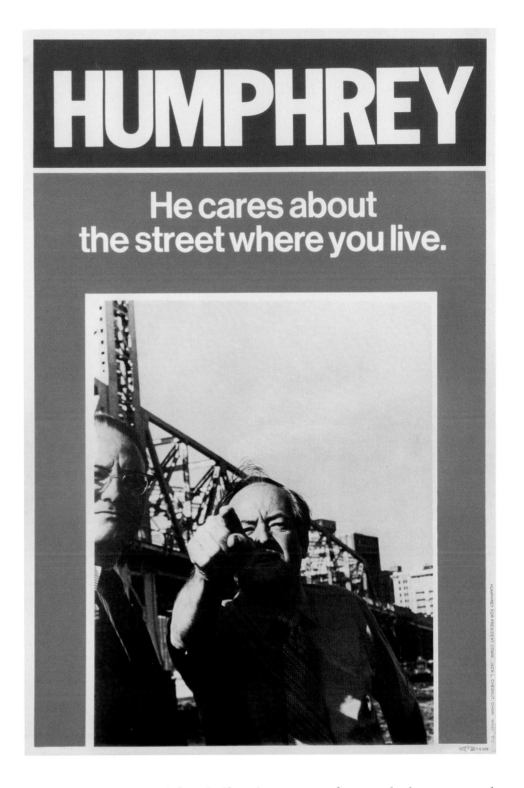

HUMPHREY

**He cares about
the street where you live.**

30" × 20", offset lithography
Hubert Humphrey campaign's innovative
orange and green graphics were designed
to appeal to Florida voters. George Wallace
won the Florida primary; nationwide Hum-
phrey polled more votes than any other
Democrat running but lost the party nomina-
tion to George McGovern. Humphrey was
anathema to the young counterculture crowd
and could not remove the LBJ albatross
hung securely around his neck.

since Franklin Roosevelt defeated Alf Landon in 1936. Left-wing radicals were stunned, seeing McGovern as America's last chance for redemption. Hillel Italie, in a recent Associated Press article reflecting on McGovern's run for the presidency, wrote, "Abbie Hoffman sobbed that fateful night at the downtown Manhattan apartment of fellow activist Jerry Rubin. So did Rubin and Alan Ginsberg. John Lennon was drunk, and out of control, shouting 'Up the Revolution!' in mock celebration of a dream defeated."

The McGovern campaign may have been one "bright shining moment," but why was the loss so horrific? Surely the mistakes made in the campaign were not the only reasons. Hunter S. Thompson, speaking with McGovern in his Senate office in December, went over a myriad of explanations and finally asked the senator, "Do you think you ran a '68 campaign in '72?" McGovern conceded that might have been the case, perhaps

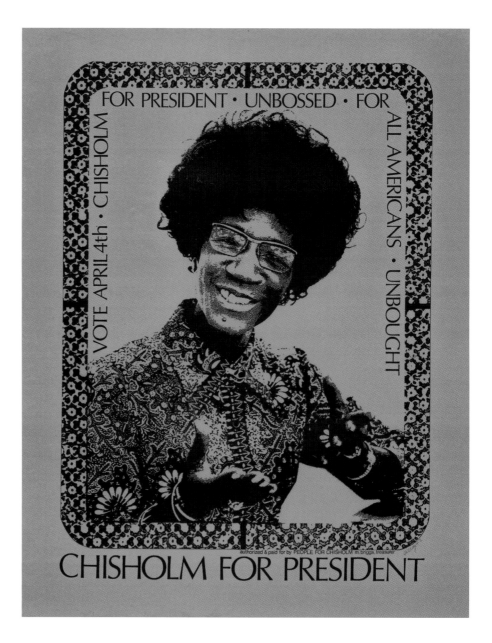

CHISHOLM FOR PRESIDENT

103. William Weege, 1972

28" × 22" and 22½" × 17½", offset lithography
Courtesy Wisconsin Historical Society, WHS-56800.

Well-known artist William Weege's poster is a welcome change from standard campaign graphics. Created for the Wisconsin primary, the poster captures the "unbossed and unbought" candidate's charm in this two-color design. Shirley Chisholm was famous for wearing flower-embroidered jackets.

104. Mary Corita Kent, 1972

22" × 17", offset lithography

The Chisholm campaign issued a number of top-notch posters, but this poster by Mary Corita Kent, an activist artist and former nun who created dozens of screen prints in support of peace and social justice and who signed her work simply Corita, rises to the top and makes the short list as one of the all-time great political posters. The abstract figure of Chisholm and the use of the Langston Hughes poem written in script are its hallmark features.

a denial of political possibility. The air was already out of the civil rights movement, the peace movement, and the black power movement, and the great boomer revolt had fizzled. In reaction to the excesses and turmoil of the sixties—the riots, killings, violent demonstrations, assassinations, war, and drugs—Americans moved to the center and to the center Right. The 1972 campaign was in many ways a requiem for the end of an era. The counterculture dream failed, hippie communities faded away, American participation in Vietnam was winding down, major political reforms were not enacted, and the country went off in a new direction—a direction heavily influenced by the sixties experience. Whatever the future held, people rationalized that the seventies had to be better than the preceding ten years. The campaign poster explosion of 1972 went the way of the campaign, but the innovative graphics of the decade had a decided effect on future political posters. However, it would take an inspiring Democratic candidate to motivate artists on the Left and those outside the system to ignite another burst of political artistic expression. McGovern's overwhelming rejection by the voters aside, the 1972 campaign posters were outstanding and remained the benchmark until the unprecedented outpouring of posters in the 2008 presidential campaign of Barack Obama thirty-six years later. The candidate himself, a deeply religious, principled man, retained his Senate seat in 1974, continuing his efforts to better his country by helping others.

Shirley Chisholm
unbossed and unbought

I play it cool and dig all jive
that's the reason I stay alive
My motto: As I live and learn
to dig and be dug in return
Langston Hughes

Corita

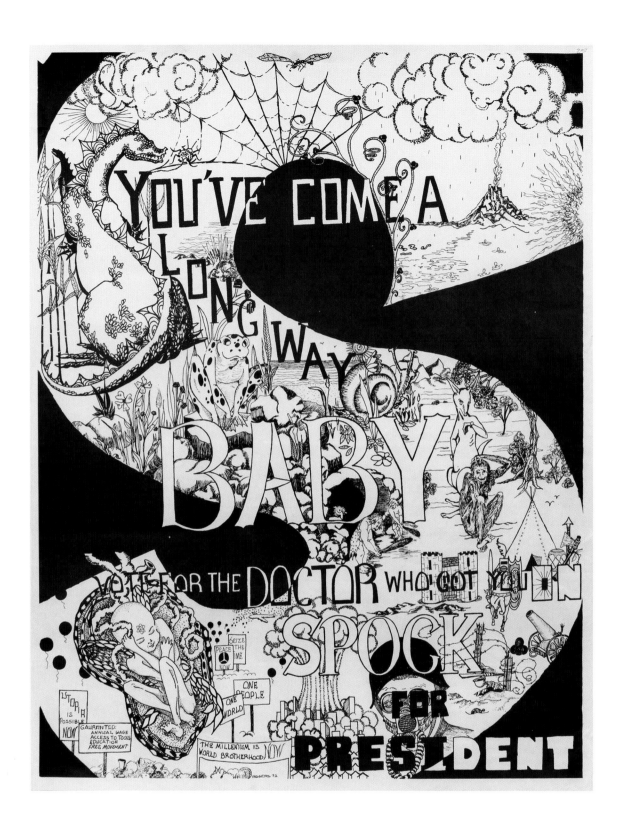

105. Roger, 1972

22½" × 17½", offset lithography

The famous baby doctor Benjamin Spock ran with Julius Hobson as nominees of the People's Party, and their names appeared on a number of state ballots under a variety of left-wing party names: Peace and Freedom Party, Human Rights Party, New American Party, No Party, etc. The candidates advocated free medical care, legalized abortion and marijuana, a guaranteed minimum wage, and the withdrawal of all U.S. troops stationed abroad. The full name of the artist who created this wild psychedelic poster is unknown.

106. Unknown artist, 1972

33" × 24", offset lithography

The Nixon campaign generally issued more traditionally designed posters, but this photomontage celebrating the candidate's achievements is one of the best. Around the oval portrait of the president are photos of his successful trip to China, his work with Soviet premier Leonid Brezhnev, his work with minorities and American youth, and his solid relationship with his wife, Pat.

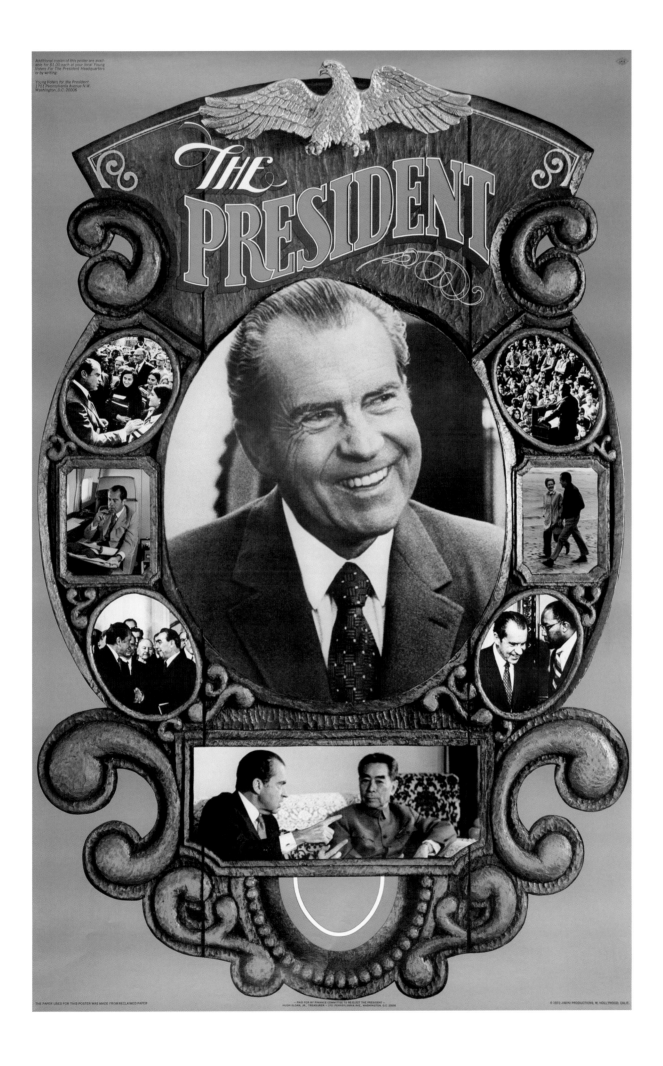

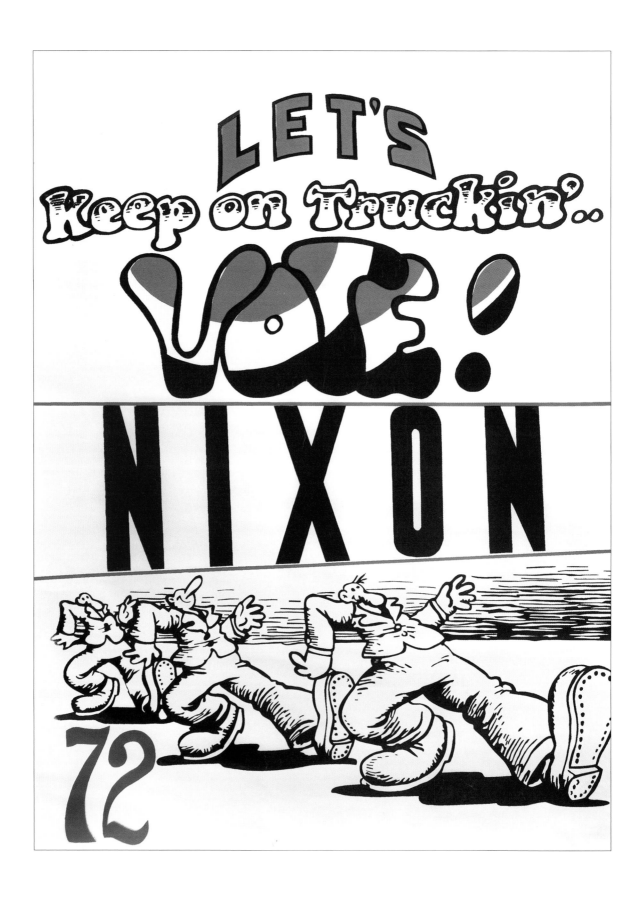

107. Unknown artist, 1972

24" × 36", screen print

Robert Crumb's wildly popular Do-Dah men, employed on behalf of candidate Nixon, may represent a bold attempt on the part of supporters to attract the mass of recently enfranchised young voters, but some have claimed that the poster is satirical. Ed Muskie too "kept on truckin'" with a Do-Dah man dressed as a Maine jack pine hillbilly on one of his campaign buttons.

108. Unknown artist, 1972

22" × 18", offset lithography

The Flair Election Collection poster is just that, a fun cartoon caricature rendering of nearly every Democrat and Republican involved in the 1972 campaign. The poster is signed, but the artist's name is illegible.

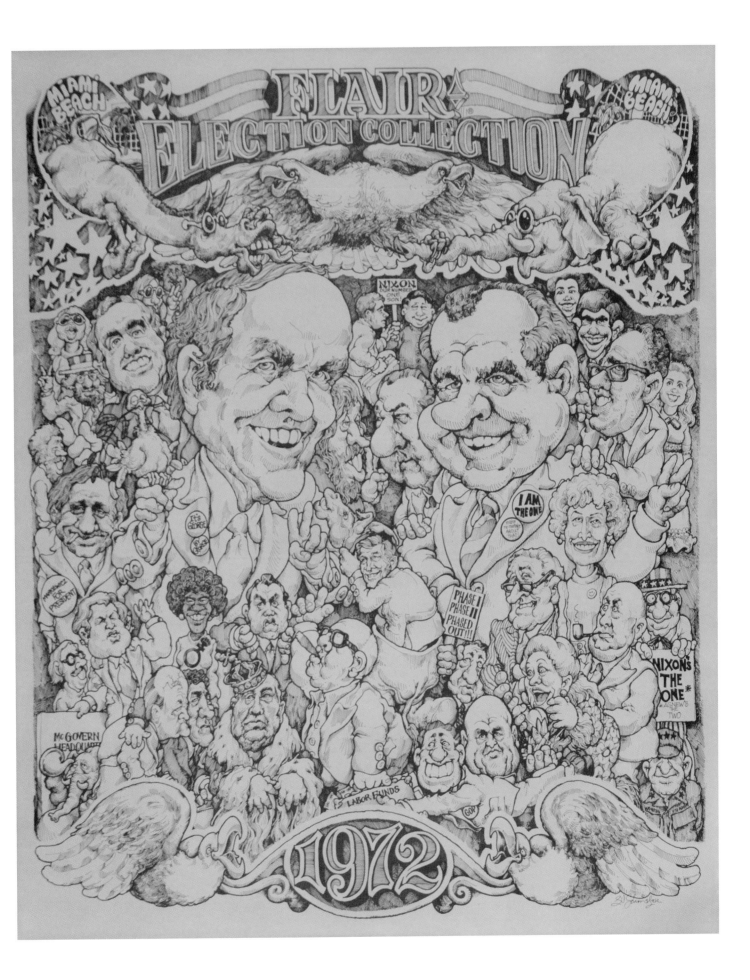

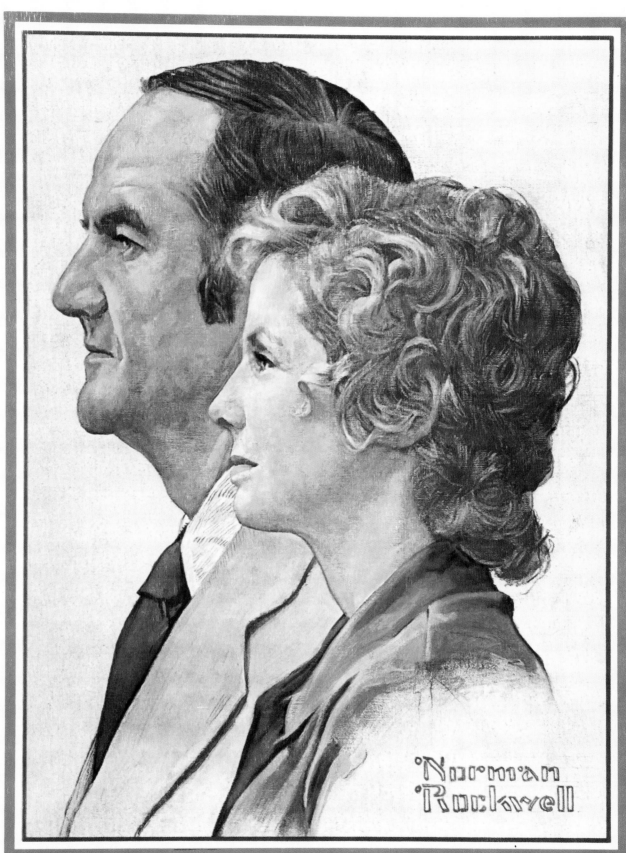

Eleanor and George McGovern

sincerely
Norman
Rockwell

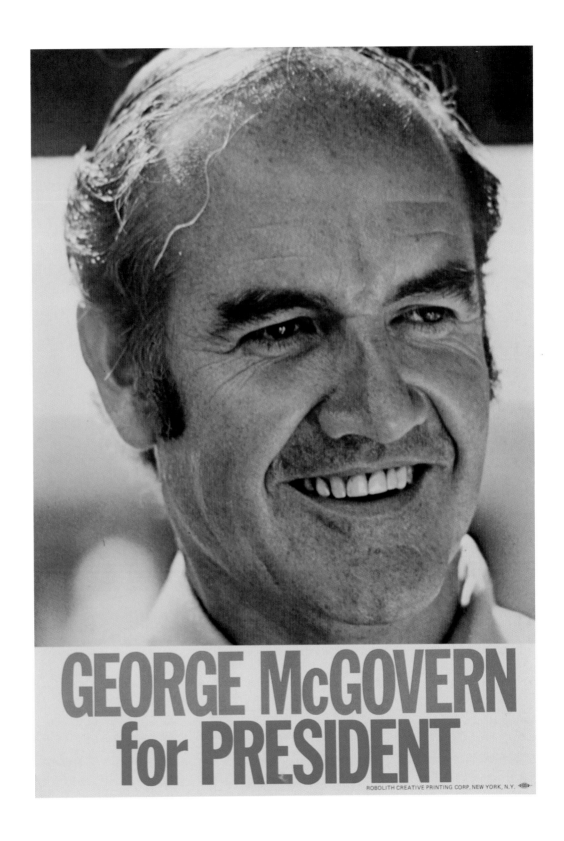

GEORGE McGOVERN
for PRESIDENT

ROBOLITH CREATIVE PRINTING CORP. NEW YORK, N.Y.

109. Norman Rockwell, *Eleanor and George McGovern*, **1972**

13¾" × 10⅛", offset lithography

Printed by the permission of the Norman Rockwell Family Agency. © 1972 the Norman Rockwell Family Entities.

Norman Rockwell created this painting along with one of Richard and Pat Nixon that appeared in the Novemeber 1972 issue of *Ladies Home Journal*. Rockwell began his distinguished but controversial career when he was sixteen years old. In 1916 he painted his first cover for the *Saturday Evening Post*. He eventually painted 321 covers that captured an idealized American life. His artwork, disparaged by some critics for its romanticism, was beloved by his fellow countrymen who ordered millions of copies of his work, especially the World War II print set entitled *The Four Freedoms*. This print is signed by the artist.

110. Unknown designer, 1972

20" × 14", offset lithography

As posters throughout this book demonstrate, Senator McGovern possessed the political asset of being very photogenic. This standard issue, full-color poster is a prime example.

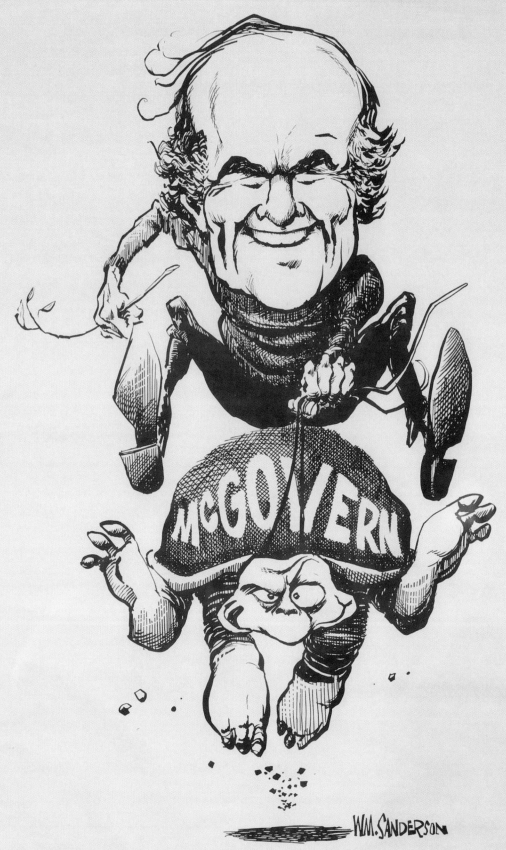

WM. SANDERSON

"Comin' On Home!"

Oregonians for McGovern, P.O. Box 4242, Portland, Oregon 97208, Jean Dale, Treasurer

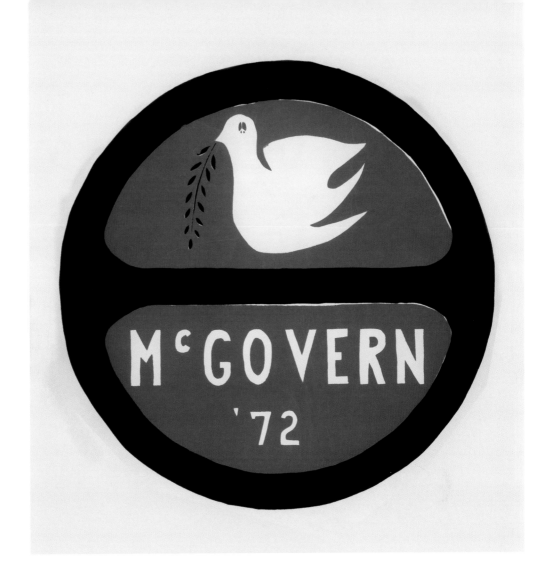

111. William Sanderson, 1972
27" × 23", offset lithography
Senator George McGovern Collection,
McGovern Library / DWU Archives, Dakota
Wesleyan University, Mitchell, South Dakota.
Celebrated longtime cartoonist for the
Portland-based newspaper the *Oregonian*,
William Sanderson created this fine
poster for Oregonians for McGovern.
McGovern won more than 50 percent of
the vote and all of Oregon's thirty-four
delegates on his road to the nomination.

112. Unknown artist, 1972
26" × 20", screen print
Grassroots screen prints pushing McGov-
ern as the peace candidate were pulled
at a number of headquarters during the
campaign to win the Wisconsin primary
on April 4, 1972.

113. Unknown artist, 1972
26⅛" × 20⅛", screen print
Prints were done in a variety of colors, but
the number remains unknown.

YOU CAN
MAKE IT HAPPEN!

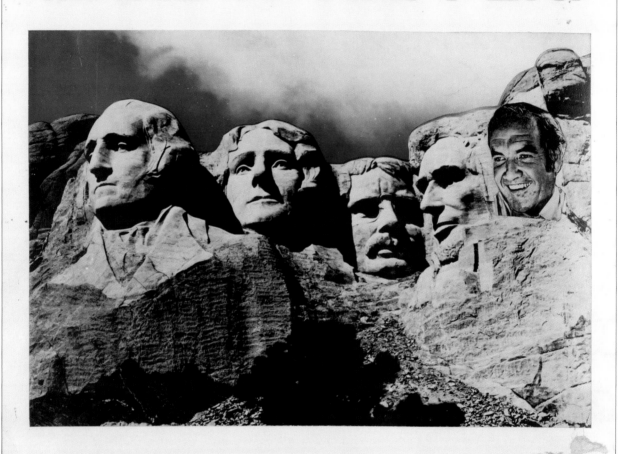

Vote
McGOVERN
On
NOV.7th

114. Unknown artist, 1972

17½" × 11½", offset lithography

Viewing this wonderfully humorous poster it's clear you're voting for McGovern for president, and his accomplishments in the White House will warrant a place for him on Mount Rushmore.

115. Unknown artist, 1972

23" × 11¾", screen print

McGovern campaign workers nailed these screen prints to telephone poles and fence posts across the state of Wisconsin in the lead-up to the primary.

116. Unknown artist, 1972

23" × 12", screen print

The grassroots poster barrage must have helped the candidate as McGovern won the Wisconsin primary with just 30 percent of the vote and picked up fifty-four more delegates. It was at this point that McGovern's confident campaign manager Frank Mankiewicz declared the race over, exclaiming that McGovern would sweep to victory and be nominated on the first ballot.

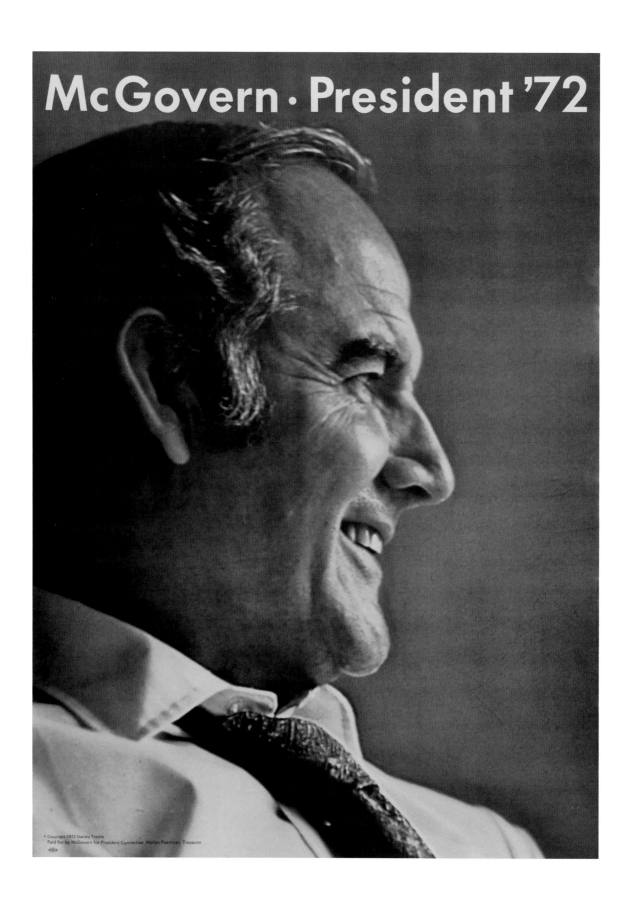

McGovern · President '72

© Copyright 1972 Stanley Tretick
Paid for by McGovern for President Committee, Marian Pearlman, Treasurer

117. Unknown designer, 1972
28½" × 22", offset lithography
This widely distributed poster by the
Democratic National Headquarters
was a workhorse of the campaign.

118. Unknown artist, 1972
27" × 20", offset lithography
*Senator George McGovern Collection, McGovern
Library/DWU Archives, Dakota Wesleyan University,
Mitchell, South Dakota.*
One of the better posters of the McGovern campaign
with a message aimed at midwesterners: get out of
Vietnam and come home—home to the heartland.

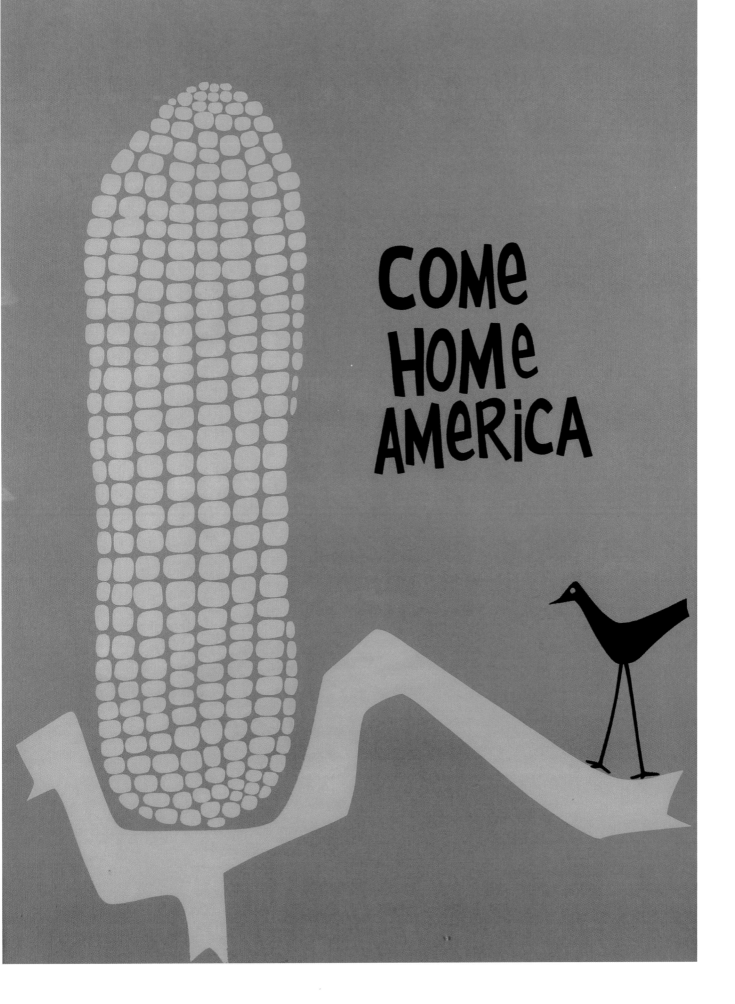

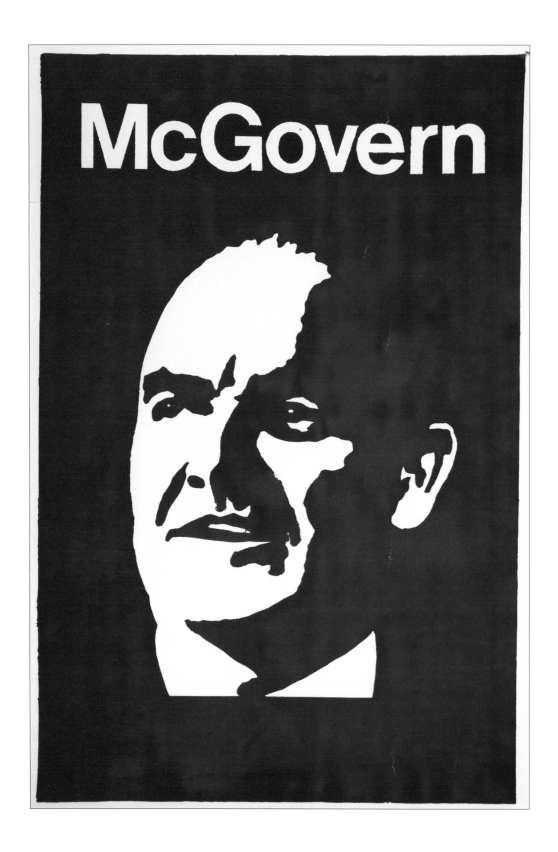

119. Unknown artist, 1972

35" × 23", screen print

In the weeks leading up to the May 9 primary, the Lincoln, Nebraska, McGovern headquarters was a beehive of activity. Supporters had set up several wooden screen print presses, and on each press a different poster design was being printed. The stencil-like shadowing of McGovern's uplifted head is reminiscent of Shepard Fairey's iconic 2008 Obama poster, though it is unlikely that Fairey ever saw either of the two posters featured here.

120. Unknown artist, 1972

35" × 23", screen print

On the Saturday before the Nebraska primary the McGovern headquarters was packed with people who waited patiently for posters to dry before scooping them up and plastering them around the city. Some loaded stacks of posters into the trunks of their cars and headed for other cities in the Cornhusker state. McGovern won the primary with a little over 42 percent of the vote.

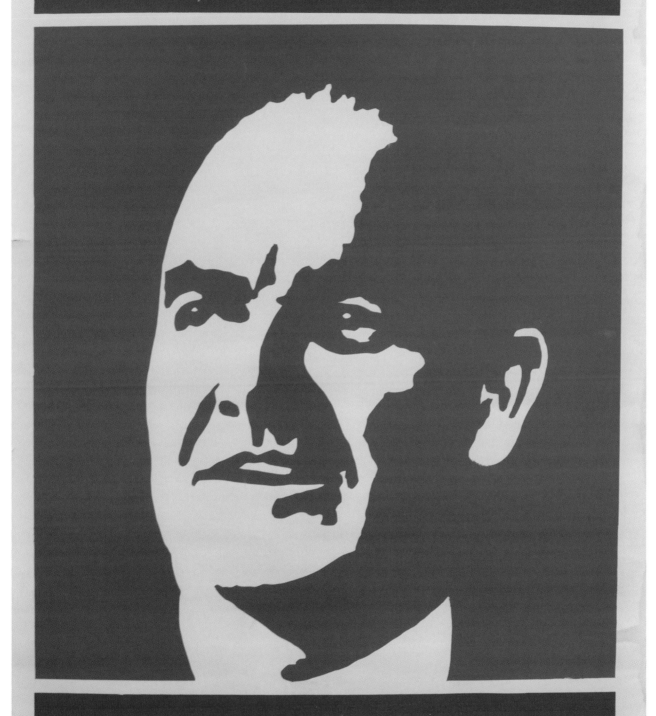

121. Unknown artist, 1972
35" × 23", screen print
How many different poster designs were created by the Lincoln, Nebraska, artists remains unknown, and it is likely that others will be discovered. How many posters were pulled in each design is also unknown as the prints are not numbered, but the quantity was large enough that sets were mailed to McGovern headquarters in other states.

122. Unknown artist, 1972
22" × 14", screen print
This poster is likely from the Massachusetts primary that Senator McGovern handily won. "Row G" refers to where McGovern's name appears on the ballot.

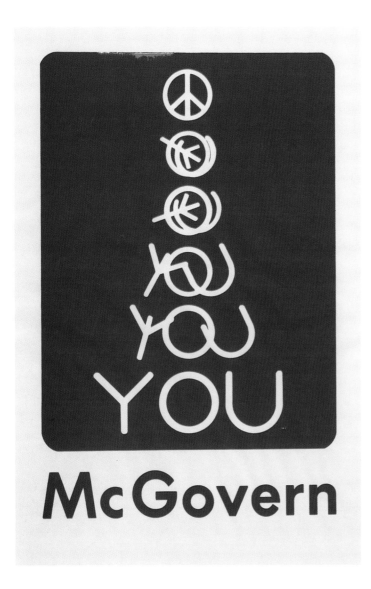

123. Unknown artist, 1972
19" × 12½", screen print
This fine, innovative screen print appeared in Madison, Wisconsin, leading up to the all-important primary on April 4, but little is known of its origins. The same image was used on a Madison poster promoting student interviews with the Peace Corps.

124. Unknown designer, 1972
18" × 25", offset lithography
Gary Hart, his enthusiasm bolstered by a big McGovern win in the Nebraska primary on May 9, was already looking forward to the general election. But the fact that by this same date George Wallace had won five primaries, Hubert Humphrey four, and Ed Muskie three might have suggested that if McGovern won the nomination, a large portion of the Democratic Party was lukewarm on his candidacy and unifying the party would prove a difficult challenge.

''I hope the Nixon people do to George McGovern what the Democrats did . . . underestimate him. If they do that . . . WE'LL KILL THEM.''

Gary Hart
McGovern Campaign Director
Washington Post May 14, 1972

In Concert at the Forum – April 15th · 8:30 PM

Carole King Barbra Streisand James Taylor

Use the Power ⑱ Register and Vote

Quincy Jones and his Orchestra

Ushers: **Warren Beatty · Jack Nicholson · Julie Christie · Sally Kellerman · James Earl Jones · Jacqueline Bisset Michelle Gilliam · Mike Nichols · Shirley MacLaine · Goldie Hawn · Gene Hackman · Elliott Gould Marlo Thomas · Burt Lancaster · Jon Voight · Raquel Welch · Michael Sarrazin · Britt Ekland and more**

125. Unknown artist, 1972
25½" × 36", offset lithography
One of the finest and rarest McGovern campaign posters features drawings of Carole King, Barbra Streisand, and James Taylor for a McGovern concert at the Los Angeles Forum on April 15. The staff, clef note, and time signature of ¾ followed by *McGovern* is a very original design. The evening also boasted a large number of stars who acted as ushers. A slightly smaller version of this poster was also printed.

126. Unknown artist, 1972
21" × 30", screen print
Courtesy of the Center for the Study of Political Graphics.
Posters utilizing hand-drawn lettering, a technique often employed by psychedelic poster makers, helped McGovern to a huge victory in the California primary and secure enough delegates for a first ballot nomination at the national convention in Miami.

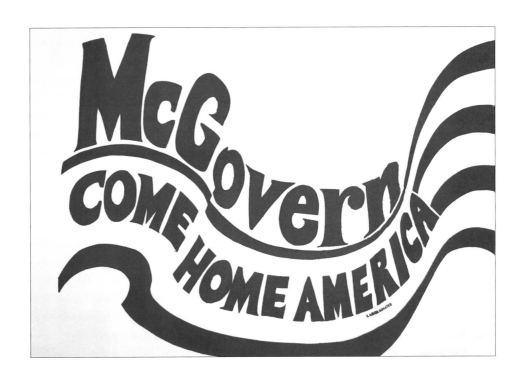

YALE POLITICAL UNION

presents

Gary Hart

McGOVERN CAMPAIGN MANAGER

discussing

The McGovern Plan
for
The Defeat of Nixon

SUNDAY, OCTOBER 8

201 WLH

7:45 p.m. UNION MEMBERS ONLY

127. Unknown artist, 1972
14" × 11", offset lithography.
Gary Hart, serving as one of McGovern's
campaign managers, gave dozens of
speeches for his candidate in the fast-
paced primaries that came one after
another in the spring of 1972.

128. David F. Stern, 1972
24" × 14", screen print
Senator George McGovern Collection, McGovern Library/DWU
Archives, Dakota Wesleyan University, Mitchell, South Dakota.
Robin McGovern was a popular poster and button created
for the Oregon primary that strongly appealed to the Popu-
list elements in the Democratic Party that advocated for
more income equality and an increase in entitlements.

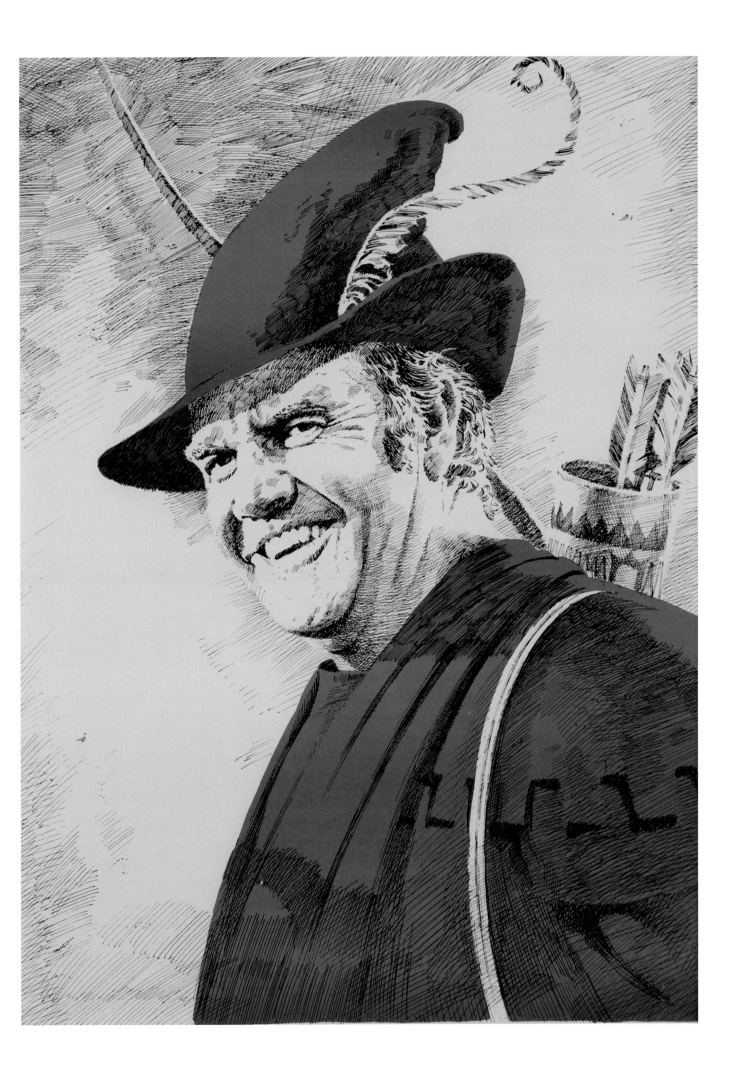

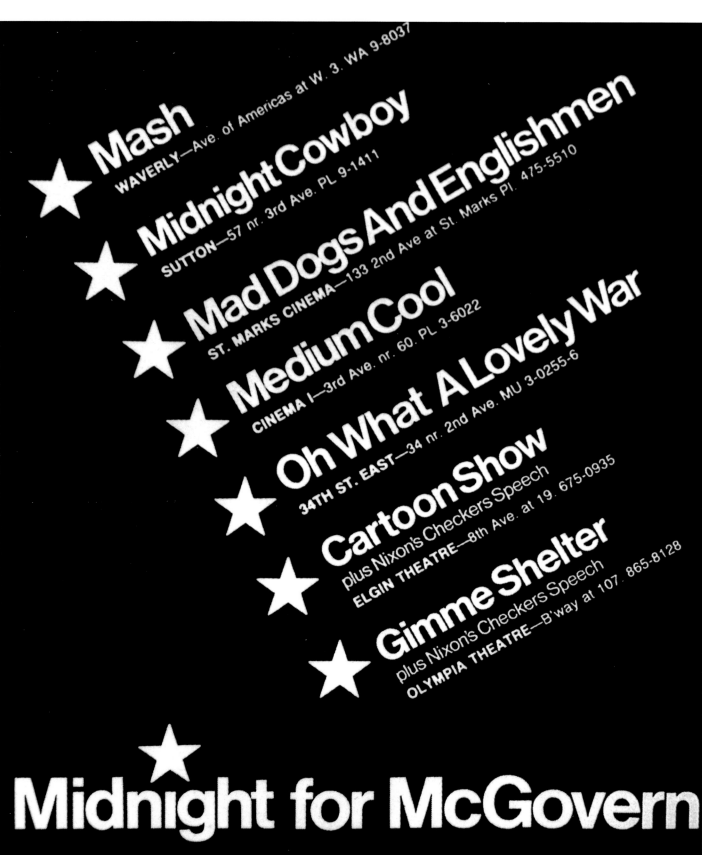

★ **Mash**
WAVERLY—Ave. of Americas at W. 3. WA 9-8037

★ **Midnight Cowboy**
SUTTON—57 nr. 3rd Ave. PL 9-1411

★ **Mad Dogs And Englishmen**
ST. MARKS CINEMA—133 2nd Ave at St. Marks Pl. 475-5510

★ **Medium Cool**
CINEMA I—3rd Ave. nr. 60. PL 3-6022

★ **Oh What A Lovely War**
34TH ST. EAST—34 nr. 2nd Ave. MU 3-0255-6

★ **Cartoon Show**
plus Nixon's Checkers Speech
ELGIN THEATRE—8th Ave. at 19. 675-0935

★ **Gimme Shelter**
plus Nixon's Checkers Speech
OLYMPIA THEATRE—B'way at 107. 865-8128

★

Midnight for McGovern
Film Festival Midnight Wed. October 25

Guest Star Host at each Theater Tickets available at theaters & local Democratic Headquarters

Admission $3 McGovern For President/Manhattan 59 East 43rd Street, New York, N.Y. 10017 972-1180

129. Unknown artist, 1972

23" × 14½", offset lithography
The Midnight for McGovern film festival,
held a few weeks before the election,
promised an unnamed guest star host at
each theater and a number of films with
an antiwar tilt.

130. Unknown artist, 1972

27" × 10¾", offset lithography
Rock stars, celebrities, and some of Holly-
wood's finest turned out in droves to play,
sing, and act as ushers at this gala rally
and fund-raising event at Madison Square
Garden. *Together for McGovern*, one of the
candidate's oft-used slogans, was printed
on various-hued rainbows and showed up
regularly on a variety of campaign literature,
buttons, stickers, patches, and posters.

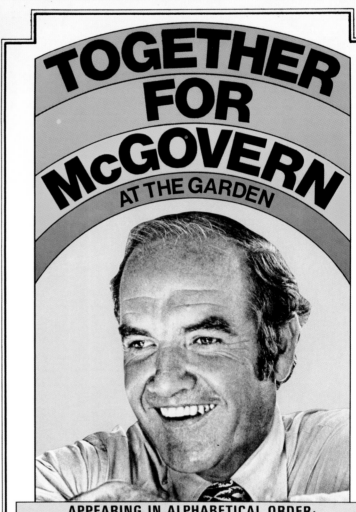

TOGETHER FOR McGOVERN
AT THE GARDEN

APPEARING IN ALPHABETICAL ORDER:

MIKE NICHOLS & ELAINE MAY
PETER, PAUL & MARY
SIMON & GARFUNKEL
DIONNE WARWICKE

WED., JUNE 14th AT 8 P.M.

SENATOR McGOVERN WILL BE THE *ONLY* SPEAKER

SEAT ESCORTS: WARREN BEATTY, JULIE CHRISTIE,
BETTE DAVIS, BEN GAZZARA, LEE GRANT, TAMMY GRIMES,
GENE HACKMAN, GOLDIE HAWN, DUSTIN HOFFMAN,
ROBERT HOOKS, JAMES EARL JONES, STACY KEACH,
SHIRLEY MACLAINE, PAUL NEWMAN, JACK NICHOLSON,
ROBERT PRESTON, JANICE RULE, DIANA SANDS,
JON VOIGHT, RAQUEL WELCH , AND MANY MORE.

GIANT COLOR PROJECTION BY JOSHUA TELEVISION

TICKETS: $5.00, $8.00, $15.00 , $25.00

AVAILABLE AT MADISON SQUARE GARDEN CENTER EIGHTH AVE. BOX OFFICE
ON SUNDAY, JUNE 4th. AND ALL TICKETRON OUTLETS. FOR IN-
FORMATION: 564-4400 OR TICKETRON: 644-4400. NO MAIL
ORDERS ACCEPTED AT MADISON SQUARE GARDEN.

SPECIAL TICKETS: $50.00 & $100.00

AVAILABLE ONLY AT McGOVERN FOR PRESIDENT HEADQUAR-
TERS OFFICE, 520 EIGHTH AVE., NEW YORK, N.Y. 10018. MAIL
ORDERS ACCEPTED, MAKE CHECKS PAYABLE TO: McGOVERN.

A copy of our report Filed with the appropriate supervisory officer is (or will be) available for purchase from the
Superintendent of Documents United States Government Printing Office, Washington, D.C. 20402. John W.
Branner, Treasurer.

madison square garden
Pennsylvania Plaza, 7th Ave., 31st to 33rd Sts.

A POLITICAL CABARET, AT THE DAISY, 326 NO. RODEO DRIVE, BEVERLY HILLS 274-8669 OPEN THURSDAY THRU SUNDAY 9PM ALL PROCEEDS TO McGOVERN FOR PRESIDENT

LABOR DONATED / DESIGN CONTRIBUTED BY KLEIN &

131. Unknown artist, 1972
25¼ × 16½", offset lithography
This hip Beverly Hills poster promotes Club George, a gathering spot for elite liberal supporters who listened to music, readings, and informal talks given by famous people about their lives and their work. Donated paintings and sculptures by well-known artists were for sale to help fund the campaign. Modeled on similar salon-like clubs established for Eugene McCarthy (fig. 44), these venues created a friendly environment for like-minded people that in turn prompted them to make significant contributions.

132. William Ehlert, 1972
13" × 16¾", offset lithography
Courtesy of the Center for the Study of Political Graphics.
The poster designed for a rally in Bakersfield, California, known as the southern gateway to the San Joaquin Valley, chose a photograph of McGovern taken on the prairies of South Dakota that suggested the designer understood the residents of Bakersfield and their problems. Rock concerts that attracted the newly enfranchised young voters were central to the McGovern campaign's strategy for success and were held throughout the country.

133. Dan Flavin, 1972
32" × 26⅜", offset lithography
Flavin's simple offset print in an edition of one thousand proved a popular fund-raiser during the campaign.

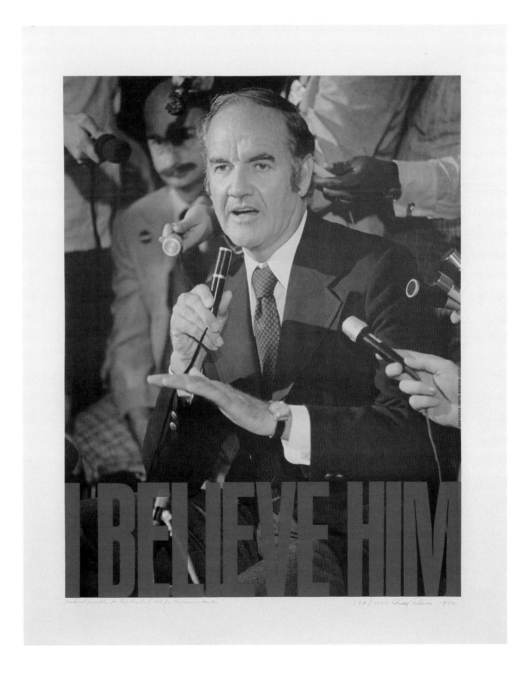

GOVERNMENT OF THE PEOPLE BY THE PEOPLE FOR THE PEOPLE

GEORGE McGOVERN

134. Unknown artist, 1972
36" × 24", offset lithography
Senator George McGovern Collection,
McGovern Library/DWU Archives, Dakota
Wesleyan University, Mitchell, South Dakota.
This well-designed poster references
Lincoln's Gettysburg Address and, of
course, by inference "promises" a new
birth of freedom.

135. John P. Carobus II, 1972
17" × 11", offset lithography
Illinois McGovern Week, May 21–28, was drawn in the California countercul-
ture comix style. Muskie had won the Illinois primary in March with over
62 percent of the vote, but by late May McGovern's nomination was all but
assured and the Illinois McGovernites were energized. This poster has a
mimeograph look, and mimeograph posters and leaflets were a way for
small political headquarters and local grassroots organization short of
money to produce campaign material. They were often well-designed and
proliferated throughout McGovern organizations nationwide.

ILLINOIS McGOVERN WEEK MAY 21-28

ART AUCTION

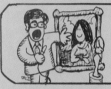

Works by . . .

Jules Feiffer, Jack Beal,
Peter Saul, and others

PREVIEW 1-3 P.M.
AUCTION BEGINS 3 P.M.

STEVE URRY STUDIO
2433 N. Lincoln
ADMISSION: $3

Sunday
May
21

STEVE GOODMAN CONCERT
TICKETS AT TICKETRON

Sunday
May
21

2 P.M.
ATHENAEUM THEATER
2936 N. Southport

$3.50 in advance -- $4.50 at the door

FEATURING --

Ed and Fred Holstein
& Lou Desio
MC: Ray Nordstrand

ADVENTURES IN JAZZ

SINGLES NITE ON RUSH STREET

with the ADVENTURES IN JAZZ ORCHESTRA

CORONA CAFE
501 N. Rush
DOORS OPEN 7 P.M.
$2

Tuesday
May
23

SECOND CITY GALA EVENING

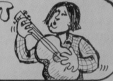

Wednesday
May
24

9 P.M.
1616 N. Wells
$10

SEE "43rd Parallel"

Hors d'oeuvres by Sage's East
Valuable Door Prizes

THE ISSUES AND McGOVERN'S ANSWERS

U. of C. PROFS DISCUSS CAMPAIGN ISSUES

8 P.M.
QUANTRELL AUDITORIUM
5826 S. Ellis

Thursday
May
25

PEOPLE'S PICNIC

Saturday
May
27

NOON - 3 P.M.
WASHINGTON PARK
55th and King Drive

BRING YOUR OWN BALLOONS,
BANNERS, FOOD
AND FRISBEES!

!!!!!!! FREE BEER !!!!!!!

BLUES NIGHT
TICKETS AT TICKETRON

SIEGEL-SCHWALL BAND
MIGHTY JOE YOUNG
JIMMY "Fast Fingers" DAWKINS
SUNNYLAND SLIM

7:30 P.M.
Highland Park H.S. -- AUDITORIUM
$3 in advance - $3.75 at the door

Sunday
May
28

THE SPECIAL McGOVERN PLANE TO CALIFORNIA

JOHN P. CAROBUS II

ILLINOIS McGOVERN WEEK EVENTS ARE ONLY A PRELUDE
TO AN ILLINOIS-CALIFORNIA AIRLIFT OF MONUMENTAL
DIMENSIONS. OUR CHARTERED AIRPLANE WILL LEAVE
O'HARE MAY 30 AND RETURN FROM L.A.
JUNE 7.

Meals and lodging on the trip
will be provided.

McGovern
72

Reservations and payment of the $115 fee
must be in our hands by May 26.

FOR INFORMATION CALL:

McGOVERN for President ★ 73 W Monroe St. ★ Chicago · 60603 ★ 263-6133

COME AND HEAR
A Major Address By
SENATOR GEORGE
McGOVERN

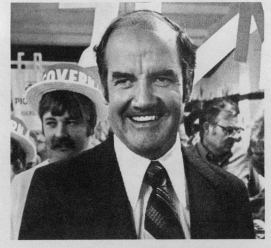

Centennial Room - Student Union

UNIVERSITY OF NEBRASKA

LINCOLN

Friday, October 1st

1:30 - 3:30 P.M.

(ADMISSION FREE)

SENATOR McGOVERN WILL GIVE A FIRST-HAND REPORT

ON HIS RECENT TRIP TO SOUTHEAST ASIA.

DON'T MISS THIS ONE!!

UNL Students for McGovern - Mary Kris Jensen, Patricia Humlicek

 76

136. Unknown artist, 1972
11" × 8½", offset lithography
McGovern won the Nebraska primary with
the support of Gov. Frank Morrison who
held off candidates Hubert Humphrey and
Scoop Jackson.

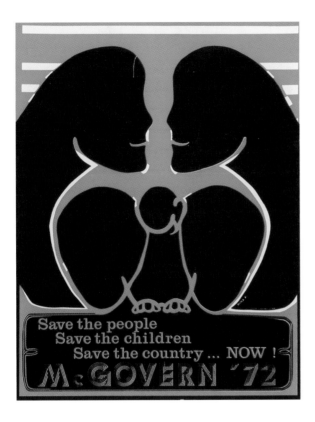

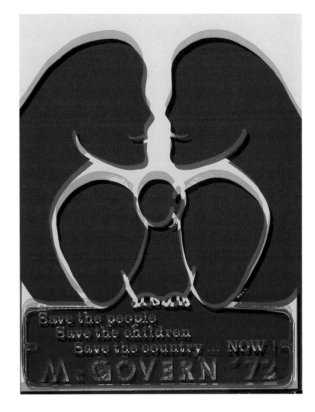

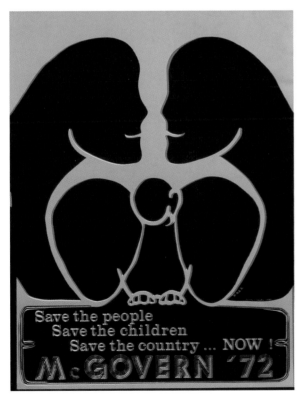

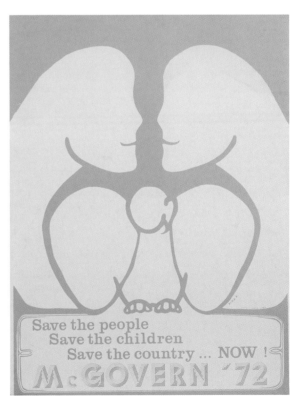

137. Unknown artist, 1972

22¾" × 17¼", screen print

One of a series of twelve screen print posters that were likely created by a Chicago college student either for the March 21 Illinois primary or for the fall general election. While a strange design with an art nouveau flavor, the vibrant colors are eye-catching.

138. Unknown artist, 1972

22¾" × 17¼", screen print

By moving the paper and creating overlap printing on some of the posters in the series, the artist achieves the illusion of depth in the lettering.

139. Unknown artist, 1972

22¾" × 17¼", screen print

It is quite possible that this series of posters was quickly pulled and dried in a McGovern headquarters much like the Lincoln, Nebraska, screen prints. Producing locally designed posters by local artists gave the McGovern campaign a sense of authenticity and direct democracy it so admired.

140. Unknown artist, 1972

22¾" × 17¼", screen print

A few of the prints in this series effectively minimized color use.

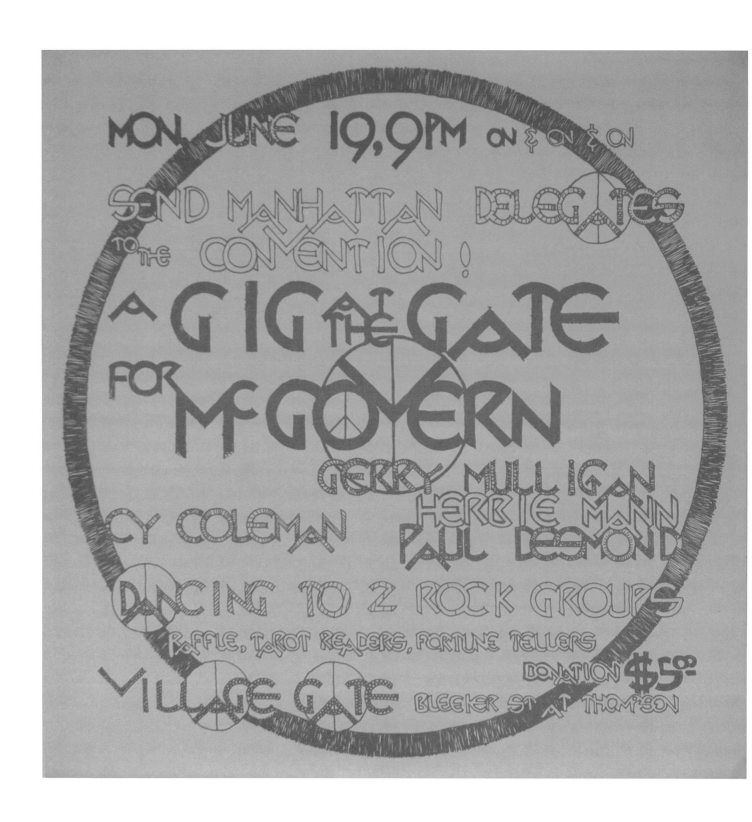

141. Unknown artist, 1972
21" × 21", offset lithography
A who's who of jazz musicians, *Gig at the Gate*
attempted to raise money with this hand-drawn poster
to send delegates to the national convention in Miami
by promoting the event that promised to go on and on.
While the peace symbols are an interesting part of the
poster's design, unfortunately it is hard to read.

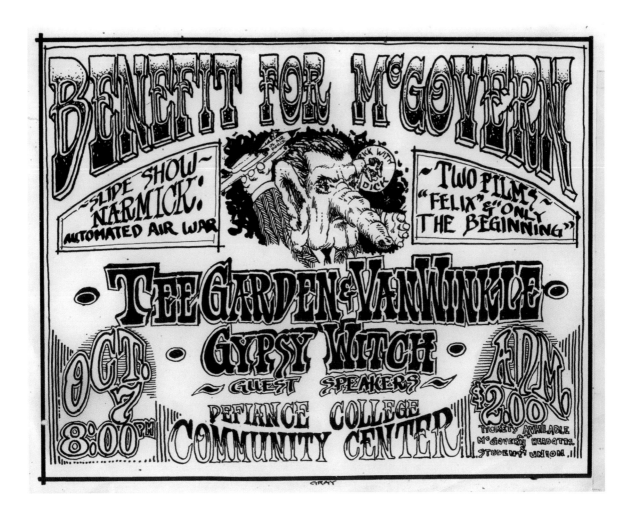

142. Gray, 1972

11" × 17", offset lithography

Courtesy of the Pilgrim Library, Defiance College.
Gray's hand-drawn cartoonish poster for the Defiance College benefit is in the California psychedelic style. His caricature of an elephant-nosed war-mongering Nixon is a good example of counterculture humor. Unfortunately nothing is known of the artist who may well have done many other posters for McGovern campaign events in Ohio. Gray's posters seldom surface, but the rarest is a small hand-lettered poster by an unknown promoter for Bruce Springsteen's benefit concert for McGovern in Red Bank, New Jersey. Likely one of a kind, it is written in red pencil.

143. Gray, 1972

17" × 11", offset lithography

A funky hand-drawn psychedelic-style gig poster announces a benefit for McGovern and attempts to garner support for the candidate in the small town of Bryan, Ohio.

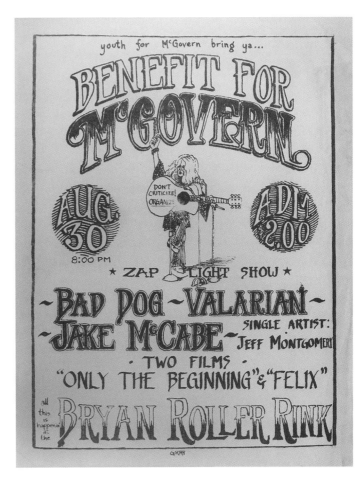

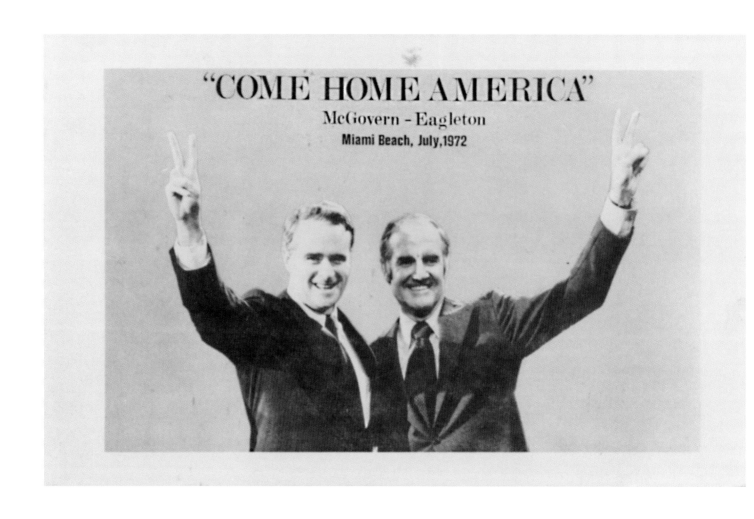

"COME HOME AMERICA"
McGovern - Eagleton
Miami Beach, July, 1972

144. Unknown artist, 1972

3½" × 5½", offset lithography

McGovern picked Missouri senator Tom Eagleton as his running mate after having been turned down by half a dozen others. This postcard, also a poster, pictures them holding up their arms in victory after the convention approved Eagleton's selection. No vetting occurred, and it was soon discovered that Eagleton had suffered psychological problems. McGovern at first stood by his choice, but as the pressure increased he asked Eagleton to step down. Eagleton had been on the ticket only eighteen days, but campaign posters, buttons, and bumper stickers had already been produced.

145. Unknown designer, Jerry Rudquist painting, 1972

22" × 14", offset lithography

Minneapolis was the site of this art auction to benefit candidate McGovern. This attractive poster in the more traditional international style features a painting by Jerry Rudquist, one of the premier artists in the Midwest, who taught for many years at Macalester College in St. Paul. Art auctions for McGovern occurred in many cities throughout the United States.

Paid for by McGovern for President / 4th District, St. Paul, Minn. 55103 ● William Sackett, Treasurer.

the art auction for the McGovern Campaign
October 28th, Saturday
One Hundred and Eighteen: An Art Gallery
1007 Harmon Place, Minneapolis

Preview 10 a.m. to 6 p.m. No Admission
Auction 8 p.m. to 11 p.m. $2.50 per person
For advance tickets call 222-7843.

McGovernART Auction

WHEN YOU TALK...
PEOPLE WILL LISTEN
WALK A PRECINCT
for
McGOVERN
come into any headquarters
right NOW!

CALIFORNIA STUDENTS FOR McGOVERN 3938 WILSHIRE BLVD. LOS ANGELES, CA 90010

146. Unknown designer, 1972
25" × 17¹³⁄₁₆", offset lithography
*Courtesy of the Center for the Study of
Political Graphics.*
A rather pedestrian poster, nevertheless it
incorporates the idea of making direct
contact with voters to answer questions
and to listen to concerns and aspirations.

147. Hudgeons Creek Farm, 1972
23" × 17", screen print; 17" × 11", variant screen print
This rare screen print appealing to the rural inhabitants of south-
ern Illinois, while restrained, still embodies the central elements of
the psychedelic poster in its use of color—red overlapping into
orange on the wheel of the tractor—and in the use of the decora-
tive symbols that add balance on either side of the word *for*. The
smaller variant employed a different font for the lettering,

McGOVERN
SHRIVER

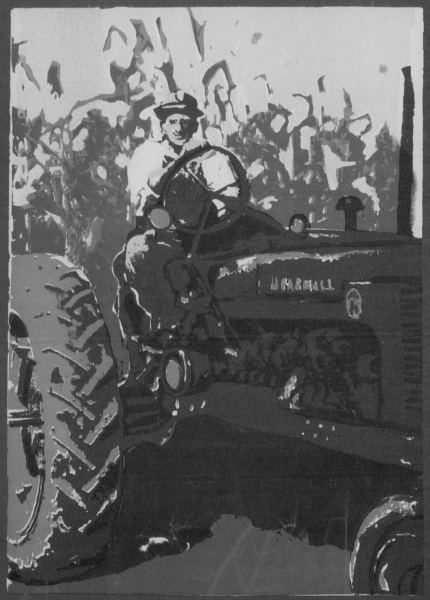

FOR
Southern ILLINOIS

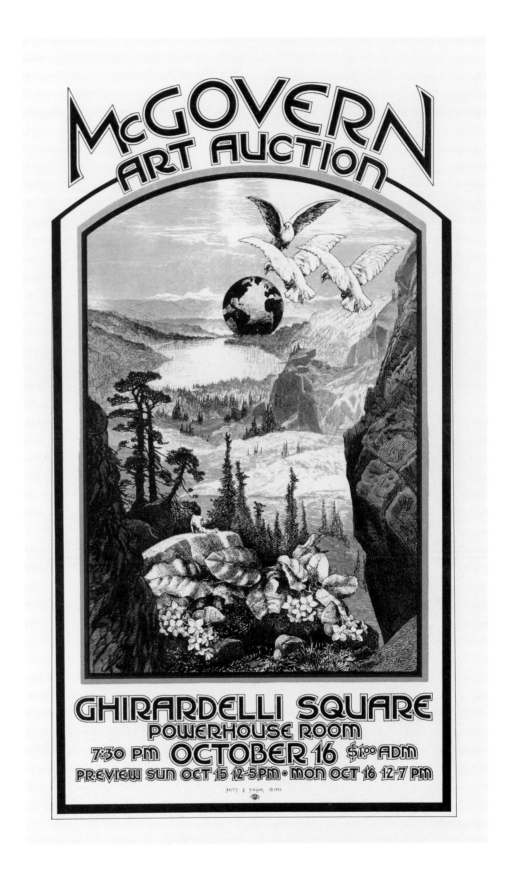

148. Ben Stein, 1972

20¼" × 15¹⁵/₁₆", screen print

Very little is known about this poster or the artist other than the information on the print, which graphically suggests all roads lead to McGovern. A print run of 375 of these signed, limited edition posters were sold to raise money for McGovern.

149. Wilfred Sätty (Wilfred Podreich) and David Singer, 1972

8⅜" × 5" and 27½" × 16½", offset lithography

The images in this handbill are typical of Sätty and Singer—art nouveau with a San Francisco twist. Wilfred Sätty's North Beach basement apartment, christened the U-boat, was a honeycombed mass of imagination; 2143 Powell Street was where "it was at." Nightly parties were all-night affairs that often

included Truman Capote, Michael Douglas, Jack Nicholson, Francis Ford Coppola, Grateful Dead band members, Wes Wilson, and German filmmakers Werner Herzog and Wim Wenders. U-boat Captain Sätty and First Mate David Singer, of Fillmore poster fame, whose art is often characterized by the bizarre and the beautiful-grotesque, here create a fantastical view of a utopian future. This San Francisco art auction was promoted with a poster as well.

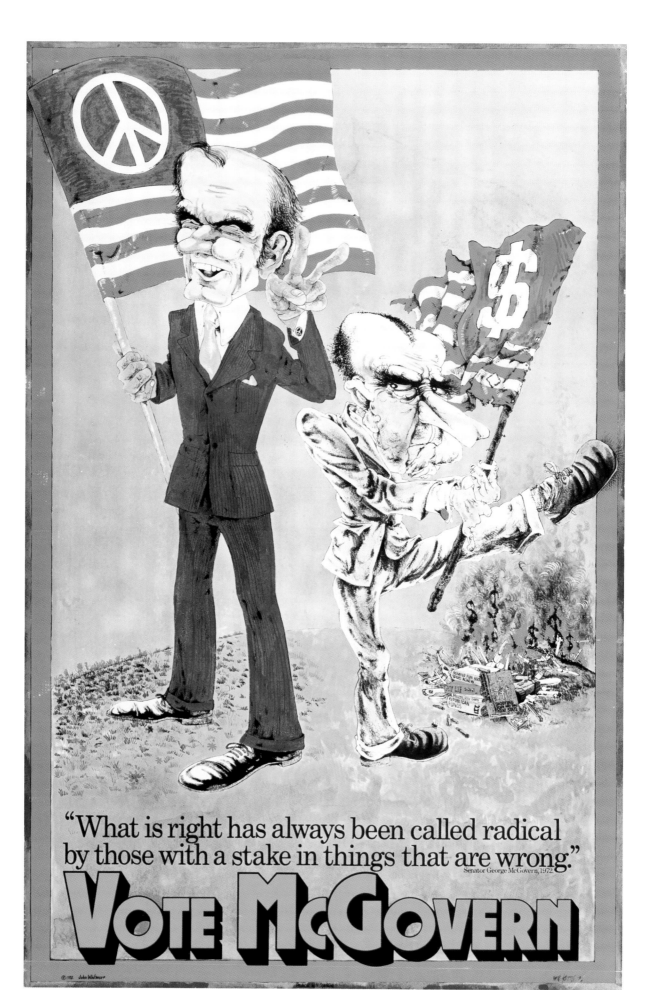

"What is right has always been called radical by those with a stake in things that are wrong."
Senator George McGovern, 1972

VOTE McGOVERN

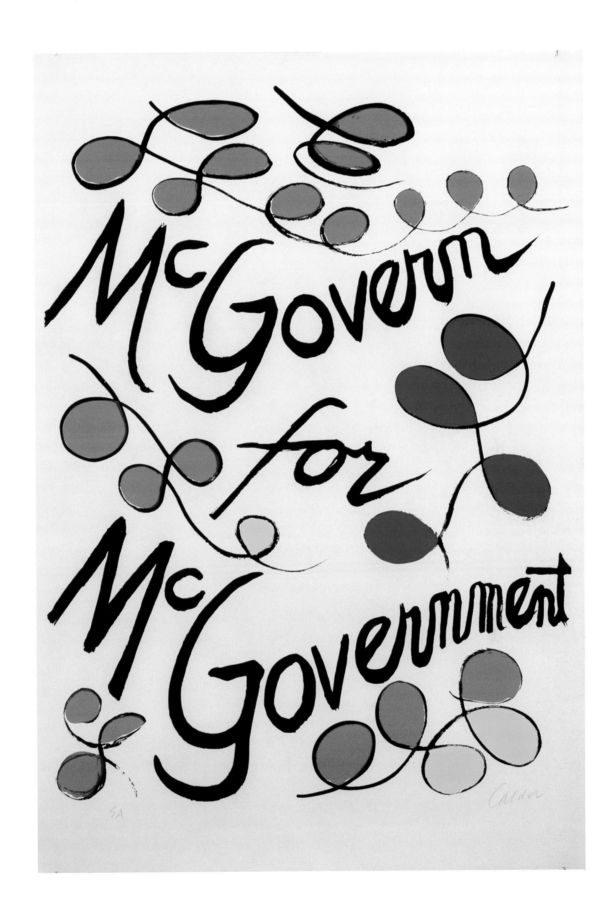

150. John Whitmore, 1972
29" × 19", offset lithography
John Whitmore's caricature of McGovern and Nixon was a widely distributed and popular poster among supporters.

151. Alexander Calder, 1972
34¾" × 23⅞", screen print
Alexander Calder, long a political activist, only briefly made posters for candidates, but for McGovern in 1972 he created five different prints whose total print run was 875. The slogan "McGovern for McGovernment" came from Calder's imagination; it caught on and ended up on a number of buttons and bumper stickers. The prestigious New York Styria Studio undertook the printing, and the edition of 200 is numbered, signed in pencil, and embossed with the Styria imprint.

Calder

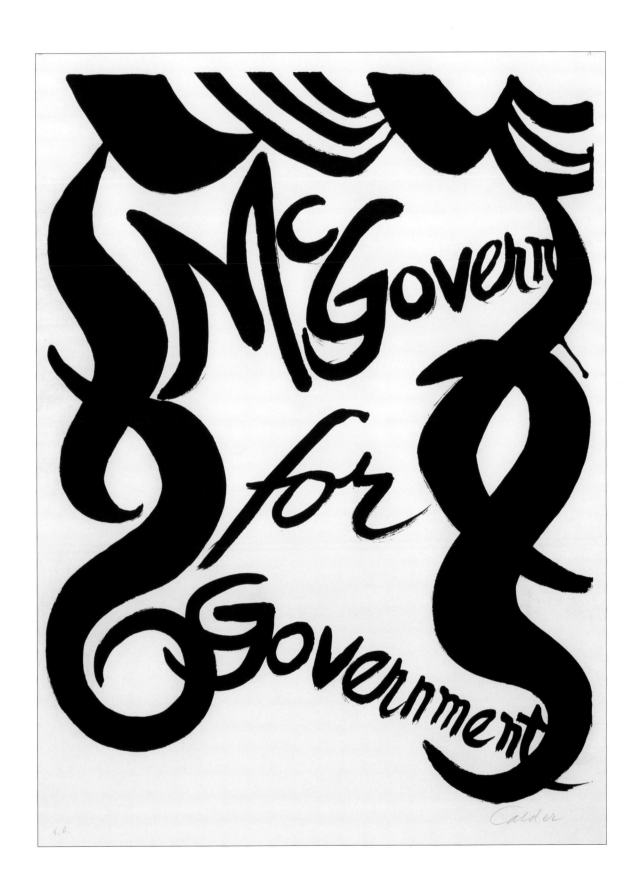

152. Alexander Calder, 1972

34½" × 24", screen print

This *McGovern* screen print was also in an edition of two hundred, signed in pencil, and printed at the Styria Studios. Artist's proofs, hand written in pencil in the lower left corner, were labeled *E.A.* as Calder used the French *epreuve d'artiste*. The artist's proofs are not numbered.

153. Alexander Calder, 1972

34¾" × 23⅞", screen print

Calder usually worked in bold colors, which makes this black-and-white *McGovern for Government* unusual. It was printed at Styria in a pencil-signed, numbered edition of two hundred. Styria Studio also produced prints for Alex Katz, Robert Rauschenberg, Larry Rivers, and Andy Warhol.

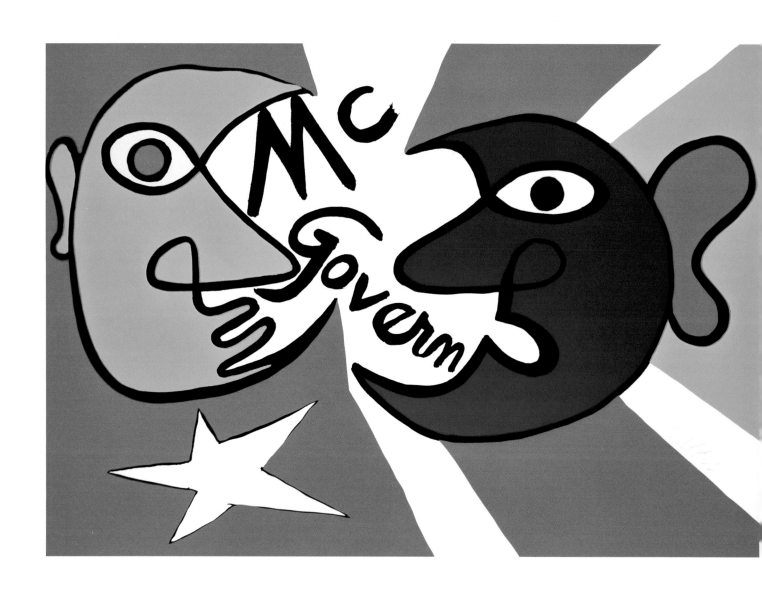

154. Alexander Calder, 1972
30" × 42", screen print
Calder had used this basic sun and moon dichotomous caricature in earlier prints, but he painted another version, altering the caricature and using different colors. This print's attractiveness lies not only in its bold use of color, but also its large size. The print is pencil signed and numbered in an edition of two hundred.

155. Alexander Calder, 1972
32" × 24", screen print
This Cubist-like, disassembled print was a far more limited pencil-signed and numbered edition of seventy-five and was not printed by Styria Studio. An unknown number of *E.A.*s of this scarce print exist. All five Calder prints were successful in raising money for McGovern and in garnering media attention due to the artist's fame. In 1974 Calder created his last political prints for candidate Abe Ribicoff's run for the U.S. Senate in Connecticut and for Toby Moffet's run for Congress in the same state. Calder died in 1976. Often a problem with political posters done by famous artists is that the art does not contain a political message, but for art aficionados and political junkies a chance to buy a signed, limited edition print for a few hundred bucks is irresistible.

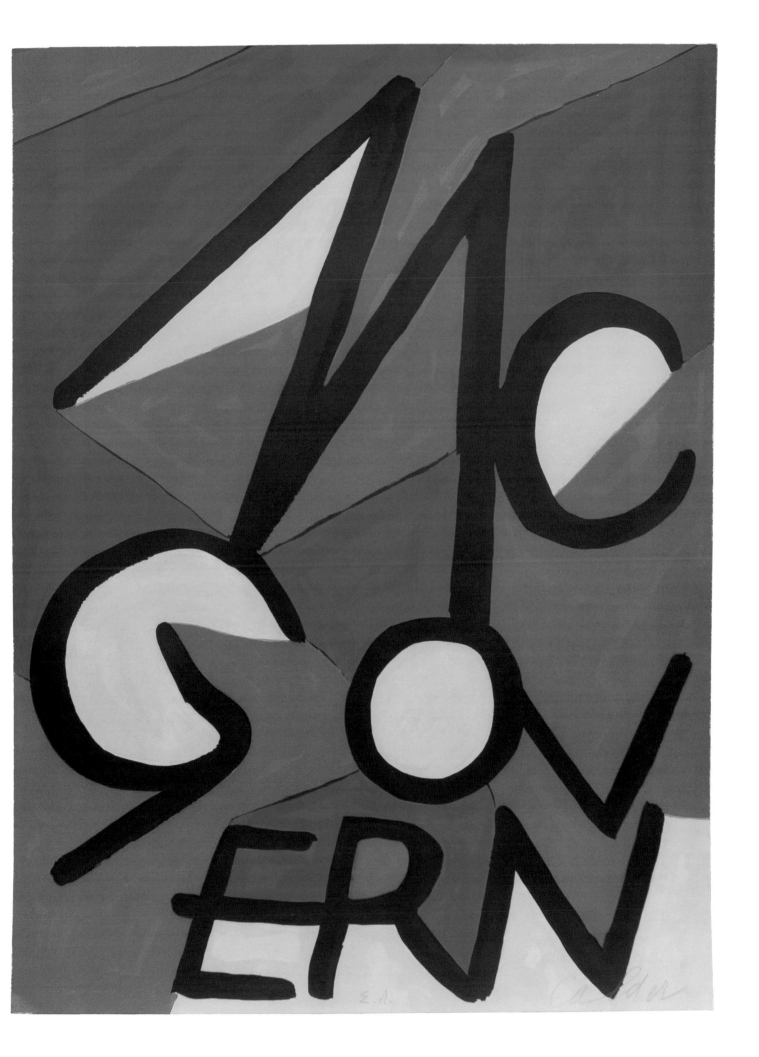

PEOPLE·BEFORE·PROFITS

GUS HALL
FOR PRESIDENT

ANGELA DAVIS
FOR VICE PRESIDENT

EQUALITY
IN SCHOOLS
HOUSING AND
JOBS
in a world of
PEACE

VOTE
ON
NOV. 4TH.

HVGO GELLERT

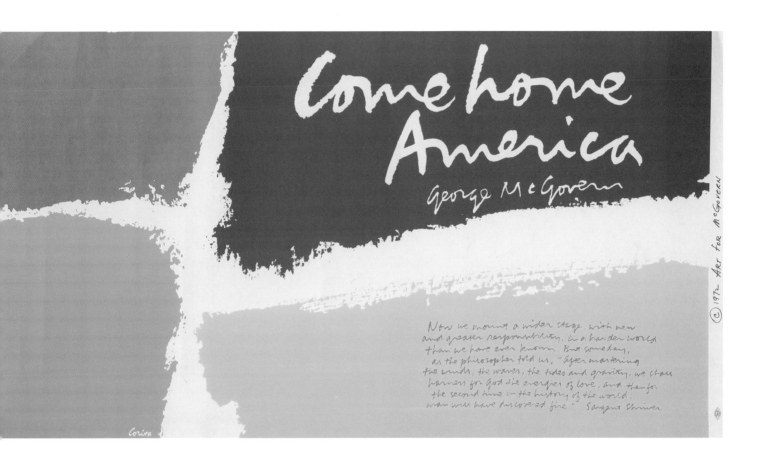

156. Hugo Gellert, 1980
39" × 25" and 24" × 22", offset lithography
Courtesy of Hake's Americana, Hakes.com.
Artists and musicians tend to float in and out of political campaigns depending on the candidate or the cause, but Hugo Gellert, like Ben Shahn, is the exception. Gellert's long career began in 1916 drawing and illustrating for *Elore,* the radical New York–based, Hungarian, Socialist newspaper, and wound down in 1980 when he created a final poster for the Communist Party USA. His 1924 poster for the Communist Workers Party was done in a Russian Constructivist style, but later his images softened as seen in this 1980 poster *People Before Profits.*

157. Mary Corita Kent, 1972
13¼" × 24½", offset lithography
Sister Corita, who turned out dozens of fine posters throughout this era in support of progressive and radical causes, produced a very popular signed, limited edition screen print and open offset edition poster using McGovern's campaign slogan "Come Home America," with a quote from Sargent Shriver. This poster was widely distributed by the McGovern campaign.

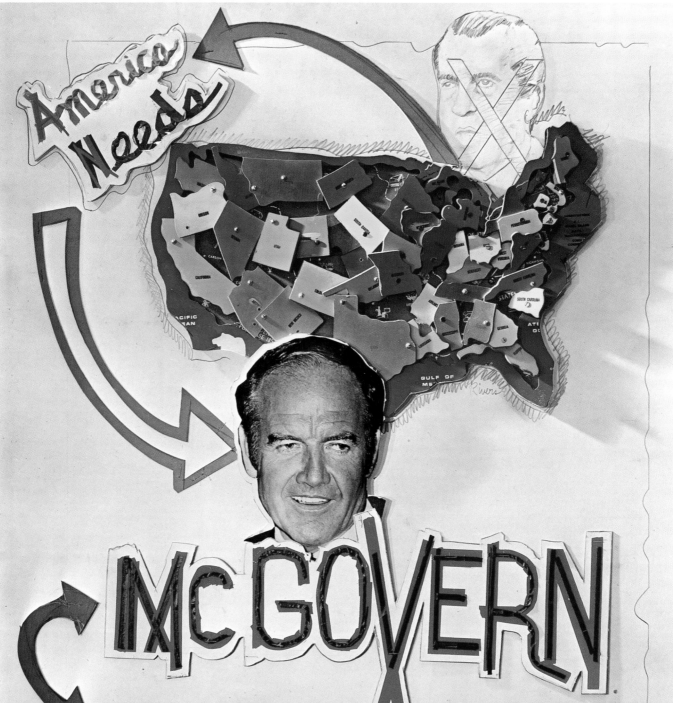

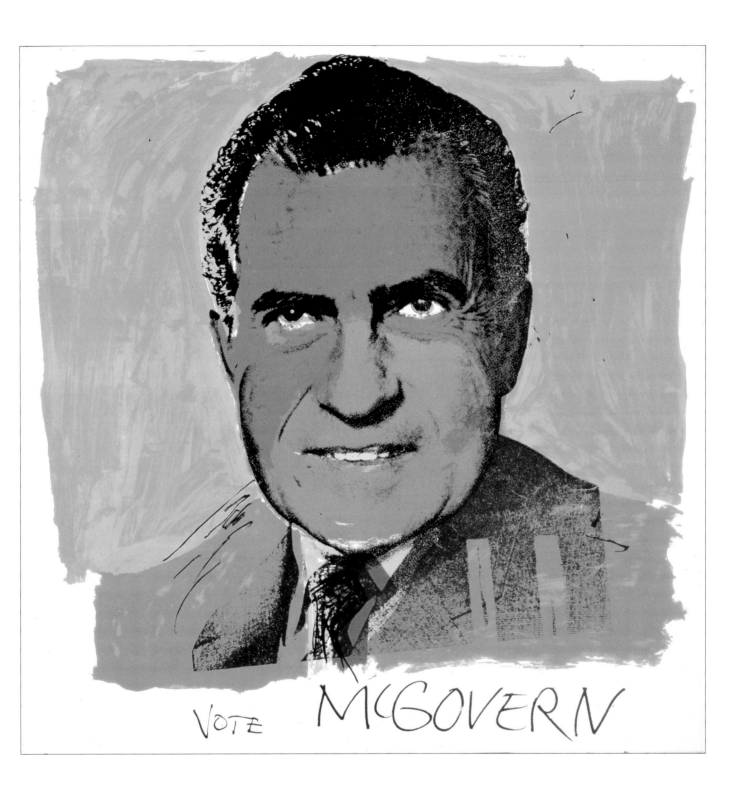

VOTE MCGOVERN

158. Larry Rivers, 1972

23" × 29¾", offset lithography

Larry Rivers's classic seventies avant-garde, pop art, pencil-signed, limited edition mixed media montage of one hundred was an instant hit among McGovernites as was the open offset edition that followed. The poster was extremely popular as it embraced a rebellious new style that mirrored the mood of many young people dedicated to the New Politics. The poster incorporated photography, radical variation of lettering, puzzle pieces, pencil sketches, and stencil. Rivers also signed an extremely rare set of thirty *hors commerce* (not for sale) that was likely given to McGovern to distribute to deep-pocket contributors. The number of artist's proofs remains unknown.

159. Andy Warhol, 1972

42" × 41¹³/₁₆", screen print

© 2014 *The Andy Warhol Foundation for the Visual Arts, Inc./Artist Rights Society (ARS), New York.*

A chromatic clash of color in a biting political satire, Andy Warhol's *Vote McGovern* pop art cliché is one of the finest political posters ever created, rivaled perhaps only by Ben Shahn's McCarthy peace dove (fig. 62). The print was published by Gemini G.E.L. of Los Angeles in a signed, limited edition screen print of 250 for an LA art auction for McGovern. The wicked demonic nature of the sickly green *schrecklich* image of Nixon has a Hieronymus Bosch touch. Jasper Johns used black, green, and orange in a similar way on his 1969 flag poster *Moratorium* (fig. 76).

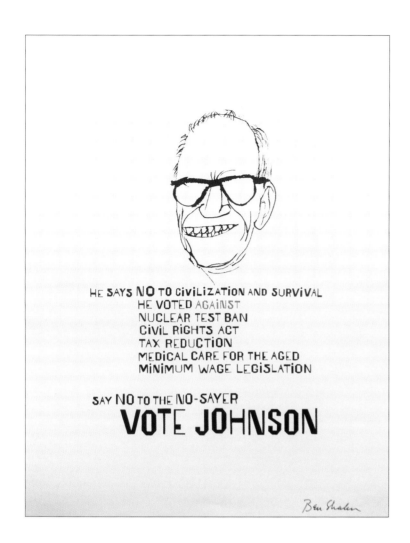

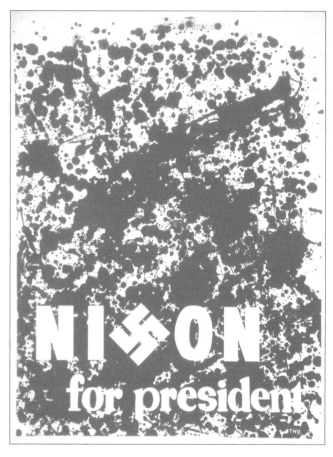

160. Ben Shahn, 1964
28" × 22", offset lithography
Art © Estate of Ben Shahn / Licensed by VAGA, New York NY.
Ben Shahn's fine 1964 poster negatively caricaturing Barry
Goldwater must have influenced Andy Warhol's 1972 *Vote
McGovern* poster (fig. 159). Shahn employed caricature and
drew cartoon-like figures in a simple style reminiscent of
children's drawings or those of the folk artist. A master of
visual communication, his eclectic illustrations and prints
are characterized by an original use of line and contrasting
colors carefully rendered.

161. Thomas W. Benton, 1972
26" × 20", screen print
Courtesy of Daniel Joseph Watkins.
This hard-hitting print titled *Bloody Nixon* by Aspen
printmaker Thomas W. Benton leaves nothing to
the imagination and goes directly for the jugular in the
tradition of the great German propagandist and master
of photomontage John Heartfield. Red is spattered
in Jackson Pollack–like fashion to great effect. While
the screen print is signed, Benton rarely numbered his
prints and the number produced is unknown.

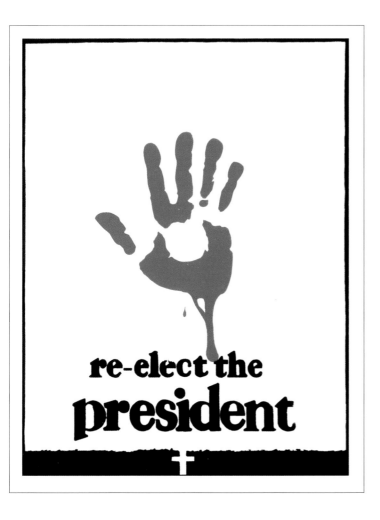

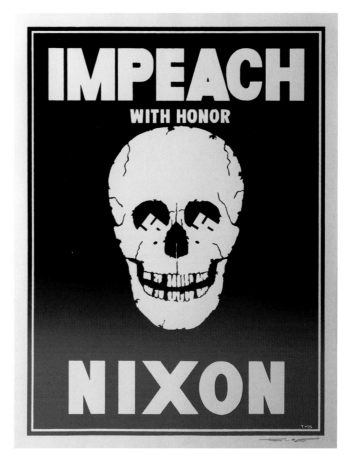

162. Thomas W. Benton, 1972

22" × 15", screen print

Courtesy of Daniel Joseph Watkins.

Benton and his friend and collaborator, Hunter S. Thompson, were enraged
activists who showed no mercy to Nixon and his escalation of bombing North
Vietnam. The bloody handprint had been used in the past by propaganda
poster makers, such as in famous World War I poster artist J. Allen St. John's
The Hun—his Mark, Blot it Out with Liberty Bonds, but here Benton also turns
Nixon's campaign slogan into an indictment. Many of Benton's in-the-gut Gonzo-
style posters were rarely seen outside Colorado's Roaring Fork Valley. For a
wide array of recently unearthed Benton posters, see Daniel Joseph Watkins,
Thomas W. Benton: Artist/Activist (Woody Creek CO: People's Press, 2011).

163. Thomas W. Benton, 1972

26" × 20", screen print

Courtesy of Joseph Daniel Watkins.

Impeach with Honor is another example of the in-
your-face Gonzo style that Thomas W. Benton
used in creating posters and Hunter S. Thompson
used in his writings. The freak power partnership
produced the famous *Thompson for Sheriff* poster
and the series of scurrilous Aspen Wall Posters.
The pair became a kind of Colorado agitprop unit
that took on all authority.

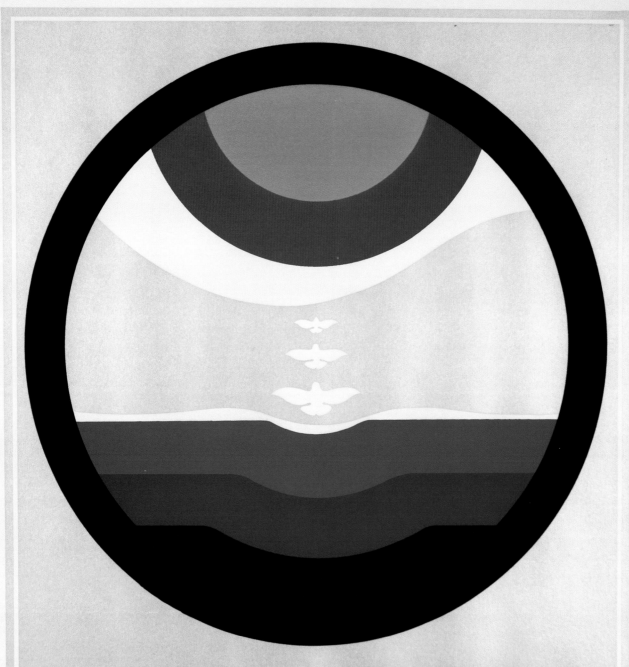

"we may not be able to change the past but we can help to shape the future."

MC GOVERN

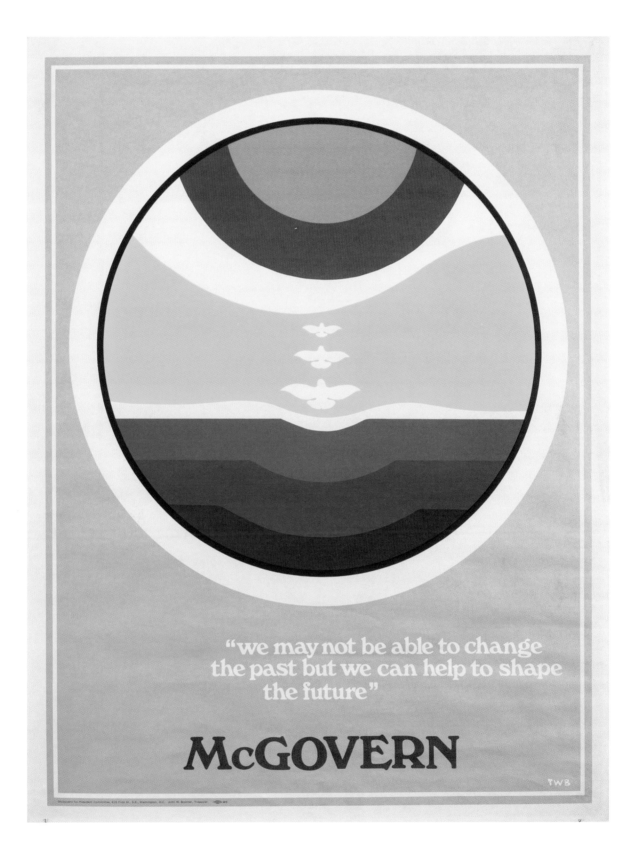

164. Thomas W. Benton, 1972

26" × 20", screen print

Courtesy of Joseph Daniel Watkins.

Gary Hart, a Coloradan and McGovern's campaign manager, likely commissioned Benton to create this signed, limited edition run of one hundred prints that were sold at the Washington DC headquarters for ten dollars. The run quickly sold out.

165. Thomas W. Benton, 1972

26" × 20", offset lithography

Due to the print's popularity, the McGovern camp ordered a large offset run but with a slight variation of the original color. The silver in the center of the circle was changed to yellow, and the poster was widely distributed. The original screen print for this altered design has been recently discovered.

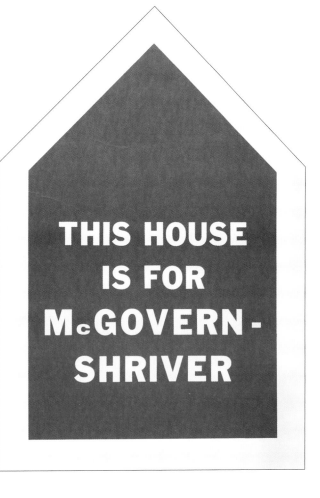

THIS HOUSE
IS FOR
McGOVERN -
SHRIVER

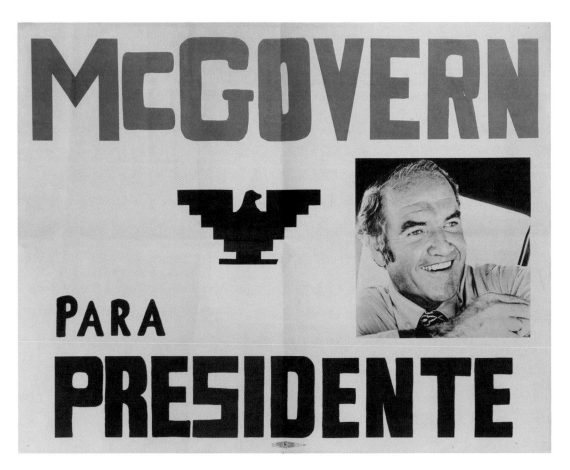

McGOVERN
PARA
PRESIDENTE

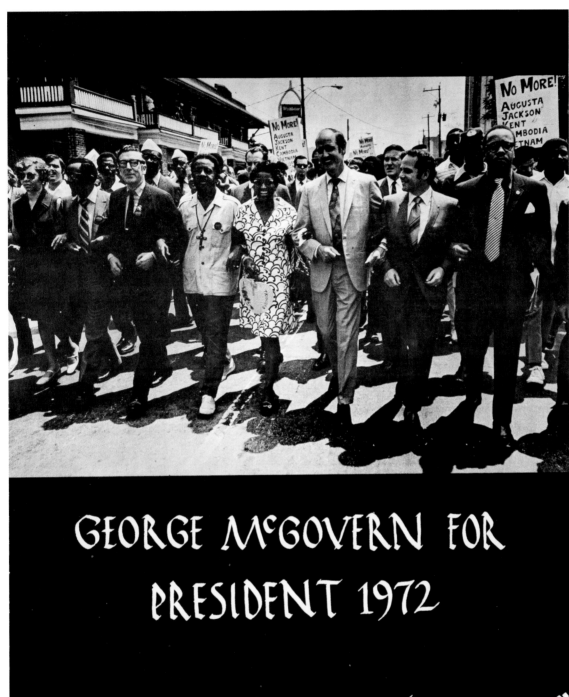

GEORGE McGOVERN FOR
PRESIDENT 1972

"THE CHARISMA OF CREDIBILITY"

166. Unknown artist, 1972

22½" × 15½", screen print

This uniquely cut, simple screen print uses a slogan with deep roots in past political campaigns. "This house is for" or "This home is for" window cards go back at least as far as Herbert Hoover's campaign for the presidency in 1928, and the slogan was popular in the Goldwater-LBJ contest in 1964.

167. Unknown artist, 1972

17¼" × 22¼", offset lithography

McGovern won the support of Cesar Chavez and the United Farm Workers of America. Importantly, they gave McGovern a bump in the California winner-takes-all primary. Since McGovern won the primary by only 4½ percentage points, Chavez's endorsement was a factor in the victory.

168. Unknown designer, Donald Rutledge photo, 1972

14" × 11", offset lithography

McGovern marched on numerous occasions for civil rights and used this photograph taken by the famous Black Star photo agency photographer Donald Rutledge on a poster and on this flyer.

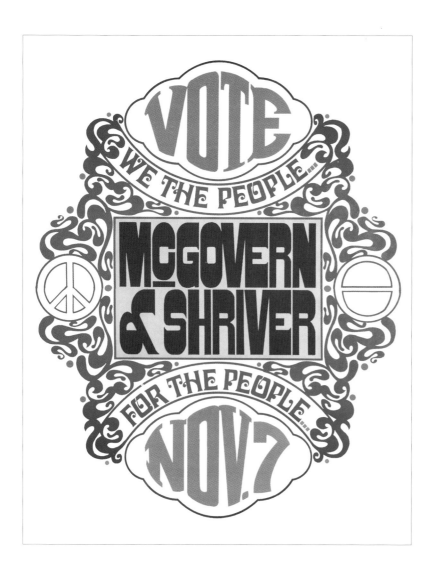

169. Unknown artist, 1972

21½" × 17", offset lithography
This psychedelic-style poster uses the peace sign on the left and the symbol for ecology on the right as well as giving a nod to the preamble to the U.S. Constitution.

170. Unknown artist, 1972

17" × 7⅛", offset lithography
A nationwide college teach-in on how to oppose the war and organize for McGovern occurred on October 25. The particular teach-in on this poster was scheduled for Kansas University in Lawrence, a campus that had witnessed several tension-filled years of antiwar protests and racial confrontations called Days of Rage.

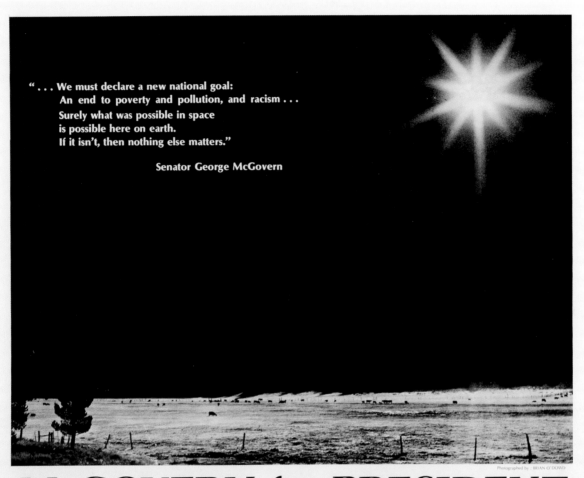

"... We must declare a new national goal:
An end to poverty and pollution, and racism ...
Surely what was possible in space
is possible here on earth.
If it isn't, then nothing else matters."

Senator George McGovern

Photographed by : BRIAN O'DOWD

McGOVERN for PRESIDENT

Published by: CALIFORNIA STUDENTS FOR McGOVERN

171. Unknown designer, Brian O'Dowd photo, 1972
17½" × 23", offset lithography
California Students for McGovern issued this
poster featuring a photograph of a tranquil, pasto-
ral setting to emphasize McGovern as the peace
candidate—a return to normalcy. Stopping the war
was important but so were the issues of poverty,
pollution, and racism.

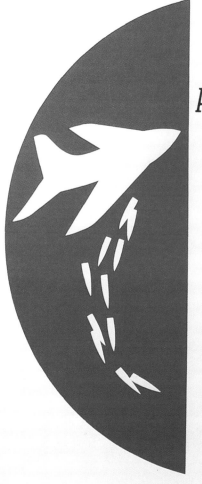

COME
HOME
AMERICA

McGOVERN

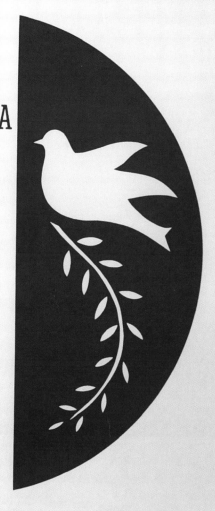

Come Home America!
George McGovern

B M Jackson
51/300

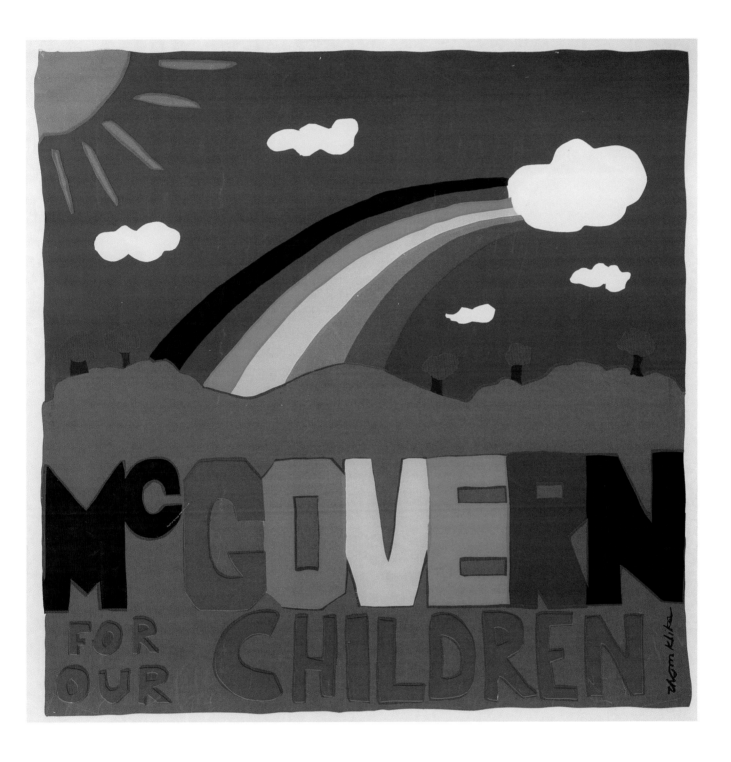

175. Thom Kilka, 1972

22½" × 22½", screen print

Outsiders and children were enshrined by the counterculture as having an authenticity and innocence not possessed by the rest of us. Thom Kilka, the Rainbow Man, captured in a spectrum of rainbow colors the deep yearning for a more idyllic, even childlike world, as opposed to the war-torn world in which we were living. Other artists, like Peter Max, tapped into this yeaning as did the Beatles in many of their songs like "Yellow Submarine," "Blackbird," and "Here Comes the Sun." Kilka spent his artistic career painting rainbows on canvases, clothing, and accessories and creating rainbow jewelry.

176. Paul Bacon and Paul Weller, Alix Nelson photo, 1972

38" × 25", offset lithography

This poster was first fabricated from an American flag and then photographed and printed on heavy stock. As the poster proved popular, it was printed on standard glossy poster paper as well. Paul Bacon created many innovative dust jacket illustrations and designed LP album covers for Riverside Records.

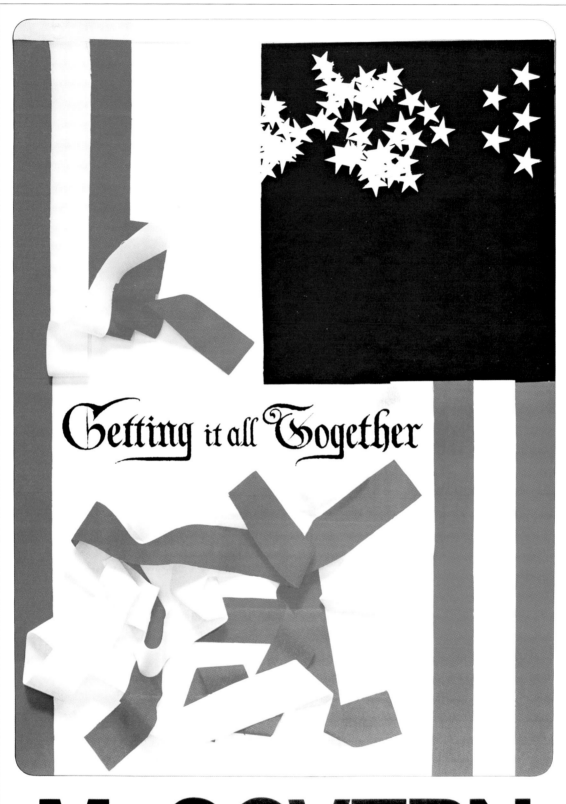

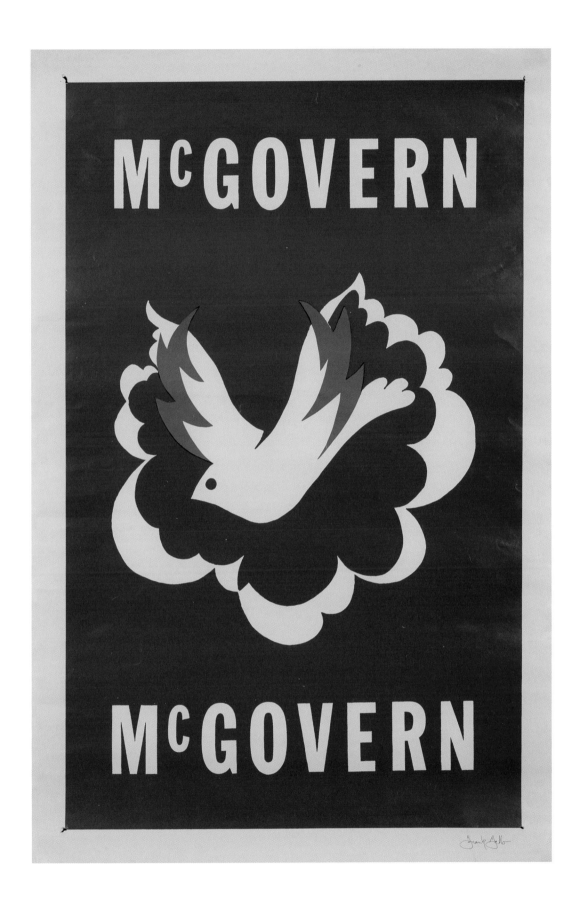

177. Frank Gallo, 1972

35¹⁄₁₆" × 16¾" and 25¹⁄₁₆" × 16¾", offset lithography

Frank Gallo, a sculpture professor at the University of Illinois and friend and colleague of Billy Morrow Jackson (fig. 172), designed this handsome poster in both a signed, unnumbered limited offset edition and in an open offset edition. The poster was printed in two sizes and also turned into highly prized campaign buttons.

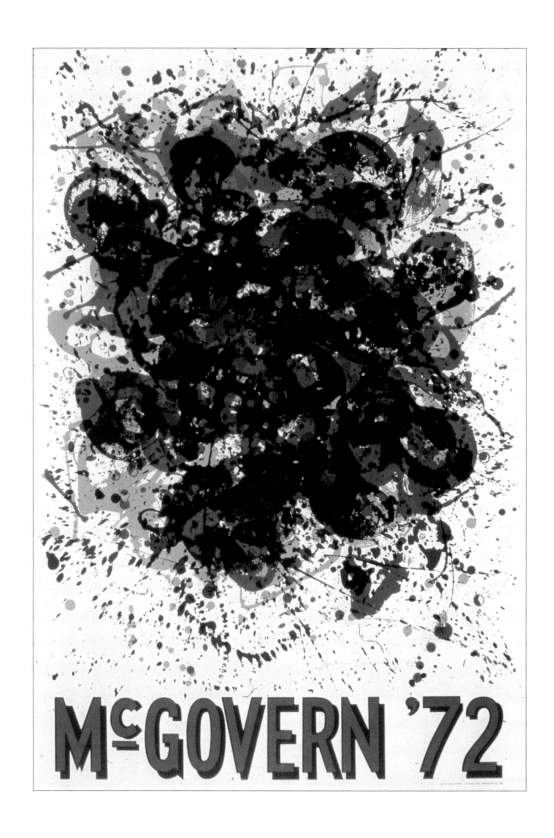

178. Sam Francis, 1972
38" × 25", offset lithography
Sam Francis's deep interest in color and
his splash-splatter method are clearly
on display in *McGovern '72* as is his use
of drop shading to make the candidate's
name stand out. The artist signed a
number of these posters in both red and
black ink.

179. Paul Davis, 1972
45" × 30", offset lithography
Paul Davis's *Together with McGovern* in a
neorealist social style is among the best of
the McGovern posters. Davis also created a
fine Che Guevara poster, an equally fine
poster for a benefit concert at Carnegie Hall
for Cesar Chavez and the California grape
workers, as well as several posters for Bill
Bradley's challenge to Al Gore for the Dem-

ocratic nomination in 2000. Davis, who grew
up in Oklahoma, received a scholarship to
the School of the Visual Arts in New York
City. After receiving his degree, he was
hired by Milton Glaser and Seymour Chwast
at Push Pin Studios. He has done hundreds
of illustrations for America's leading maga-
zines and books. *Together with McGovern*
recalls the popular paintings, prints, and
posters of Norman Rockwell.

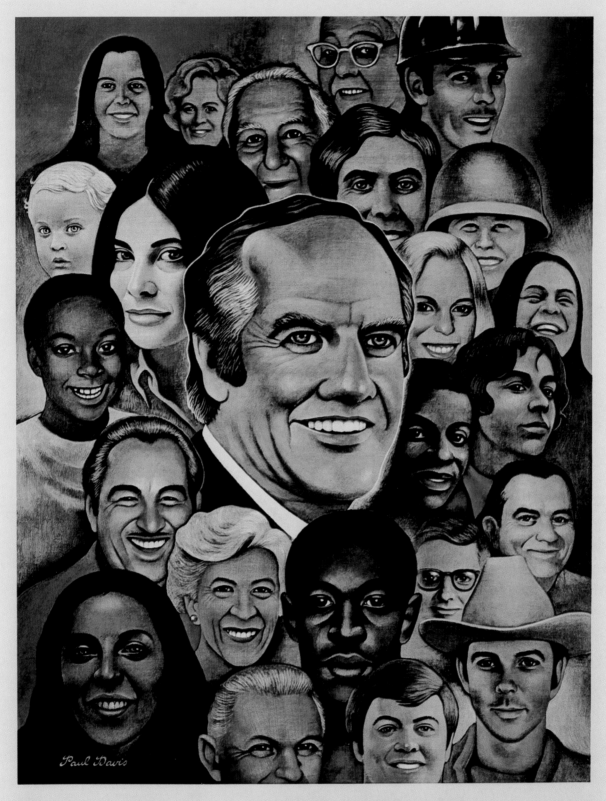

Together with McGovern

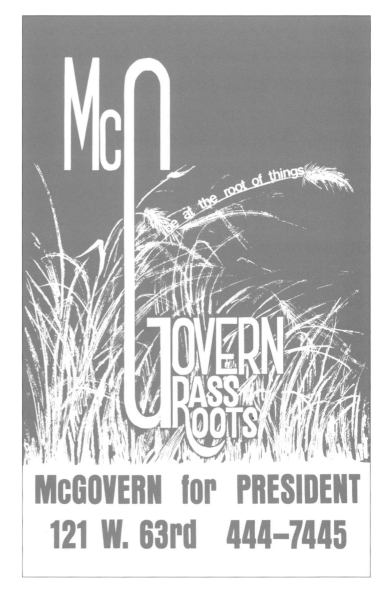

180. Unknown designer, 1972

14½" × 22½", offset lithography
McGovern's name was typed more than two
hundred times as the background for this
yard sign. Poster makers often use repeti-
tion to make their point as Mark Morris did
when he used the Mahatma Gandhi drawing
by Ben Shahn multiple times in his poster
for the Mobes (fig. 86) and as Peter Max
(figs. 83 and 280) has so often done.

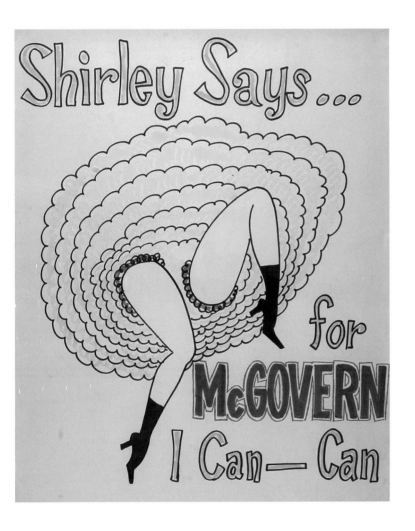

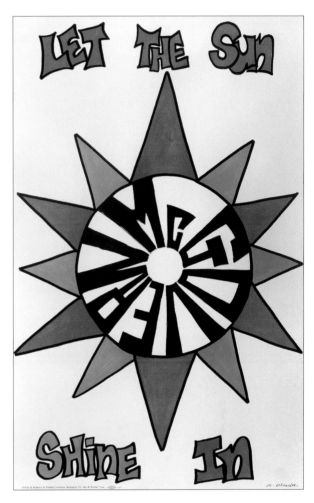

181. Unknown artist, 1972

22" × 14", offset lithography

This creative and very rare poster using prairie grass as a metaphor for heartland grassroots activism appeared in the Kansas City, Missouri, McGovern headquarters.

182. Unknown artist, 1972

29" × 23", screen print

Courtesy of Hake's Americana, Hakes.com.

This fun screen print poster very cleverly alludes to actress Shirley MacLaine's enthusiastic support of McGovern. She served as the editor for the senator's book, *McGovern: The Man and His Beliefs*. Supposedly she broke down in tears when learning of her candidate's lopsided loss. It's possible that the artist printed the outline of the letters and then colored them in by hand, a technique used by the Charlatans (fig. 10) and by psychedelic poster maker Wes Wilson (fig. 11).

183. N. Schneider, 1972

22" × 14", offset lithography

The McGovern committee printed six posters done by N. Schneider (first name unknown) in a laid-back, easy style in an effort to pull in the newly enfranchised voters, many of whom failed to register and vote.

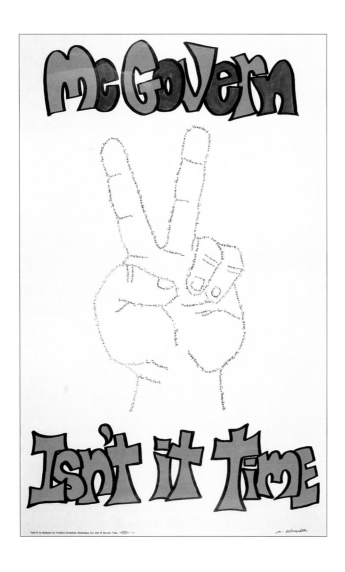

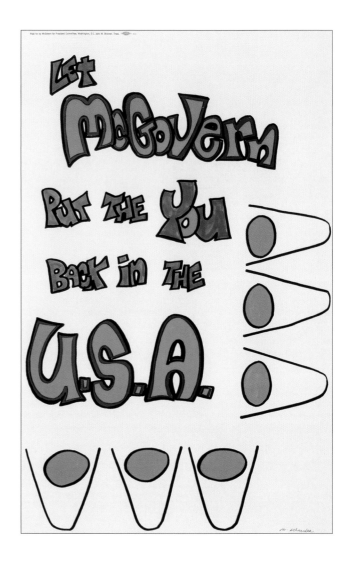

184. N. Schneider, 1972
22" × 14", offset lithography
Of all the Schneider designs, this one
is particularly interesting as the outline
of the hand flashing the peace sign
repeats the phrase "McGovern for
President."

185. N. Schneider, 1972
22" × 14", offset lithography
Put the You Back in the U.S.A. points out
to young voters their importance in
bringing about the change they desire.
The poster brings to mind the Obama
slogan, "We are the ones we've been
waiting for."

186. N. Schneider, 1972
22" × 14", offset lithography
This design has a Peter Max–like quality.

187. N. Schneider, 1972
22" × 14", offset lithography
The popular Schneider posters, all in
vibrant colors, communicate a youthful
hopefulness and enthusiasm for a better
world. A variant or misprint exists without
the color red in the wording.

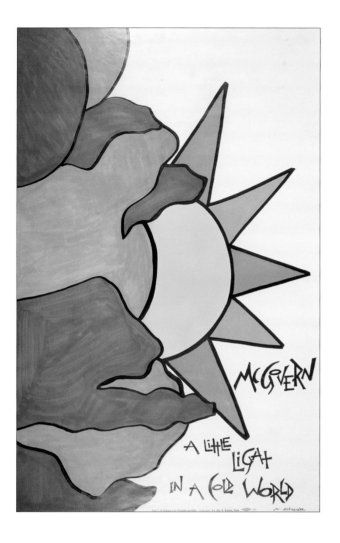

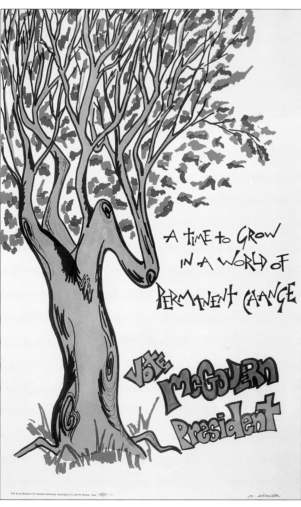

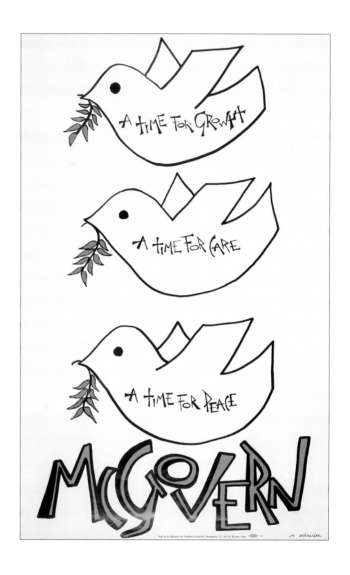

188. N. Schneider, 1972

22" × 14", offset lithography

The posters may not have been shipped as sets, and McGovern campaign committees may have been able to order any of the posters in desired quantities as currently some designs are much scarcer than others. This particular poster is difficult to find.

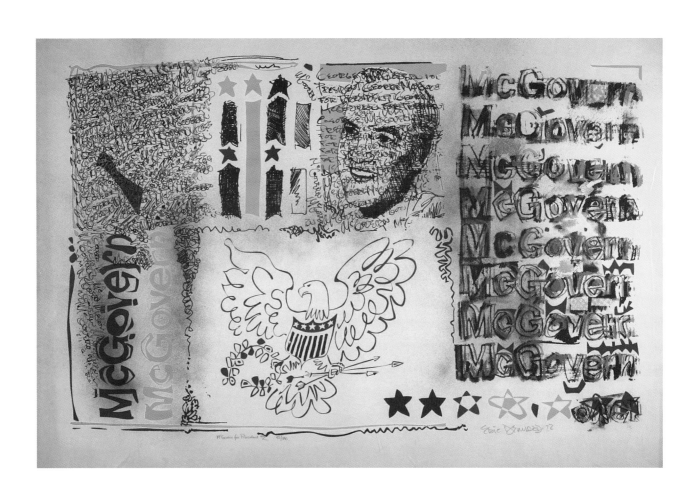

189. Eric Demord, 1972
26" × 40", screen print
Courtesy of Hake's Americana, Hakes.com.
Screen print number 2 in an edition of 180 is a fine
example of the painterly style. Very little is known
about this print, but being labeled number 2, an
elusive number 1 print has yet to emerge.

190. Unknown artist, 1972
28" × 21", offset lithography
The inclusion of newspaper and magazine clip-
pings along with the use of photos, an assort-
ment of cartoons, the flag, the Statue of Liberty,
the White House, and the Liberty Bell are typical
of counterculture collages from this period.

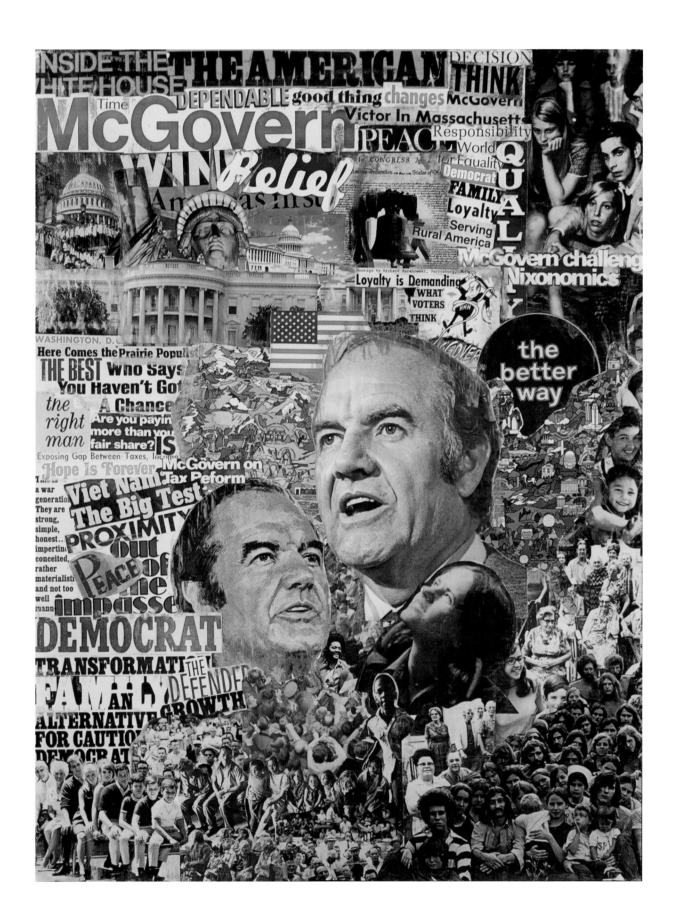

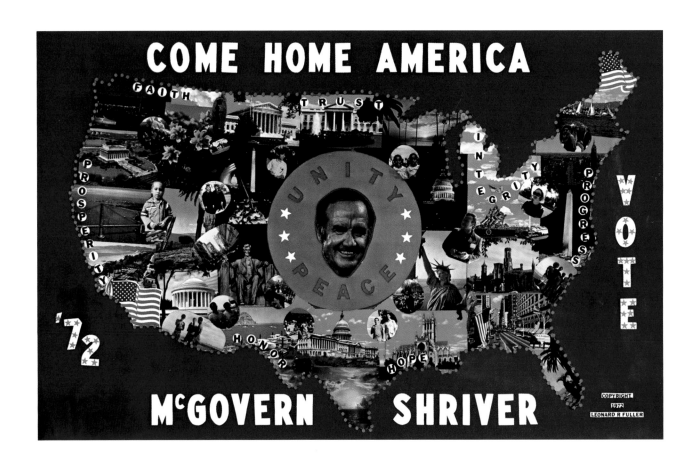

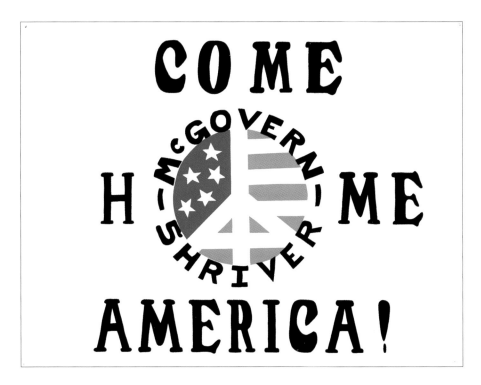

191. Leonard R. Fuller, 1972
21½" × 38", offset lithography
This photomontage has something for everybody. Curiously, the images placed within the various states are only on occasion landmarks that actually appear in those states. Still, the Leonard Fuller montage was popular and received a fairly wide distribution.

192. Unknown artist, 1972
20" × 26", stencil and spray paint
Come Home America is a fine example of hand-drawn and stencil posters that popped up in headquarters and at rallies. Often these grassroots posters were one of a kind, and on other occasions batches were made by copying the original.

DIG IT!

THE CONCERT THAT WILL
FEED VOLUNTEERS OF
AMERICA —
JOY OF COOKING
YOUNGBLOODS

SATURDAY — JUNE 3 8 PM

PEPPERLAND — SAN RAFAEL
TICKETS — TICKETRON OUTLE:

BENEFIT FOR SENATOR

GEORGE McGOVERN

ALL PROCEEDS TO FUND FEEDING
ARMY OF McGOVERN SUPPORTERS
WHO HAVE CONVERGED ON
CALIFORNIA TO GUARANTEE
HIS PRIMARY VICTORY

ALL TICKETS $3.50

LABOR DONATED

193. Unknown artist, 1972
8½" × 11", offset lithography
This unique, small poster was drawn for a concert to raise funds to feed young people who had poured into California to work for McGovern during primary season. The concert features two prominent bands, Joy of Cooking and Youngbloods, which suggests that a more professionally designed poster may have been created for this event. It is possible that the handbill and a poster were hastily drawn and printed to deal with an unforeseen contingency.

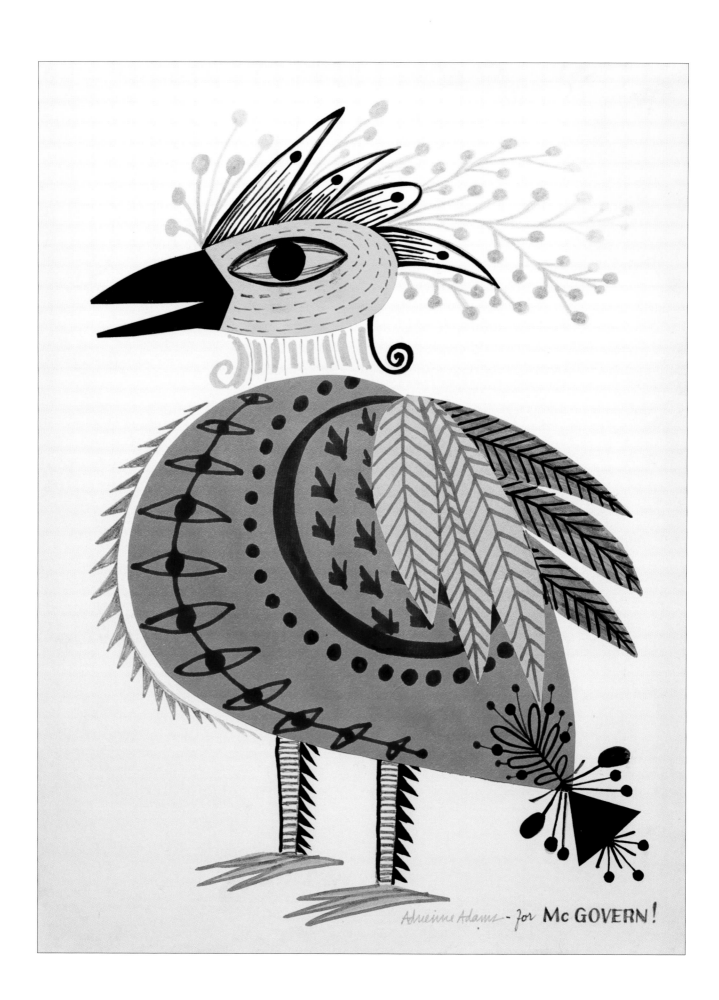

Adrienne Adams — for Mc GOVERN!

Official MᶜGOVERN FOR PRESIDENT Neighborhood Center

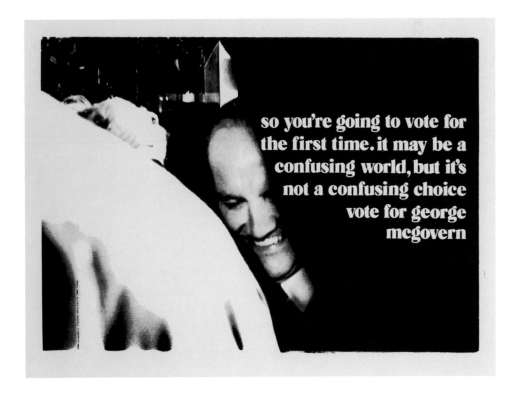

so you're going to vote for the first time. it may be a confusing world, but it's not a confusing choice vote for george mcgovern

194. Adrienne Adams, 1972
20" × 15", offset lithography
Senator George McGovern Collection, McGovern Library/DWU Archives, Dakota Wesleyan University, Mitchell, South Dakota. Renowned children's book illustrator Adrienne Adams won two Caldecott Medals for her drawings. Over the course of a long career she illustrated more than thirty books, including classic fairy tales by Hans Christian Andersen and the Brothers Grimm. The phoenix-like bird in this poster seems to promise to take flight for McGovern.

195. Unknown artist, 1972
22" × 14", offset lithography
These *Official Neighborhood Center* window cards were likely printed in very small runs. The location where these signs were used is unknown. The font used for "Official Neighborhood Center" appears hand written in blue and is thus warm, friendly, and inviting.

196. Unknown artist, 1972
22" × 30", screen print
Chicago McGovern supporters produced this handsome screen print along with several others. Establishment Democrats in the Windy City did not cotton to the candidate or to McGovern's criticism of the police riot in Grant Park at the 1968 Democratic convention. However, Mayor Daley reluctantly supported the McGovern-Shriver ticket and appeared with McGovern when he campaigned in Chicago.

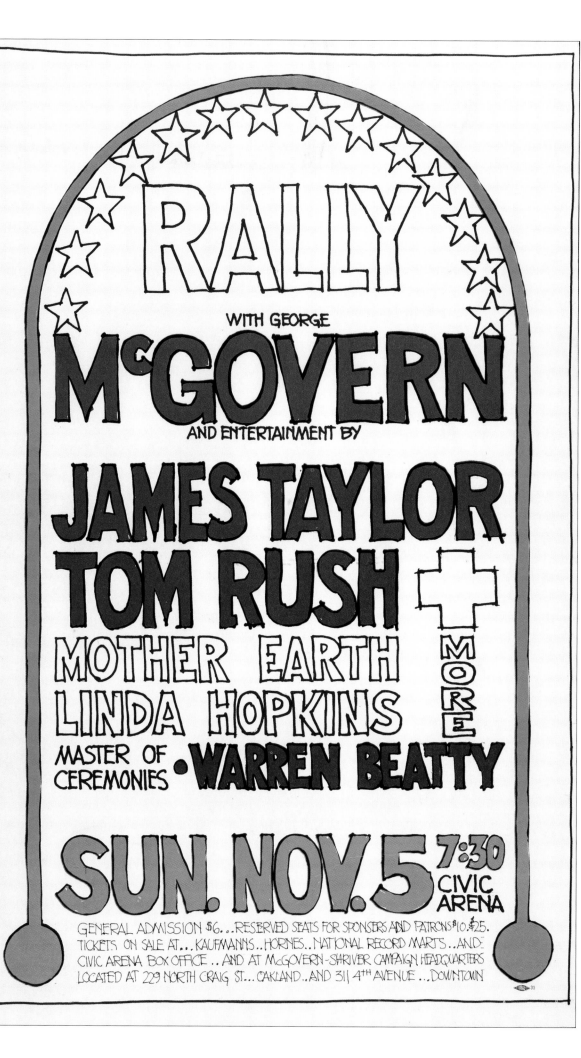

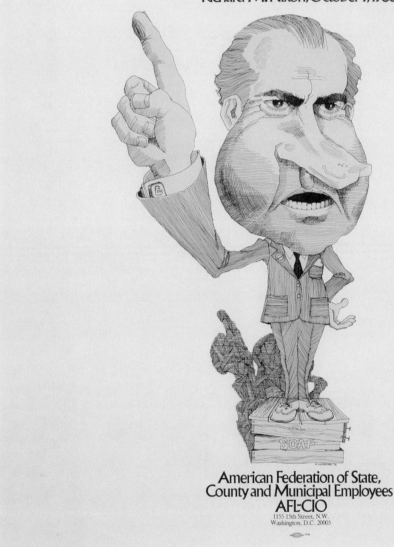

"Those who have had a chance for four years and could not produce peace should not be given another chance."

Richard M. Nixon, October 9, 1968

American Federation of State, County and Municipal Employees AFL-CIO
1155 15th Street, N.W.
Washington, D.C. 20005

197. Unknown artist, 1972

22" × 14", offset lithography

With the election but forty-eight hours away, San Francisco McGovernites made a last push effort for their candidate at the Civic Arena. A hand-drawn and hand-colored poster for an event of this magnitude with top-notch talent is very unusual.

198. Unknown artist, 1972

22" × 17", offset lithography

Widely distributed by the American Federation of State, County, and Municipal Employees, this poster caricaturizing Nixon was enthusiastically received and showed up in many McGovern headquarters.

"I stake my hopes in 1972 in large part on the energy, the wisdom and the conscience of young Americans."

McGovern

WORK
It's Your Campaign

VOTE
He's Your Candidate

CALL

Paid for by McGovern/Shriver '72
19 East Fifty Third Street
New York, New York 10022

E.C.L.146 Fifth Ave., N.Y.N.Y.

ABSENTEE BALLOT PROBLEMS? CALL ABOVE NUMBER.

McGovern
'72

for President
'72

MPP 831

McGOVERN for PRESIDENT
IF YOU <u>REALLY</u> WANT CHANGE

199. Unknown artist, 1972
26½" × 11¼", offset lithography
A New York poster, *Work Vote* was printed on a thicker paper to enable it to hold up when attached to telephone poles, light poles, and bus kiosks. McGovern won the June 20 New York primary after he had already secured enough delegates to win the nomination.

200. Unknown artist, 1972
42" × 28", offset lithography
This large, simple, and eye-pleasing poster was printed on cheap paper and produced for the general election in the state of California. Even larger versions were printed for campaign appearances.

201. Unknown artist
38" × 28", offset lithography
McGovern's winning smile is on display in this blue-tone offset poster of which little is known.

© NABIS FINE ARTS, INC. NEW YORK

McGOVERN
FOR PRESIDENT
1972

202. Marco Spalatin, 1972

38¾" × 27¾", offset lithography

The fascinating geometric cube representing a peace sign seems to be a Rubik's Cube, but by 1972 the Hungarian university professor had only developed a prototype. This cyber cube, by Croatian-born artist Marco Spalatin, is much larger, a figment of Spalatin's imagination. Representative of the abstract minimalist and conceptual art popular in the sixties and seventies, the construction is a mode reminiscent of the famous Hungarian artist Viktor Vasarely. Explaining his art, Spalatin says, "My work represents a continuous involvement with abstract geometric forms defined by careful manipulation of color and light." The poster was adapted from an earlier screen print and was hard at work for McGovern in the all-important Wisconsin primary.

203. Unknown artist, 1972

29" × 23" and 16¾" × 13", offset lithography

This New York poster picturing McGovern in a winter coat was printed in two sizes and featured the candidate as "a man of reason and compassion" who stands for "peace and honesty." This simple poster was used throughout the fall campaign.

For peace
and honesty.

MCGOVERN FOR PRESIDENT
605 Fifth Avenue
New York, N.Y. 10017

McGovern for President

A man of reason and compassion.

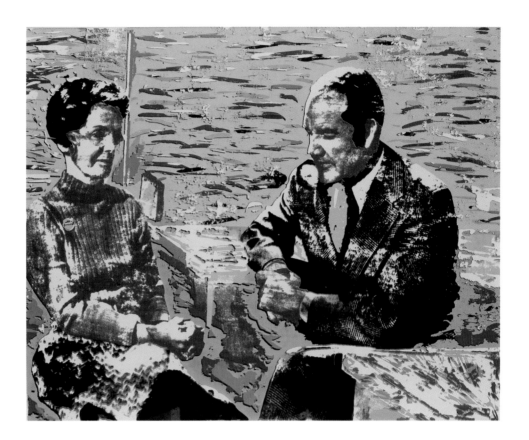

204. Poster Factory, 1972
22½" × 17½", offset lithography
This very attractive poster differs from the majority of McGovern posters in that it stresses ecology as a mainstream campaign issue. This poster, created at a Minneapolis poster workshop, was printed in several sizes.

205. Gary N. Murphy, 1972
20" × 24", screen print
Senator George McGovern Collection, McGovern Library/DWU Archives, Dakota Wesleyan University, Mitchell, South Dakota.
Gary Murphy used a photo of McGovern and his wife, Eleanor, to create this painterly montage that is not signed or numbered. Little is known about the artist.

206. Gary N. Murphy, 1972
22" × 26½", screen print
Senator George McGovern Collection, McGovern Library/DWU Archives, Dakota Wesleyan University, Mitchell, South Dakota.
Printed in a signed, limited edition of nineteen, another painterly montage screen print, number thirteen, was inscribed "To my friend George."

a time for Peace

a time for Growth

a time for Care.

McGovern
SHRIVER
'72

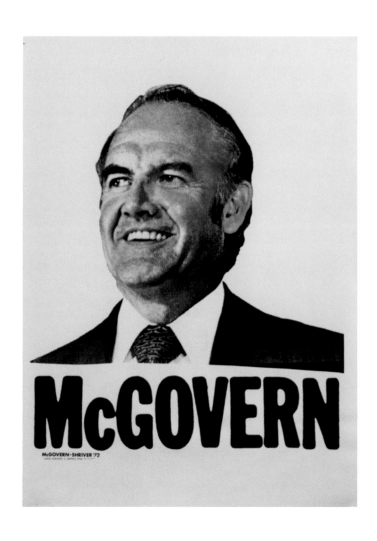

207. Unknown artist, 1972
22½" × 17½", offset lithography
A fine counterculture-style poster from the Santa Barbara area, the design is reminiscent of the peace dove poster created by N. Schneider (fig. 188).

208. Unknown artist, 1972
32" × 22", screen print
Another of several Chicago-area McGovern screen prints that portrays the candidate as friendly and accessible. The poster was also printed in yellow and perhaps other colors as well.

209. Unknown artist, 1972
6⅜" × 11", offset lithography
This small window card was printed with a coating to withstand the elements. You could nail it to a tree in your front yard in September with some assurance that it would last until Election Day.

McGovern

210. Unknown artist, 1972
22" × 14", offset lithography
No office sought or date is listed on this workhorse poster that simply posited a political solution to America's problems—*McGovern*.

211. Unknown artist, 1972
14¼" × 11", offset lithography
Gloria Steinem supported Shirley Chisholm up through the '72 convention and was at first reluctant to campaign for McGovern, although she had been one of his biggest contributors in his short '68 run for the presidency and called him "The real Gene McCarthy." Once onboard, she made appearances for the senator and worked hard for his election. The McGovern event pitched on the poster was at the well-known club Your Fathers Mustache in Greenwich Village.

oct. 4

McGovern
FOR PRESIDENT
PARTY

Come and meet
Gloria Steinem
at

YOUR FATHERS
MUSTACHE

7th Ave. and 10th St. 5:00-9:00

Buffet + Banjo Band Contrib. 2.00

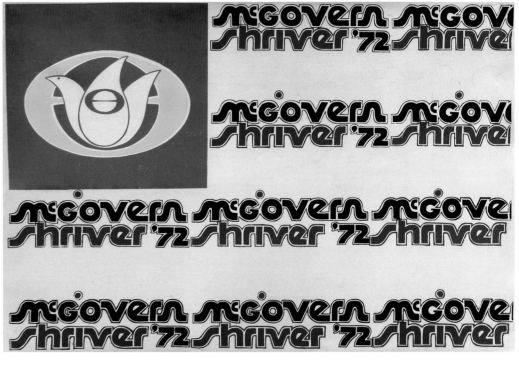

**END THE WAR
M^cGovern Rally
Oct. 9**

"Those who have had a chance for four years and could not produce peace should not be given another chance."

Richard Nixon
Oct. 9, 1968

Al Lowenstein

Joe Duffy

Hank Parker

OLD CAMPUS **4 P.M.**

Sponsored by Yale Students for M^cGovern

212. Gil Stratton, 1972
24" × 18", screen print
Senator George McGovern Collection, McGovern Library/DWU Archives, Dakota Wesleyan University, Mitchell, South Dakota.
The artist screen printed only ten of these signed posters. Little is known about the artist or the circumstances surrounding the print.

213. Unknown artist, 1972
23" × 35", stencil and spray paint
Takeoffs on the American flag are quite common in propaganda art. The use of the ecology symbol and the dove to replace the stars and the blue/red McGovern-Shriver to replace the stripes is an innovative technique on this spray-paint stencil poster.

214. Unknown artist, 1972
16¼" × 11", offset lithography
Less than a month before the election, the nationwide rallies that occurred on October 9 were a big push for McGovern. New Yorker Allard Lowenstein, an antiwar and civil rights activist, had supported Eugene McCarthy in '68, won a seat in Congress in '70, and supported McGovern in '72. He lost, along with McGovern, and served only one term in the House of Representatives.

PUBLIC RALLY !
Sen. McGovern
with Sen. Kennedy

Thurs.
12:oo noon
Sept. 14th

on the
Capitol steps

TO VOLUNTEER FOR McGOVERN CALL 463-3113 IN ALBANY.

LABOR DONATED

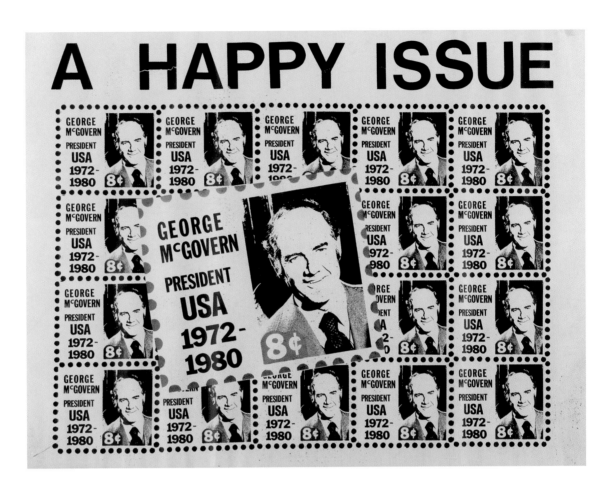

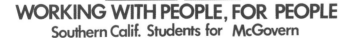

215. Unknown artist, 1972
22¼" × 17", offset lithography
McGovern wanted Ted Kennedy as his running mate and was disappointed to be told no. Kennedy did campaign for McGovern and they appeared together at this rally in Albany, New York.

216. Unknown artist, 1972
23" × 29", offset lithography
This large, cheap offset poster featuring the antiwar candidate McGovern as Uncle Sam is an ironic takeoff on James Montgomery Flagg's famous World War I poster, *I Want You for U.S. Army.*

217. Unknown artist, 1972
20" × 26", offset lithography
Senator George McGovern Collection, McGovern Library / DWU Archives, Dakota Wesleyan University, Mitchell, South Dakota.
An engaging poster, *A Happy Issue* placed McGovern on a U.S. stamp and projected a two-term president and presidential success.

SAVING LIVES IS MORE IMPORTANT THAN SAVING FACE

McGovern was against the war long before it was fashionable. He called for a halt in Sept. of 1963. And he hasn't changed his mind. He stands for an immediate, mutual ceasefire. For a fixed date of withdrawal. And the immediate release of all our prisoners of war.

THE BIG JOB IS TO GUARANTEE A JOB FOR EVERYONE.

High unemployment must stop. McGovern is pledged to providing for everyone. Three million new jobs at a subprofessional level through federal contracting in housing, schools, public transit and environmental protection. Income support for those out of work as result of decreases in military spending and cutbacks in aerospace.

HEALTH CARE FOR POOR AND RURAL PEOPLE CAN NO LONGER BE SICKENING.

It is essential to train qualified minority group members for a place in medicine, to expand care for the isolated, to improve care of the mentally handicapped. And there has to be federal aid in family planning.

IT'S TIME TO REALLY HOLD OPEN THE DOORS FOR WOMEN.

The disenfranchisement of women in higher levels of business, industry and government is going to be over. McGovern will personally appoint women to the Supreme Court, the United Nations, the National Security Council and to his own Cabinet. And he will provide guts enforcement powers for the Equal Opportunity Commission.

WE MUST COME DOWN HARD ON DRUGS AND CRIME.

Crime is no place to be "liberal." McGovern calls for stronger penalties for use of guns in violent crimes. And a rigid program to stop traffic in hard drugs. Plus strict controls on the use of handguns while protecting the interests of sportsmen.

THE DAMAGE TO OUR ENVIRONMENT MUST BE UNDONE—OR WE ARE ALL DONE FOR.

Our resources and environment are vital and only a major commitment by the next president can reverse the trend of pollution. Ordinary citizens have a guaranteed right to fight pollution through the courts. He must halt the Cross Florida Barge Canal Project. And create a new super agency with a budget of $5 billion and real power to attack this problem.

LIFT THE TAX BURDEN FROM THE POOR AND THE PROPERTY OWNER AND QUIT BURDENING THE GOVERNMENT WITH EXCESS SPENDING.

It is unfair for the rich to be taxed less. There should be a negative income tax for the poor. The property owner should not have to pay for everything the nation enjoys. And personal exemptions should rise. $30 billion has to be trimmed from military spending over the next three years.

NO ONE SHOULD BE FORCED INTO THE ARMED FORCES.

McGovern calls for the establishment of an all-volunteer army. And quits create incentives for men to service to enlist so the caliber of men known as military below. Plus a back-up binary system to be used only in cases of national emergency, and that means real war.

GIVE BLACK AND SPANISH AMERICANS WHAT THEY DESERVE—OR WE'LL GET WHAT WE DESERVE

This calls for powerful support for the Omnibus Civil Rights Bill of 1969, to bar discrimination in employment, housing and education. And support for Cesar Chavez for fair income for farm workers.

McGovern has the guts to take sides–your side.

COME AND HEAR
SENATOR GEORGE
McGOVERN

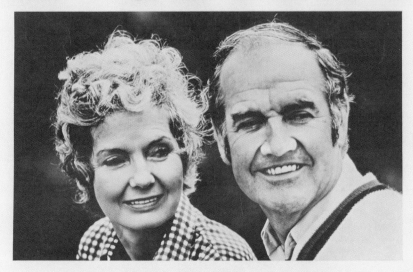

A MAJOR POLICY ADDRESS

WEDNESDAY OCT. 25
12 NOON

CLEVELAND STATE U.
E. 24th St. and EUCLID AVENUE

McGOVERN/SHRIVER '72-OHIO, 2340 PAYNE AVENUE, CLEVELAND, RICHARD SKLAR, COORDINATOR

218. Unknown artist, 1972
36" × 21", offset lithography
Hammering the viewer to support McGovern, the poster offers the candidate's position on key issues, which are printed at the bottom of the poster above the slogan "McGovern has the guts to take sides—your side." Popular halftone dots are an integral part of this poster design.

219. Unknown artist, 1972
22½" × 15½", offset lithography
Senator George McGovern Collection, McGovern Library / DWU Archives, Dakota Wesleyan University, Mitchell, South Dakota.
The McGoverns were an attractive couple, and Eleanor was always active in her hus-band's campaigns, occasionally traveling alone to speak on his behalf. She and her twin sister, Ila, were accomplished debaters in high school, and she was as passionately concerned about poverty, hunger, abortion, and the war in Vietnam as her husband.

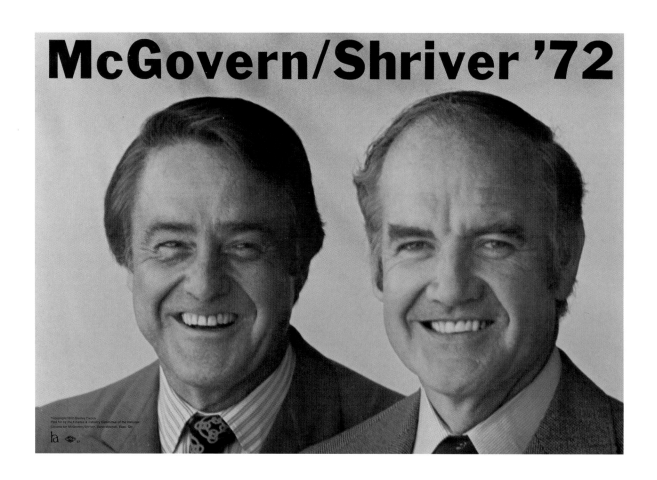

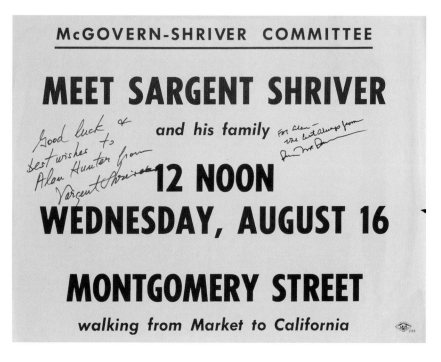

220. Unknown artist, 1972
14¼" × 20½", offset lithography
This simple-colored jugate poster of the candidates was one of the most widely distributed of the campaign.

221. Unknown artist, 1972
8½" × 11", offset lithography
This San Francisco appearance by Sargent Shriver was only two weeks after he had ascended to the ticket, replacing Sen. Tom Eagleton. The poster is signed by both Shriver and McGovern, though perhaps not at the same time.

222. Unknown artist, 1972
27¼" × 18", offset lithography
This is one in a series of at least four minimally designed blue-and-white posters featuring short quotations from McGovern. Printed on glossy, high-quality, coated paper, these expensive posters appeared in McGovern headquarters around the country.

George McGovern

It's time we won.

Paid for by McGovern for President Committee, John W. Branner, Treasurer. Ira Rosenberg, Inc., 41 E. 42 St., N.Y.

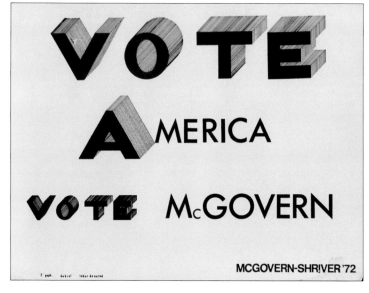

223. Unknown artist, 1972
22" × 14", offset lithography
Printed on poster paper for a Hartford, Connecticut, rally, this poster uses hand lettering to suggest grassroots populism.

224. Unknown artist, 1972
17½" × 23", offset lithography
An interesting use of close shading gives this poster a slightly three-dimensional quality, and the line use makes the letters look like machined metal castings. The poster was likely used to attract factory workers to the McGovern ticket.

225. Unknown artist, 1972
23" × 17⅜", screen print
The use of this humorous caricature silhouette of President Nixon makes this well-done poster eye-catching and particularly effective.

"THOSE WHO HAVE HAD A CHANCE FOR FOUR YEARS AND COULD NOT PRODUCE PEACE SHOULD NOT BE GIVEN ANOTHER CHANCE."

— RICHARD M. NIXON
OCTOBER 9, 1968

ON NOV. 7 REMEMBER OCTOBER 9!

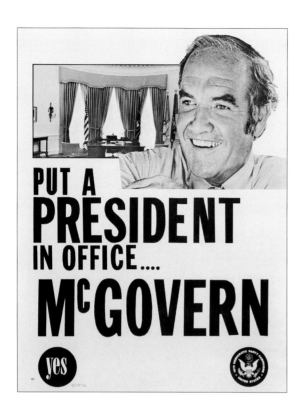

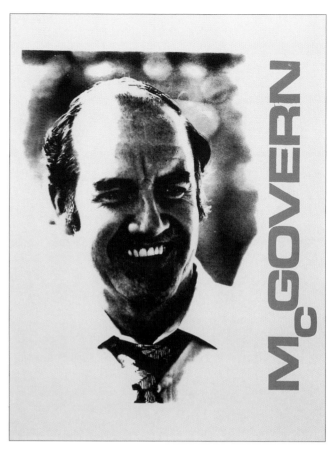

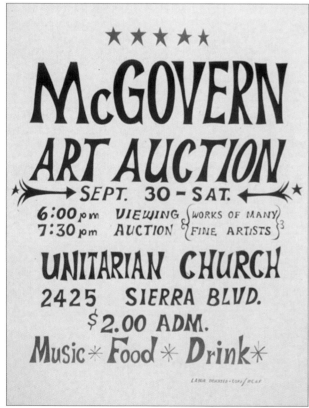

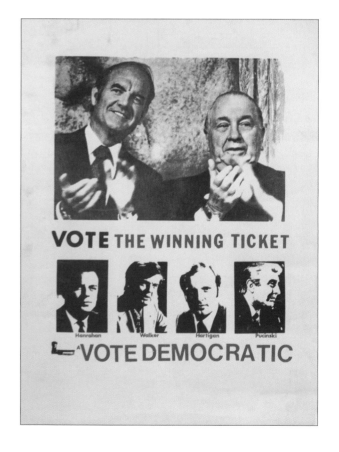

226. Unknown artist, 1972
22" × 17", offset lithography
This inexpensive poster employs a photo of the Oval Office and a variation on the presidential seal to convince the viewer that McGovern deserves to be in the White House.

227. Unknown artist, 1972
26" × 20", offset lithography
This attractive, simply designed poster was created for the critical Wisconsin primary on April 4, which was won by McGovern. The victory and the winning of fifty-four more delegates made the South Dakotan the front-runner in the campaign.

228. Unknown artist, 1972
17" × 11", screen print
Another example, from Sacramento, California, of a hand-lettered poster heralding local grassroots campaign events supporting McGovern.

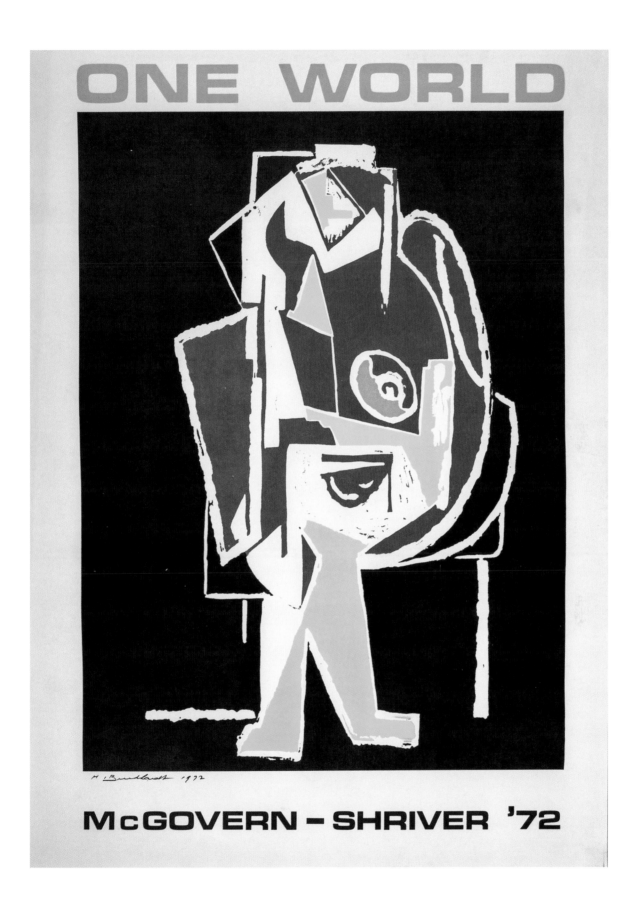

ONE WORLD

McGOVERN – SHRIVER '72

229. Unknown artist, 1972
23⅛" × 17½", offset lithography
Mayor Richard Daley of Chicago campaigned for McGovern out of loyalty to the party as he had done all in his power to deny McGovern the nomination. Only in solid Democratic areas across the country did local candidates tie themselves to the national ticket. A curious feature of the poster is that the viewer is not told what office those pictured are running for. The only information is that the candidates are Democrats.

230. Hans Burkhardt, 1972
24" × 18", offset lithography
Swiss-born abstract expressionist Hans Burkhardt's four-color painting titled *One World* was used to create this McGovern-Shriver poster. Beginning with the Spanish Civil War and continuing through Desert Storm, the artist made antiwar paintings that captured human suffering.

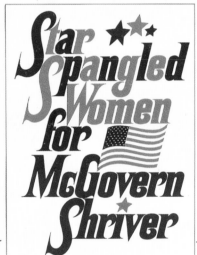

Madison Square Garden
MUSICAL SPECTACULAR
7:30 P.M. FRIDAY, OCTOBER 27

★ APPEARING IN CONCERT ★

DIONNE WARWICKE ★ TINA TURNER
& THE IKETTES ★ MARY TRAVERS
JUDY COLLINS ★ CASS ELLIOT
MARLO THOMAS ★ MELINA MERCOURI
GWEN VERDON ★ CHITA RIVERA
SHIRLEY MacLAINE ★ BETTE DAVIS
and other SURPRISE PERFORMERS

Star Spangled Women for McGovern Shriver

MRS. ROSE KENNEDY

MRS. ELEANOR McGOVERN

Produced by: SHIRLEY MacLAINE & SID BERNSTEIN

CELEBRITY USHERS ★ ★ ★ ★ ★ ★ CELEBRITY USHERS ★ ★ ★ ★ ★ ★ CELEBRITY USHERS

ROBERT ABRAMS	DANTE FERRARI	KEVIN McCARTHY	DENNIS SMITH
BELLA ABZUG	WILLIAM FRIEDKIN	MRS. EDWARD R. MURROW	GLORIA STEINEM
WARREN BEATTY	BEN GAZZARA	JACK NICHOLSON	PERCY SUTTON
JIMMY BRESLIN	DAN GREENBURG	ELEANOR PERRY	FAT THOMAS
PAT CUNNINGHAM	GOLDIE HAWN	ALICE PLAYTEN	JOSE TORRES
COLEEN DEWHURST	MARY HEMMINGWAY	GEORGE PLIMPTON	MATT TROY
HELEN GAHAGAN DOUGLAS	JAMES EARL JONES	REX REED	ELI WALLACH
NORA EPHRON	ALAN KING	FRANK ROSETTI	and many more
MEADE ESPISITO	SAM LEONE	ROBERT RYAN	
JULES FEIFFER	SIDNEY LUMET	TINA SINATRA	564

TICKETS: $25, $15, $10, $5. AT THE BOX OFFICE, 2 PENN PLAZA (564-4400) AND ALL TICKETRON OUTLETS (644-4400)

231. Unknown designer, 1972
21⅞" × 13⅞", offset lithography
Courtesy of Hake's Americana, Hakes.com.
Star Spangled Women for McGovern-Shriver at
Madison Square Garden turned out an array of
accomplished, well-known women for McGovern.

232. Unknown artist, 1972
24" × 18", offset lithography
Music for McGovern on April 30 fea-
tured a number of star musicians per-
forming for McGovern in Century City
in an effort to drum up support for the

coming California primary. The staff,
clef note, and horn image is reminis-
cent of the ¾ *for McGovern* poster (fig.
125) designed for the LA Forum concert
that occurred fifteen days earlier; both
were likely created by the same artist.

MUSIC FOR McGOVERN

We Invite You To A Very
Special Evening
Of Music At
TÉTOU
1888 Century Park East,
Century City
On Sunday,
April 30,
1972.

PERFORMING ARTISTS

Israel Baker
Larry Bunker
Chuck Domanico
Dave Grusin
Roger Kellaway
Irene Kral
Shelly Manne
and
His Men
Ruth Price
Hillard Street
John Williams
And
Roscoe Lee
Browne

Cocktails: 6:30
Dinner: 7:30
Music: 8:30

Reservations: Phone Wendy, at 487-6930

$25 per person

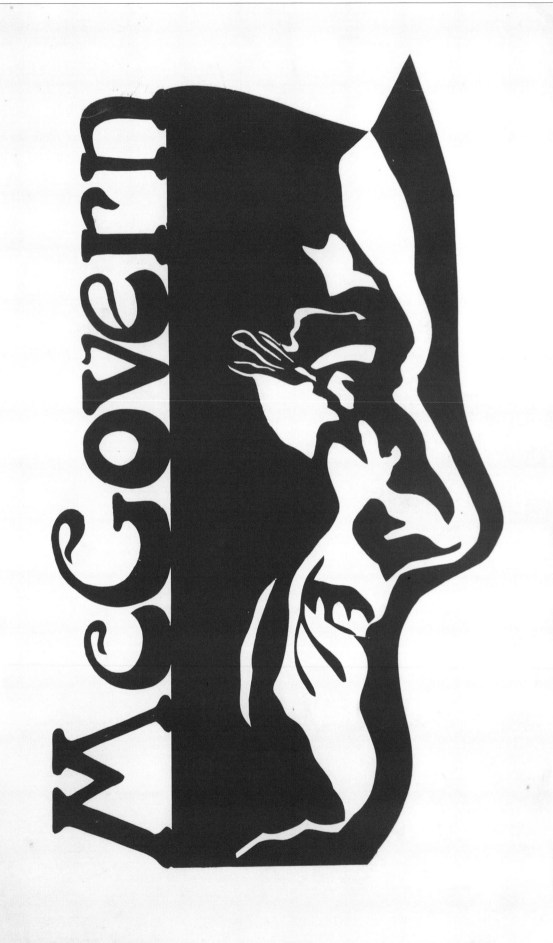

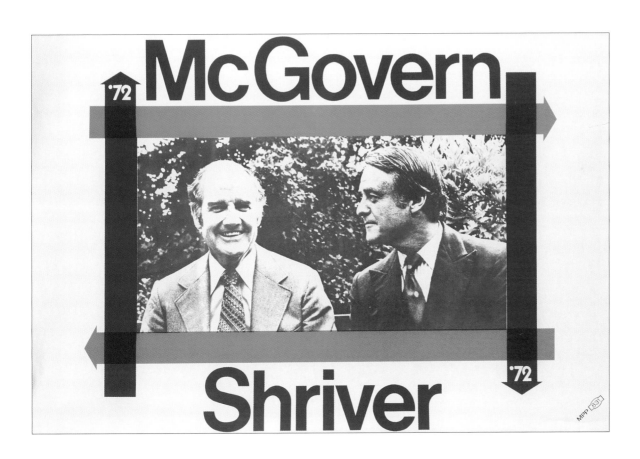

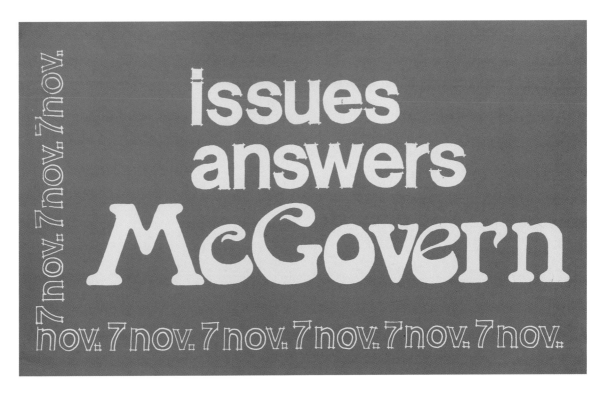

233. Unknown artist, 1972

22½" × 14¼", screen print

The attractive and simple *McGovern* profile image poster that appeared in Northern California owes much to the psychedelic style of poster making.

234. Unknown artist, 1972

28" × 42", offset lithography

The McGovern campaign favored this photo of Sargent Shriver looking admiringly at the presidential candidate. This large poster and a similar one of McGovern only (fig. 200) are from the Los Angeles, California, area.

235. Unknown artist, 1972

13" × 21½", screen print

Another handsome, simple California poster, *Issues, Answers, McGovern* was screen printed on construction-like paper for the general election.

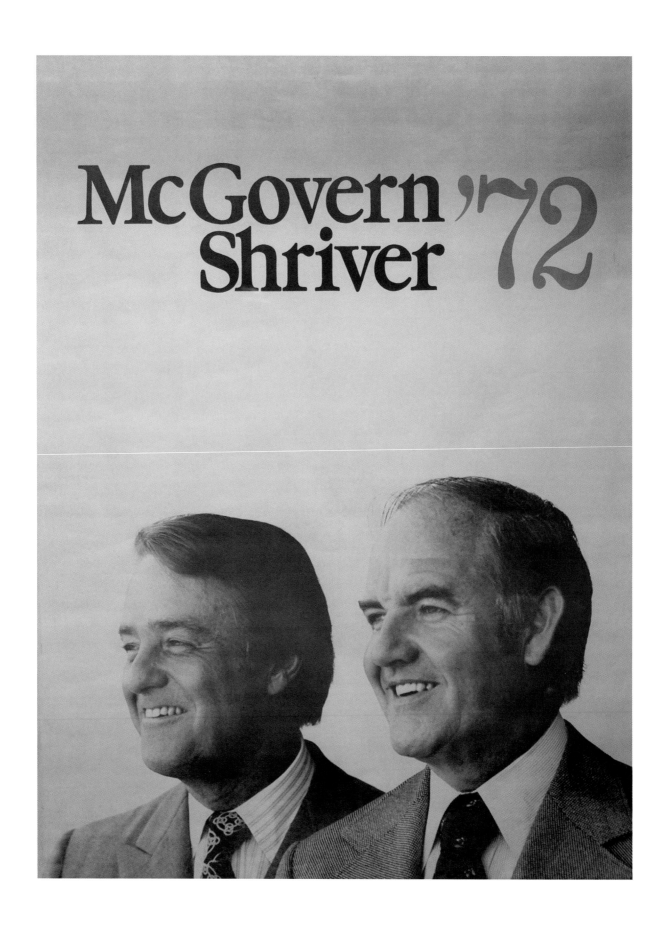

236. Unknown designer, 1972
28¼" × 17", offset lithography
Another popular jugate poster distributed by
the national campaign headquarters was
printed in two versions—one in blue and white,
and another in black and white.

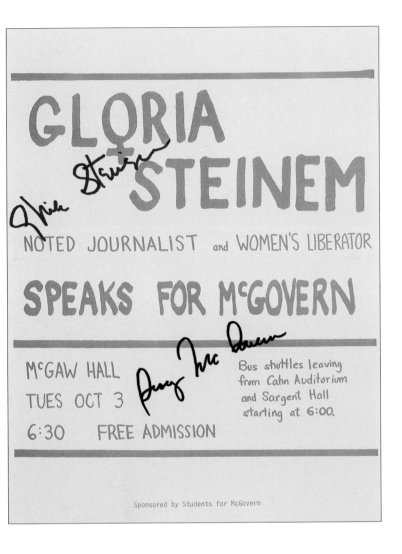

237. Unknown designer, 1972
11" × 8½", offset lithography
McGovern and Gloria Steinem both signed this poster as the candidate returned to his alma mater, Northwestern University, to solidify his support on college campuses.

238. Unknown designer, 1972
17¾" × 17¾", offset lithography
A hardworking telephone pole–type poster, *The Farmer's Voice* was tacked up in rural Wisconsin to attract the farm vote. The campaign did broaden McGovern's base somewhat in the Dairy State.

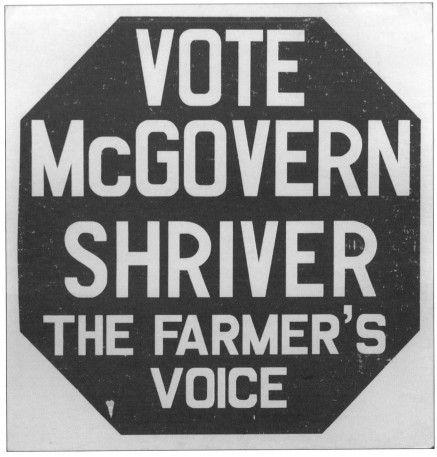

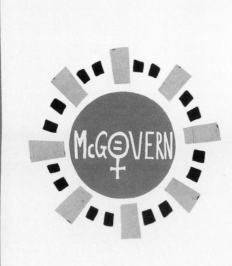

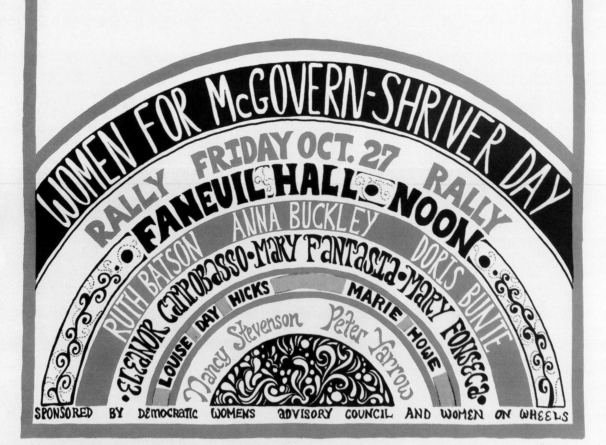

WOMEN FOR McGOVERN-SHRIVER DAY
RALLY FRIDAY OCT. 27 RALLY
FANEUIL HALL NOON
RUTH BATSON ANNA BUCKLEY DORIS BUNTE
ELEANOR CAMPOBASSO·MARY FANTASIA·MARY FONSECA·
LOUISE DAY HICKS MARIE HOWE
Nancy Stevenson Peter Yarrow
SPONSORED BY DEMOCRATIC WOMENS ADVISORY COUNCIL AND WOMEN ON WHEELS

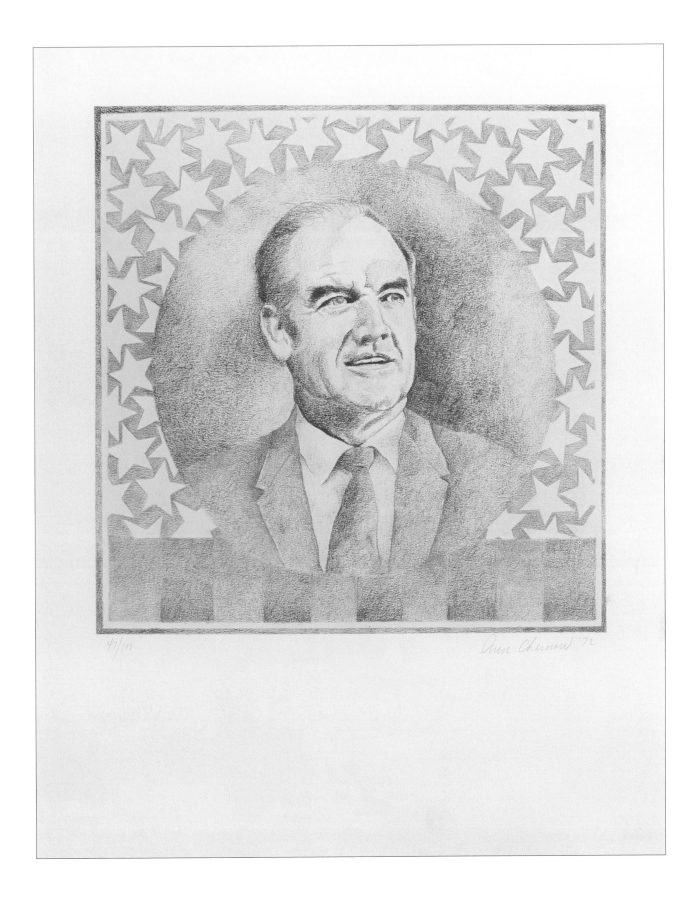

47/100 Ann Chernow '72

239. Unknown artist, 1972

19¼" × 13½", offset lithography

Women for McGovern-Shriver Day is a well-designed poster in classic psychedelic style. The rally was held in Boston's historic Faneuil Hall and turned out a number of well-known Boston women like Louise Day Hicks, who had opposed court-ordered busing, and Nancy Stevenson of Muppet fame. McGovern supported the burgeoning women's movement and sought their votes.

240. Ann Chernow, 1972

16" × 20" screen print, 12¾" × 12⅝" offset lithography

This limited edition screen print in an edition of one hundred by this well-known artist is one of her early works. Ann Chernow, a cinephile, made her reputation creating prints, drawings, and paintings of movie starlets of the thirties and forties. The McGovern print was commissioned by Harvey Koizim of Westport, Connecticut.

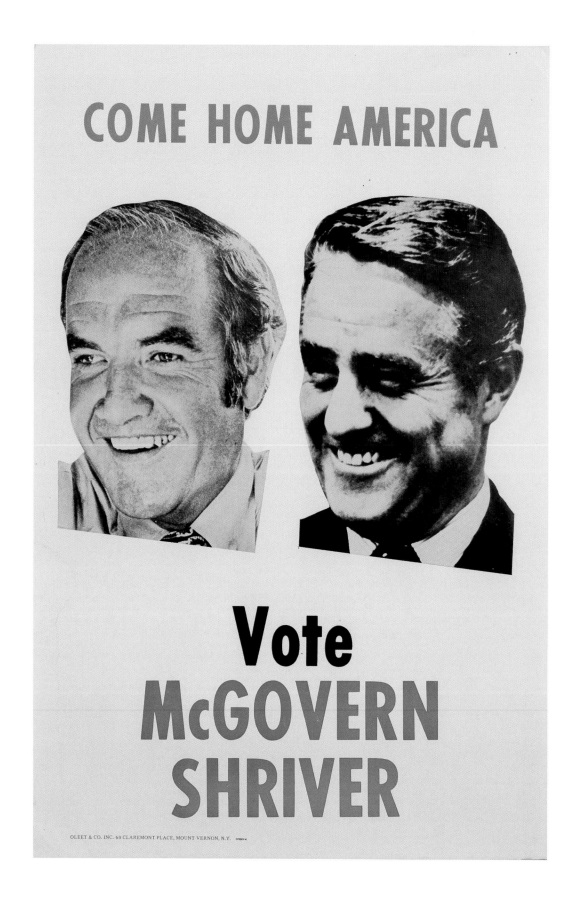

COME HOME AMERICA

**Vote
McGOVERN
SHRIVER**

OLEET & CO. INC. 60 CLAREMONT PLACE, MOUNT VERNON, N.Y.

241. Unknown designer, 1972

17½" × 11½", offset lithography

This McGovern-Shriver jugate is another example of the inexpensive poster that is the mainstay of most campaigns.

242. Unknown artist, 1972

22" × 14", offset lithography

Printing political slogans and candidates' pictures on the U.S. flag has been a common practice in American history. The first campaign flag posters and banners that pictured the candidates appeared in the 1840 election when William Henry Harrison, the Hero of Tippecanoe, and his running mate, John Tyler, defeated the incumbent, President Martin Van Buren. From then until shortly after the turn of the century campaign flag posters and banners were extremely popular. During World War II Congress passed legislation making it illegal to place a candidate's likeness on the flag. Interestingly, Richard Nixon's picture appeared on a 1960 cloth campaign flag.

For the people.

McGovern.

Vote Democratic.

Paid for by McGovern/Shriver '72
19 East Fifty Third Street
New York, New York 10022

E. C. L., 160 Fifth Ave., N. Y., N. Y.

VOTE McGOVERN SHRIVER

They listen
They care

Pull the bottom lever

By authority of Stevenson McIlvaine, Treasurer
Va. McGovern-Shriver Campaign Committee

243. Unknown artist, 1972
20⅛" × 14", offset lithography
Senator George McGovern Collection,
McGovern Library / DWU Archives,
Dakota Wesleyan University, Mitchell,
South Dakota.

Instruction on which lever to pull on Election Day was critical as the voter would have a number of choices, and it was easy to make a mistake. Posters of this type usually appeared close to Election Day.

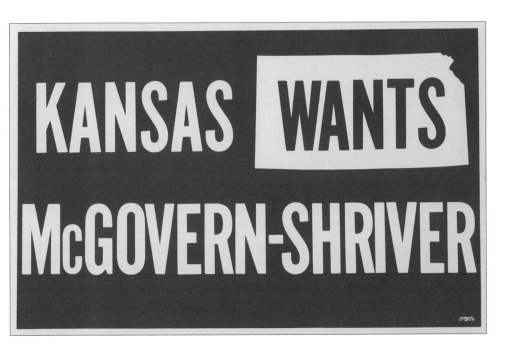

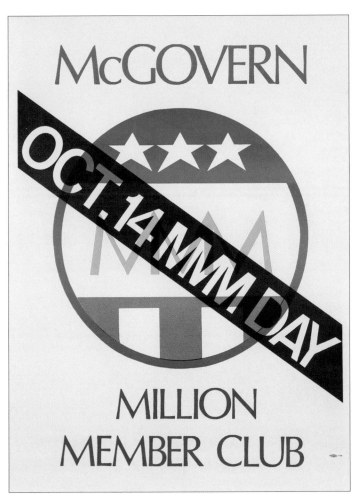

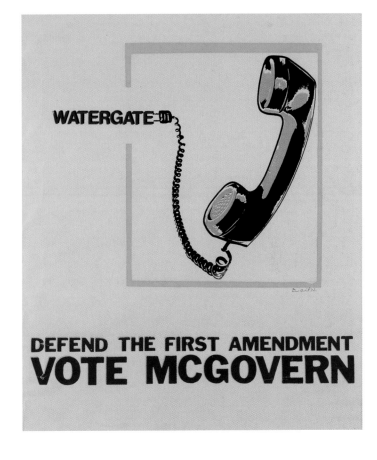

246. Unknown artist, 1972
23" × 20", offset lithography
*Senator George McGovern Collection, McGovern Library / DWU
Archives, Dakota Wesleyan University, Mitchell, South Dakota.*
This poster is one of only a few that plays on the emerging
Watergate scandal, of which little was actually known as Elec-
tion Day neared. In fact, had it not been for the investigative
skills and persistence of Carl Bernstein and Bob Woodward at
the *Washington Post*, the trail of the break-in might never have
led to the White House.

244. Unknown artist, 1972
14" × 22", offset lithography
This Kansas yard sign and/or poster,
coated for outdoor use, was produced
for several other states, including Iowa
and Nebraska, simply by changing the
name and shape of the state.

245. Unknown artist, 1972
22¼" × 16", offset lithography
The campaign made a big push to entice a
million voters to sign up for McGovern and
to contribute money or volunteer on Octo-
ber 14 in an effort to build momentum as
the election was just three weeks away.

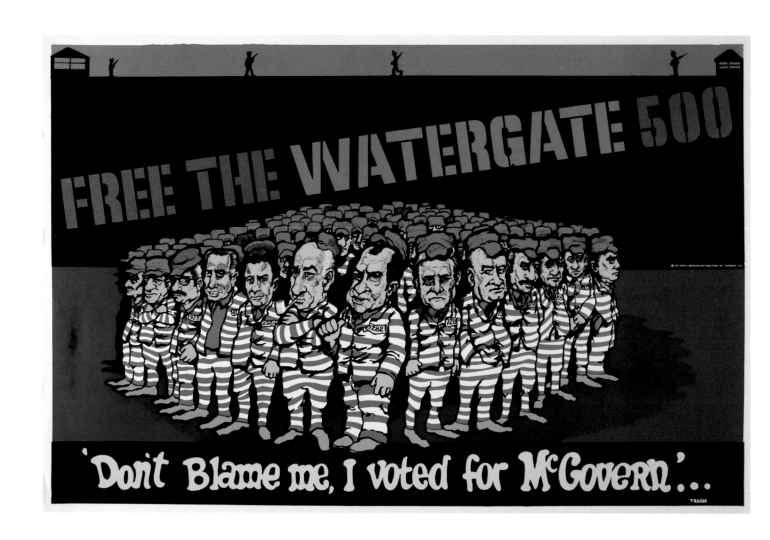

247. Unknown artist, ca. 1972–73

23" × 35", offset lithography

Blacklight posters were a favorite of the counterculture crowd. Hundreds were produced, including many antiwar posters. The "Don't blame me, I voted for McGovern" slogan appeared on posters, buttons, and bumper stickers as Watergate led to Nixon's impeachment and resignation. This caricature of the Nixon crowd in prison suits is one of the best.

248. Unknown artist, 1972
40" × 26", screen print; 35" × 23⅛", offset lithography
This aesthetically strong poster is an effective use of suggestion tied to visual communication. The print is not numbered, but it was likely a small run. An open edition offset poster in a smaller size was also created using this image.

249. Unknown artist, 1972
22" × 14", screen print
A fine screen print, *McGovern, the man for all reasons* alludes to the Academy Award–winning film *A Man for All Seasons* that was released in 1966 and achieved enduring fame.

The only man
who can make
a difference.

Gene
McCarthy

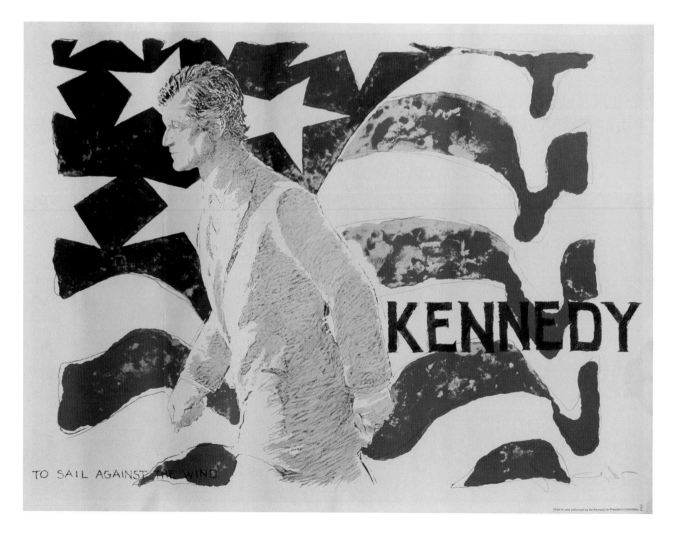

TO SAIL AGAINST THE WIND

KENNEDY

The dramatic cultural pivot in the seventies resulted in a great dearth of exciting posters during the campaigns of 1976 and 1980. Art community activists had not recovered from the stinging defeat of 1972, and they were not excited by a southern establishment centrist like Jimmy Carter or Ted Kennedy's opportunistic insurgence against the Peanut Man. Carter publically announced that he'd "whip Teddy's ass," and he did. On the Republican side of the 1980 election, Ronald Reagan's campaign generated genuine excitement on the Right and produced a plethora of quality posters and campaign memorabilia.

In 1984 the campaign poster experienced a mini-renaissance, largely due to the candidacies of Sen. Gary Hart of Colorado and George McGovern, who decided to run an issues campaign to educate the electorate. The old antiwar war horse was opposed to U.S. intervention in Nicaragua and El Salvador and wished to invoke a national debate on the issue as he feared that ground troops would eventually be sent—another quagmire, another Vietnam. As well, he deeply resented Reagan's attitude toward the Soviet Union and skyrocketing defense expenditures. McGovern strongly felt that none of the other Democratic candidates clearly framed the issues and challenged the New Right. McGovern could not accept that liberalism—even in the Reagan era—was out of favor; and against repeated advice from longtime supporters, he tossed his hat in the ring. Some were critical of his candidacy as he might spoil the chances of his former campaign manager. Many in the press noted that he had lost the 1972 presidential election and had lost his Senate seat in 1980 in a race in which he outspent his Republican opponent three to one and received but 39 percent of the vote. It was suggested by a few leading fellow Democrats, some close supporters and members of the fourth estate that it was time to gracefully bow out of politics.

To the contrary, McGovern was not dissuaded; those who knew the senator admitted, "There was no quit in George." Early contests in Iowa, New Hampshire, and Massachusetts would make or break the candidate. In Iowa, McGovern came in third in a field of seven but with only 10 percent of the vote, and in New Hampshire he ran fourth. The senator vowed that if he did not finish second in Massachusetts, the only state he carried in the 1972 presidential election, he would drop out of the race. After all the votes had been counted, including absentee ballots, he was edged out by Vice President Walter Mondale and placed third. It was to be his last campaign. A low-budget affair, the campaign produced few posters. Hart won several early primaries and swept the western states, but despite the campaign's commitment to well-done posters he did not receive the nomination so arduously sought.

250. Unknown artist, 1976

22" × 34" and 11" × 17", offset lithography

McCarthy, after challenging LBJ in 1968 but failing to secure the nomination, ran again in 1972. He fared poorly in the Wisconsin and California primaries and dropped out of the race but encouraged his supporters to vote for McGovern. He returned in 1976 as an Independent, achieved ballot status in thirty states, and was a write-in candidate in California and Wyoming. He won a little over 740,000 votes and did best in Oregon, a state he won in the 1968 Democratic primaries.

251. Jamie Wyeth, 1980

22⅞" × 30⅞", offset lithography; 25½ × 35", screen print

Jamie Wyeth, son of Andrew Wyeth and grandson of N. C. Wyeth, created this fine poster for Ted Kennedy's challenge of sitting President Jimmy Carter. Largely dependent on visual language, the poster conveys that Kennedy will move the Democratic Party to the Left, back to its liberal base. The election and primary battles on the Democratic side during 1980 produced few posters of merit, but the Wyeth pencil-signed screen print in an edition of 300 is an exception.

Walter Mondale and Geraldine Ferraro carried the Democratic banner in 1984, and Ferraro was the first woman to run as a vice presidential candidate on a major party ticket. Mondale and Ferraro, however, went down in a defeat almost as sweeping as McGovern's in 1972. The ERA floundered in a number of state legislatures and failed after a long, protracted effort to secure its passage. The majority of campaign posters throughout this period remained standardized and low voltage in terms of graphic power or visual communication.

Rock 'n' roll, not politics, lead the way to innovations in poster making in the eighties as it had with the advent of the psychedelic poster in the sixties. The rise of hundreds of regional and local bands created a need for promotional materials, and with the death of LPs, many young and talented graphic artists were there to fill the need. To create quality posters in small runs the screen print and the letterpress came back into vogue as ideal solutions. Poster art moved in fresh and creative new directions.

Established letterpress operations that were on their last legs or that had long ago shut their doors were purchased and brought back to life by young artists who saw the potential of this printing process and at the same time a chance to preserve the past. Hatch Show Print in Nashville, run by the talented Jim Sherraden, is the prime example, but many other successfully revived letterpresses are currently in operation, like Kevin Bradley's Yee Haw in Knoxville, Tennessee, and Brady Vest's Hammerpress in Kansas City, Missouri.

The new prints being made were not all gig posters. Many works were simply the expressions of the artists who created them. Others were made for various causes, some had a political theme, and some were designed for businesses that needed small runs and catered to customers who appreciated the prints. Letterpress and screen prints looked good and filled the bill. Additional trends in the eighties also heralded change, as the computer and digitalization turned the printing world upside down. The giclée print had arrived. Graffiti art stormed through the urban core like a raging forest fire and was often no more than unsightly blight. While these budding innovations would take a good deal of time to dramatically influence political art, the revolution was in motion.

In 1988 Jesse Jackson sought the Democratic nomination for president for the second time. Since Shirley Chisholm in 1972, no black candidate had run for the office. Jackson had some success in 1984, and it was thought he could influence the direction of the Democratic primaries but was not likely to win the nomination in 1988. Jackson did well in the primaries, winning six southern states and garnering a little over 29 percent of the votes, but he was overtaken by Michael Dukakis, who managed 42 percent. Neither Dukakis—The Duke, as he was affectionately known—nor Roy Lichtenstein's popular "Dukakis '88" poster could translate the Massachusetts Miracle into a win as he was handily defeated by George H. W. Bush and Dan Quayle. However, the campaigns of Jackson and Dukakis did offer up a few very well-done posters.

Unfortunately for President Bush, Clinton would not likely have been elected president had Ross "Mr. Fixit" Perot not taken 18.9 percent of the vote. If 6 percent of the Perot vote had gone to Bush, he would have won by a few thousand. Not since Bullmooser Teddy Roosevelt in 1912 had a third-party candidate done as well and helped determine an election's outcome. In the past, candidates had surrounded themselves with Hollywood stars and famous musicians, but the candidates did not present themselves as being cool or hip; even Reagan downplayed his star power. Bill Clinton was one of the first candidates to be pitched as a personality divorced from politics, qualifications, or ideas. Clinton was a "cool celeb," a sexy boomer, a saxophone-playing star who appealed to Generation Xers, a guy who made the rounds on the late shows. A poster

printed for the Democratic convention in 1992 (fig. 266)—and given out to staff and delegates—presented the political gathering more as entertainment, picturing Clinton as an Elvis look-alike on a U.S. stamp that read *R&B President-Elect 1992. Live from New York, Gov. Bill Clinton at Madison Square Garden, Democratic National Convention, July 13–16, 1992.* Playing the everyman, Clinton traveled by train from Detroit to Chicago for the 1996 Democratic convention, bringing the famous whistle-stop campaign to select cities with a style of campaigning that predated Lincoln. The art deco poster designed to promote the trip is one of the best of the Clinton years.

The presidential campaign in 2000, the closest race in U.S. political history, in which the Supreme Court ultimately declared the winner, did yield several exciting posters. And while the branding was successful and the victory secured, those who disliked, even hated, President George W. Bush for taking the country into what they saw as two unnecessary wars were determined to put a Democrat in the White House in 2008.

The country was painfully polarized, but many at the 2004 Democratic convention perked up when they heard the speech of Illinois senator Barack Obama. Perhaps, here was a man who could take the country in a new direction. The Left immediately embraced Obama. But the heir apparent for the 2008 nomination was Hillary Clinton, who was supported by the majority of the Democratic hierarchy. Powerful women in the party were determined to see Clinton receive the nomination. She would be the first female nominee to head a major party ticket and clearly her chances of winning were very good as 2008 seemed clearly to be a Democratic year. But a prolonged primary fight harkened back to 1968 with Obama playing Eugene McCarthy and Clinton cast as Hubert Humphrey. In one sense it was a replay of the young against the old; and without resolution, a split party could be an electoral disaster for Democrats. Obama's stand on most of the major issues excited the Left as he made his announcement on the steps of the Lincoln Memorial in Springfield, Illinois. As a biracial American in touch with the hopes and dreams of the younger generation, he could inspire them to political action and reignite the passions of aging boomers who had been so motivated by John F. Kennedy, Martin Luther King Jr., Robert F. Kennedy, Eugene McCarthy, and George McGovern. Obama, like Bill Clinton, became a celeb, a cool cat who played B-ball and who "got it." Hillary Clinton, much more of centrist and pragmatist, had no appeal whatsoever to the outsider art crowd.

Obama won the Iowa caucuses and touched off a new poster explosion. Street artists and antiestablishment artists decided to participate in the campaign, to drop in rather than drop out, and created dozens of exciting posters. Hollywood and rock 'n' roll turned out as well and produced a creative groundswell. There was a genuine excitement surrounding the Obama campaign; for his supporters the dream was not dead, and again fundamental change through the political process seemed possible. Was it really within the realm of possibility, as campaign poster maker Ray Noland said, "that the solution to America's problems was black"?

Many of the best campaign posters were the ones made unofficially and were a part of Obama gatherings reminiscent of concerts at the Avalon and Fillmore and the '68 McCarthy and '72 McGovern happenings. In 1968 and 1972 you heard good music and went home with a cool poster to pin up as a connection, a reminder of the music, the evening, and the cause. In 2008 you experienced the same thing, but you went home with a limited edition screen print likely by Shepard Fairey, Ron English, or Emek. Posters publicized posters and encouraged a crowd by tantalizing them with art—the first twenty, fifty, even one hundred through the door would receive a limited edition signed print. These outsider, hip-hop, skateboarder, guerilla artists brought not only their talent

but a host of newfangled communication devices and platforms into the mix—email, cell phones, video cameras, iPods, websites, MySpace, YouTube, Facebook, Twitter, podcasts, and webisodes. The changes that occurred in the eighties—the return of letterpress and screen prints—combined with the twenty-first century's technology revolution to produce hundreds of posters that were photographed with cell phone cameras and dispatched around the world in seconds.

Radical artist Ron English, who made his reputation repainting more than a thousand pirated billboards with anticorporate messages, created *Abraham Obama*, a fusion of the faces of Lincoln and Obama. His spectrum-colored portraits gained notoriety when huge installations appeared in Boston, Los Angeles, and Denver at the Democratic convention. On one of the last *Abraham Obama* signed, limited edition screen prints, English superimposed a map of the Midwest, coloring in red states and blue states to capture the fractured politics the newly elected president faced (fig. 277).

The Obama campaign quickly realized that it too needed to develop appealing posters and campaign material and recognized the importance of branding that had been done so well by the Bush campaign. Sol Sender, Andy Keene, and Amanda Gentry, working in the Chicago headquarters, created the wildly successful Obama logo that could be graphically altered for many purposes while maintaining its design integrity. Rigid control over campaign material went to the extent of picking particular fonts. No campaign in American political history has been as graphically savvy, tightly controlled, and ultimately successful as the 2008 Obama team. The campaign jumped on the art bandwagon with a series of ten screen prints that started with Shepard Fairey, who created the iconic *Hope* poster. A few outsider artists were carefully brought inside and moved into the flow of the campaign's visual messaging.

Obama went on to win the presidency and to break what many artists like to say was the McGovern rule, that cool innovative posters guaranteed a loss. After such an outpouring of posters and the support of enthusiastic artists, the question was whether or not 2008 was going to be the new campaign normal. History said that if Obama moved to the center or disappointed his constituency on the Left, the bloom would quickly fade from the rose. Though some of the same poster artists helped reelect the president in 2012, the excitement for them was gone. The war in Afghanistan continued with a Nixon-like withdrawal, Guantánamo remained open, drone strikes had increased, and the Patriot Act remained in force. The street artists and grassroots activist receded from the scene. The Left would vote for Obama, but for them he was now just another politician. Utopian dreams subsided once again; the fundamental change sought would not happen. The Obama campaign clearly recognized that the 2012 campaign demanded a different strategy and tactics. Posters played a far less important role as social media moved to the fore.

Sometime in the future, not likely in 2016, perhaps a candidate will run who again sets off an outpouring of political posters; but given the fluid nature of American politics, a dynamic process often determined by inadvertency, when is impossible to predict. Like the previous outbursts, the latest technology will determine how posters are produced. How causes, issues, candidates, voters, and art come together is a complicated process. Art and politics are in many ways serendipitous affairs. It is possible, however, that the great American political poster, like so much print media, is a thing of the past. If that is the case, the treasure trove of campaign posters created during the 2008 campaign will become known as a magnificent last hurrah in a history that begin in the 1840s and continued for nearly 170 years.

252. Unknown artist, Michael Evans photo, 1980
28" × 22", offset lithography
This poster is an example of visual communication at its best coupled with successful branding as there is no date and no information on the office Ronald Reagan is seeking. The cropped cowboy hat is problematic, but it is a great poster nonetheless. Like the Ben Shahn FDR poster, *Our Friend*, and the McCarthy *He Stood Up Alone* poster (fig. 41), little or no specifics are given or needed. The poster designer may or may not have been aware of how reminiscent the layout was of two particularly beautiful color lithographs produced in 1900 by Courier for Buffalo Bill's Wild West Show. The posters featured a portrait of Buffalo Bill with charging buffalo in the background and simply read *I am Coming* or *I'm Here*. The positive images of American life used in the poster's background produce a retro quality, engendering feelings of nostalgia and a sense of security in the viewer.

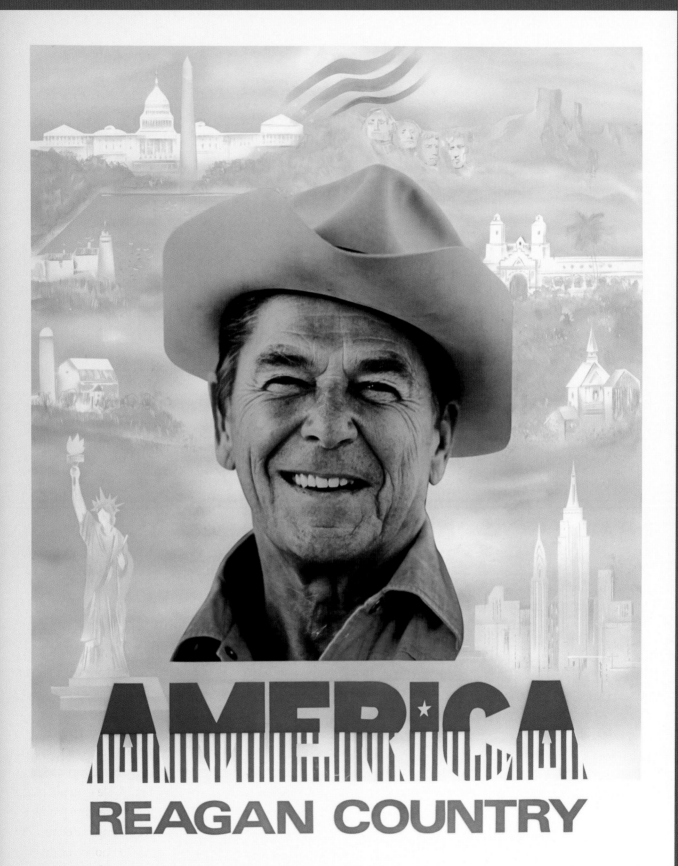

AMERICA

REAGAN COUNTRY

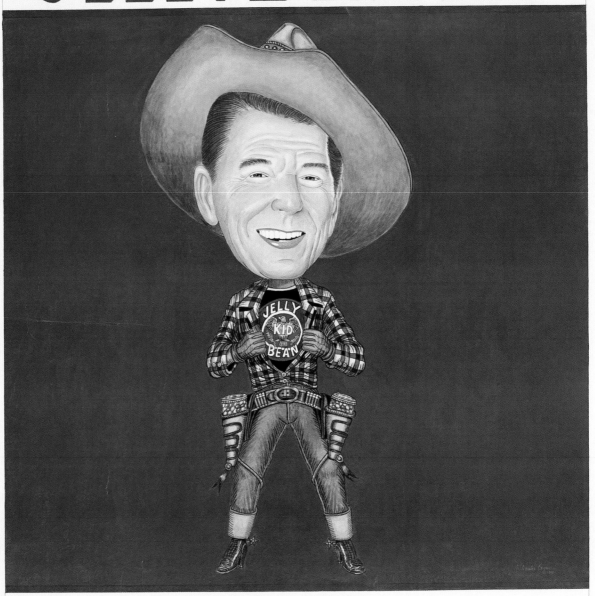

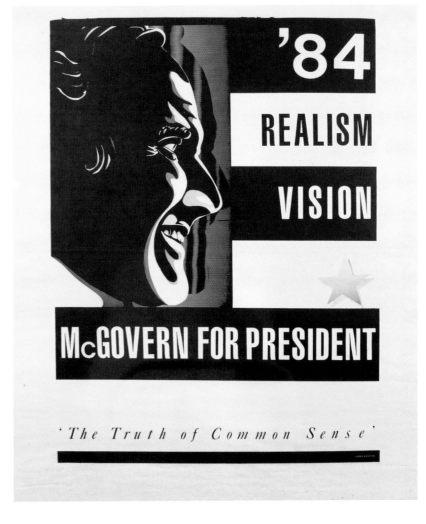

253. Unknown artist, 1980

36" × 24", offset lithography

Even in this cartoon caricature of Reagan as the Jelly Bean Kid, the poster projects the cowboy image of the candidate's confidence and strength.

254. Unknown artist, 1984

24" × 18", screen print

McGovern, against the advice of most of those around him, decided to run an issues campaign in 1984, though he had been out of office since losing his Senate seat in the Republican sweep of 1980. After the Massachusetts primary on March 13, McGovern quit the race.

255. Unknown artist, 1984

23" × 21¼", screen print

Courtesy of Richard Michael Marano.

This second poster, also using the purple and white profile caricature of the candidate, was one of only a few posters created for McGovern's 1984 issues campaign. By entering the race, it looked as if McGovern might be a spoiler for his 1972 campaign manager Gary Hart's run for the presidency. The design influence from McGovern's '72 campaign on this and the previous poster is obvious.

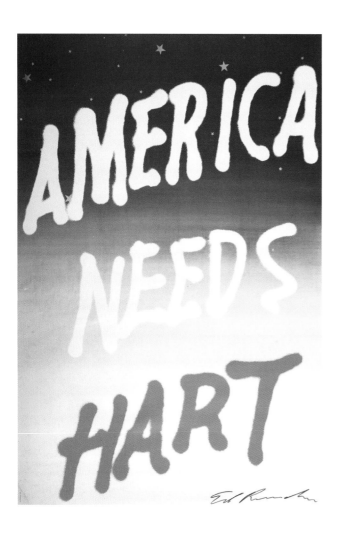

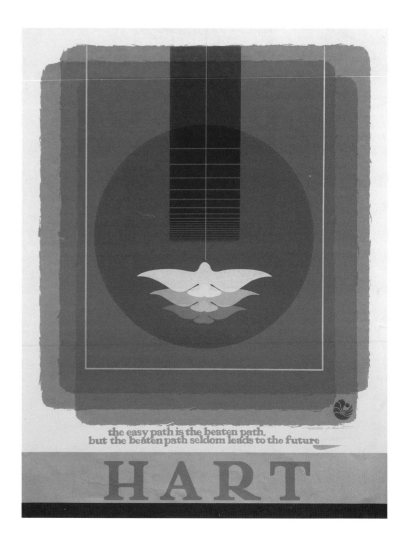

256. Ed Ruscha, 1984

35¾" × 24", offset lithography

Ed Ruscha, a leading pop artist, created this poster for Hart that is quite similar in design to the poster he made for the prestigious Bicentennial series in 1976. The artist signed a number of these posters at different venues; sometimes he used a black felt pen and at other times a fine point pen. Occasionally he added the date, 1983, after his signature. The posters created for the Hart campaign are more a throwback to McGovern's 1972 race when Hart served as his campaign manager than they are to any renaissance in poster art.

257. Thomas W. Benton, 1984

32" × 27", screen print

Most unusual for Benton, he screen printed this poster in a numbered, pencil-signed, limited edition of two hundred and pulled an unknown number that he signed but did not number. On both poster designs, he chose to use the same Gary Hart quote, and here too he used his standard images in a formal style.

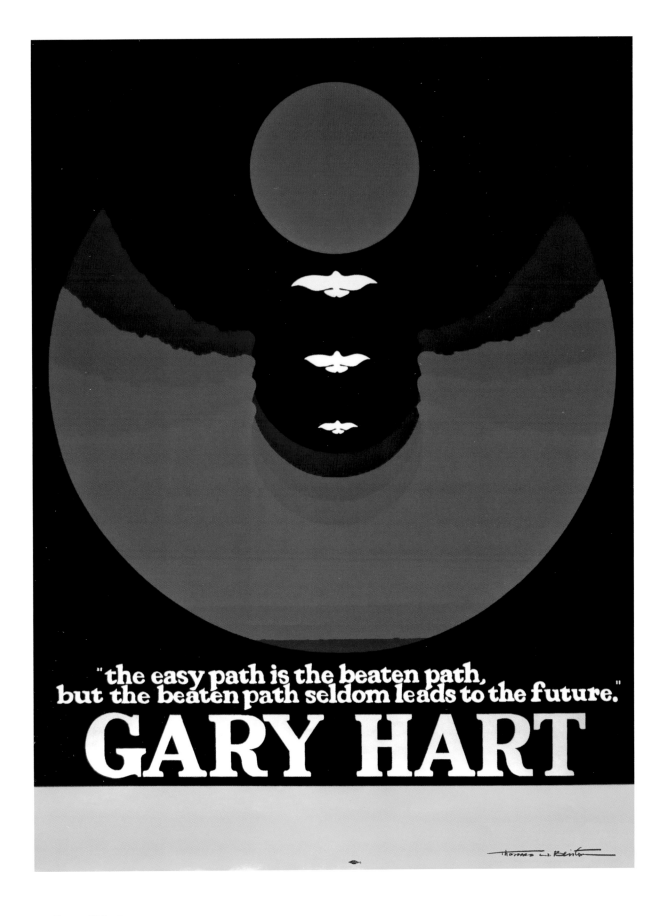

258. Thomas W. Benton, 1984

23¼" × 17⅜", screen print, offset lithography

Thomas W. Benton, relying on his standard imagery, screen printed
a number of proofs, which he pencil signed. The poster was then
printed in an open offset edition and widely distributed by the Hart
campaign. Hart swept the western states' primaries and caucuses
and came close to defeating Walter Mondale for the nomination.

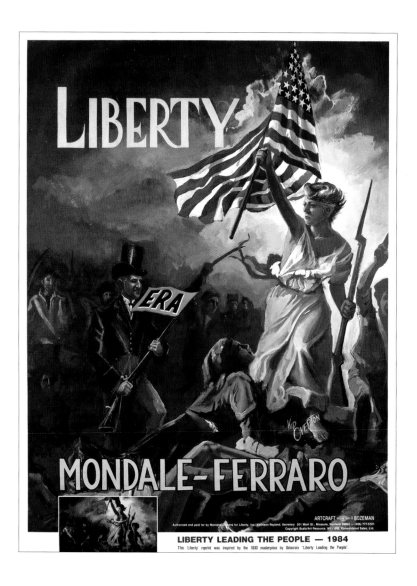

LIBERTY

MONDALE-FERRARO

LIBERTY LEADING THE PEOPLE — 1984

This 'Liberty' reprint was inspired by the 1830 masterpiece by Delacroix 'Liberty Leading the People'.

259. Kip Overton, 1984

25" × 19", offset lithography

Kip Overton created this fun poster of Geraldine Ferraro, the Democratic vice presidential candidate, as Lady Liberty, taken from a famous Eugène Delacroix painting, leading the charge in support of the Equal Rights Amendment (ERA). The poster was commissioned by the Montana Democratic Party. Neither the Mondale-Ferraro ticket nor the ERA was successful.

260. Cate Mandigo, 1984

18" × 22¼", offset lithography

This popular upstate New York print maker created this signed, limited edition poster for Ronald "Fritzbusters" Reagan and George H. W. Bush in a Grandma Moses folk art style. Cate Mandigo has created dozens of prints, usually in runs of one thousand, portraying scenes in the villages and countryside of New England.

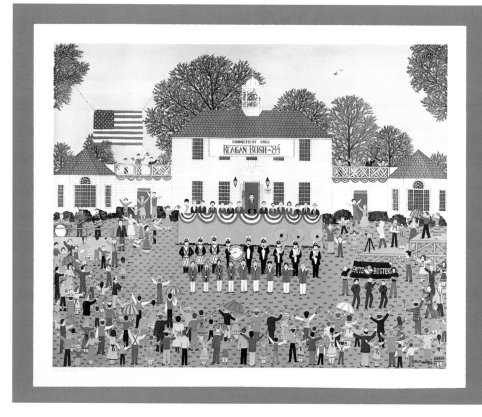

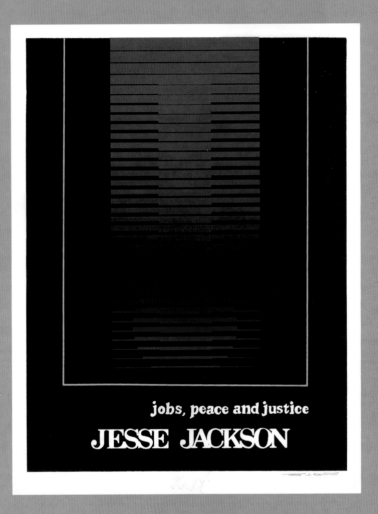

261. Leonard Baskin, 1988
26" × 19⅜", offset lithography
In 1988 the uptick in poster art nearly all came from the Jesse Jackson campaign. Leonard Baskin, a well-known illustrator, print maker, sculptor, fine art bookmaker, and graphic artist drew this compelling portrait of Jackson. Printed at the prestigious Oxbow Press, the poster was issued in an open offset edition.

262. Thomas W. Benton, 1988
26" × 20", screen print
Courtesy of Daniel Joseph Watkins.
That Benton designed a "Jackson for President" campaign poster was until very recently unknown. Daniel Joseph Watkins, author of *Thomas W. Benton: Artist/Activist*, has been maniacal in ferreting out Benton's prints and paintings. This poster uses Benton's favorite symbol, a circle or a nautilus-like open circle design, to create an attractive pencil-signed, limited edition screen print—note there is no date or naming of the office Jackson wishes to hold.

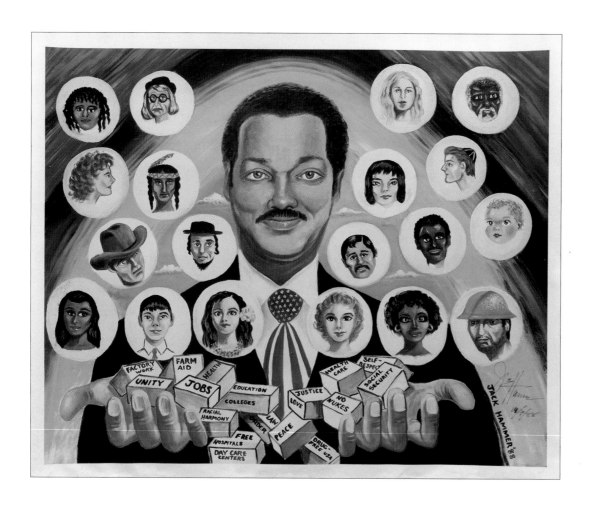

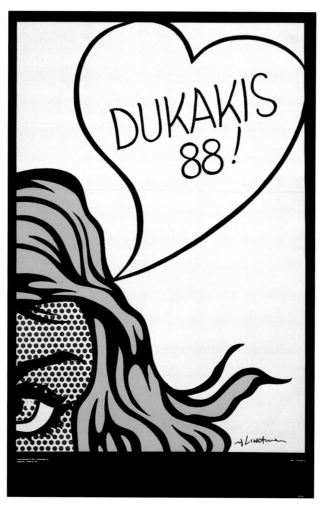

263. Jack Hammer, 1988

21½" × 26⅛", offset lithography

This extraordinary, colorful print signed by Jack Hammer captures the various human types of Jackson's rainbow coalition in a warm caricature of the candidate and his platform. The poster would have made a fantastic mural on the side of building in the urban core.

264. Roy Lichtenstein, 1988

36" × 24", offset lithography

Roy Lichtenstein entered the political fray with this comic book–style poster that incorporated dots from the enlarged halftone printing process—a personal style he favored. The poster was commissioned by the California Democratic Party for Michael Dukakis's bid for the presidency. It is the artist's first poster for a presidential candidate. Published in an edition of 1,250, the black border, to Lichtenstein's consternation, was added by the Californians. Some of the posters have a printed facsimile signature and apparently others do not. A few may have actually been signed individually by the artist.

265. Alex Murawski, 1992

28" × 20⅛", offset lithography

Ross Perot, known as Mr. Fixit, did well with voters as an Independent candidate in 1992. The donkey and the elephant in this charming poster seem equally pleased, but 18.9 percent of the vote for Perot was enough to sink President Bush and sweep Bill Clinton into the White House after twelve years of Republican rule.

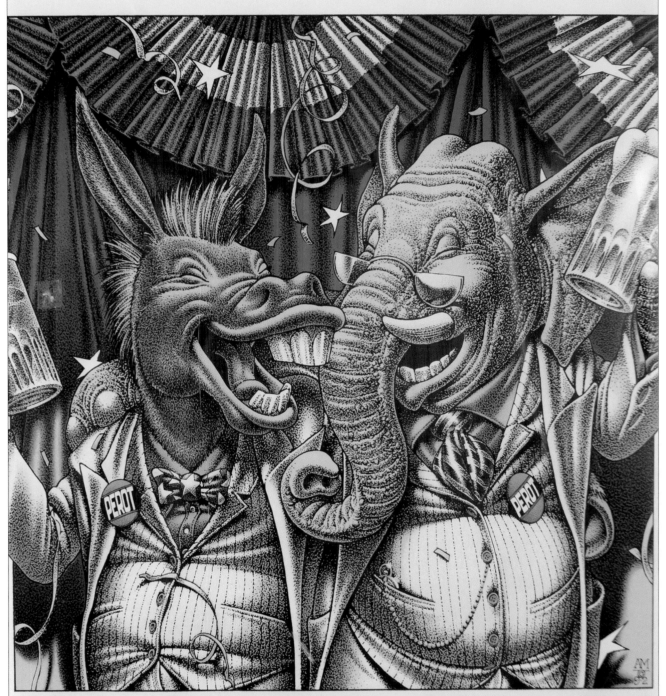

PEROT

A
MAN
FOR ALL
PARTIES
★

ART DIRECTION & DESIGN, BARTELS & COMPANY ; ILLUSTRATION, ALEX MURAWSKI ; SEPARATIONS, UNLIMITED COLOR ; ST. LOUIS, MO

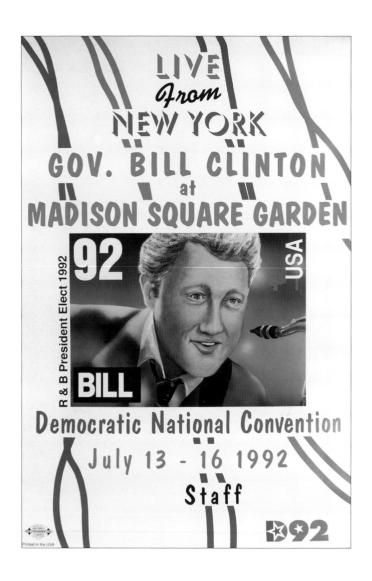

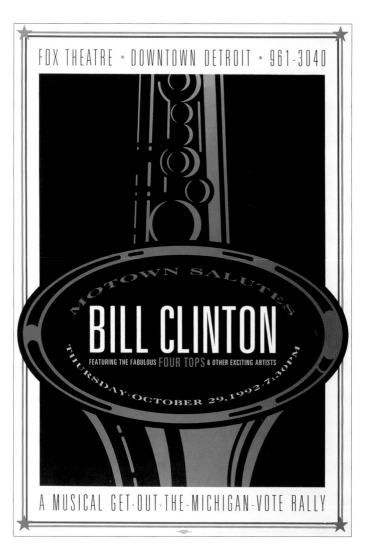

266. Unknown artist, 1992
36" × 24"offset lithography
This novel poster represents something new in the political arena as it pitches candidate Clinton as a personality and entertainer, one cool cat who can wail on the saxophone on a late night talk show. The staff poster was printed in a pencil-signed edition of 1,992 A signed edition for delegates and an edition for convention visitors was also printed.

267. Unknown artist, 1992
30" × 24", offset lithography
Courtesy of Hake's Americana, Hakes.com.
The Motor City, home of Motown, rallied for Clinton with this classy poster of a golden saxophone that again emphasized the candidate as an entertainer.

A NEW GENERATION OF LEADERSHIP

268. Roy Lichtenstein, 1992

34" × 38", offset lithography

Titled *The Oval Office*, Roy Lichtenstein's poster and print became extremely popular. The pencil-signed, limited edition of 175, and 25 artist's proofs, relied entirely on visual communication and had the additional asset of raising a substantial amount of money for the campaign. An offset signed edition of 100 and an open offset unsigned edition both added the wording "A New Generation of Leadership." Like the original *Dukakis '88* poster (fig. 264), the printing ran to the edge of the paper.

269. Peter Max, 1996

24" × 34", offset lithography

Along with the 1969 *Lindsay for Mayor* poster (fig. 83), this is one of Peter Max's very best montage political posters, and one that did not use repeated images as in *100 Clintons* or *Forty-four Obamas* (fig. 280). The four-color frame of the brown toned photo in a post-psychedelic style catches the viewer's attention.

270. Unknown artist, 1996

28" × 18¾", offset lithography

Art deco in style, this attractive poster immediately conjures up the dazzling travel posters of the thirties created by A. M. Cassandre and those created by the Russian Constructivists in the twenties. Clinton and Gore, playing the role of the common man, had done a wildly successful bus tour along the Mississippi River and into Wisconsin in 1992. Why not take the train across Michigan to the Democratic convention in Chicago? Posters were printed for the candidates' arrival in five Michigan towns, but like the Eugene McCarthy *He Stood Alone* poster (fig. 41), the original, unencumbered with specific details, is the better poster.

271. Chris Shaw, 2000

19" × 13", offset lithography

The Flying Other Brothers retro neon electric posters designed by Chris Shaw for Al Gore's campaign events presented the candidate as pop culture celeb. Two slightly different posters hyped appearances by Gore and his wife, Tipper, who played drums with Bob Weir and Mickey Hart for two numbers, "Women Are Smarter" and "Iko Iko." Shaw graduated from the College of Arts and Crafts in the 1980s, worked for Bill Graham, and went on to create thousands of rock posters. *Rolling Stone* named him Artist of the Year in 2001.

Gore 2000

THE FLYING OTHER BROS

THE FLYING FOBs OTHER BROS.

WITH BOB WEIR & MICKEY HART

Gore 2000

GEORGE & JUDY'S
LOS ALTOS HILLS, CA
FRIDAY, SEPTEMBER 17, 1999

7™

www.flyingotherbros.com

Gore 2000

PHOEBE BEASLEY

272. Phoebe Beasley, 2000
28" × 26", offset lithography
Phoebe Beasley's limited edition photo-montage was one of the top posters of the 2000 campaign. She was designated the official artist of the Democratic National Convention and produced a number of pieces to commemorate the event. Earlier she produced an inaugural print for Bill Clinton in 1993. Her colorful paintings, prints, and collages often chronicled the black experience in America. As a young artist she was aided by Bill Russell, and Maya Angelou became her mentor.

273. Emek Golan, 2004
29" × 20", screen print
Courtesy of Emek Golan.
The king of rock posters, Emek Golan screen printed this wonderfully vibrant poster for a John Kerry event in Los Angeles.

274. Unknown designer, 2004

17" × 11", offset lithography

The humorous revival of the boxing-style posters of the fifties was a welcome relief in the midst of the serious atmosphere surrounding the 2004 campaign for the White House. The poster was designed and circulated by a student group at Ohio State University to increase voter turnout.

275. Unknown designer, 2004

17" × 22", offset lithography

The fine *W 2004* poster is a tribute to successful branding and visual communication. Black posters and bumper stickers with the silver letter *W*, or Dubya, flooded the nation.

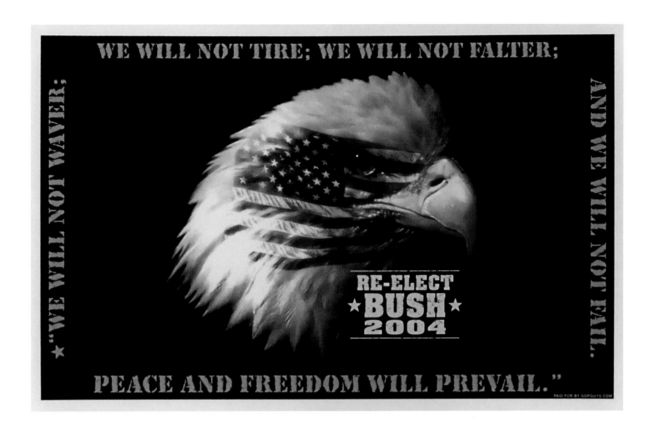

276. Unknown designer, 2004

14" × 22", offset lithography

The war in Iraq became a hot-button issue in the 2004 campaign, and Bush's position was made clear with the publication of this provocative poster promising to see the war through to a successful conclusion.

277. Ron English, 2008

24" × 18", screen print

Courtesy of Ron English.

In his *Abraham Obama* print, Ron English superimposed a map of the Midwest, coloring in red states and blue states to portray the fractured politics Obama faced. The *Abraham Obama* prints by popaganda artist English came in many sizes and colors, including two series using diamond dust in the screen printing process as Andy Warhol had done. English located Warhol's print maker, Donald Sheridan, and the two collaborated to produce a series of stunning prints. Installations of huge posters printed across the color spectrum appeared at art happenings in Boston and Los Angeles and in Denver at the Democratic National Convention. Some thought the image bizarre, but candidate's images remade or retouched to look like George Washington or Abraham Lincoln have frequently occurred and were very popular during the poster/postcard boom from 1896 to 1912, fueled by the emergence of color lithography.

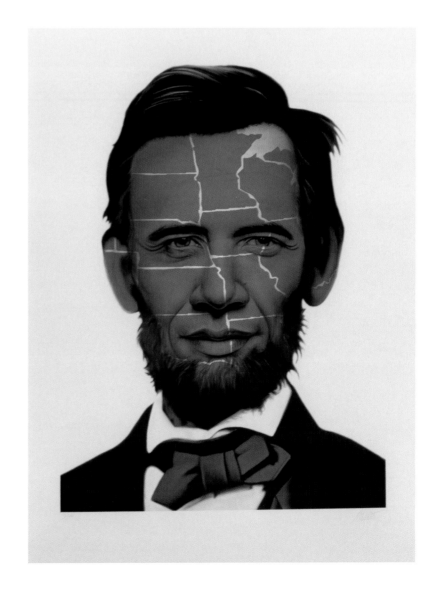

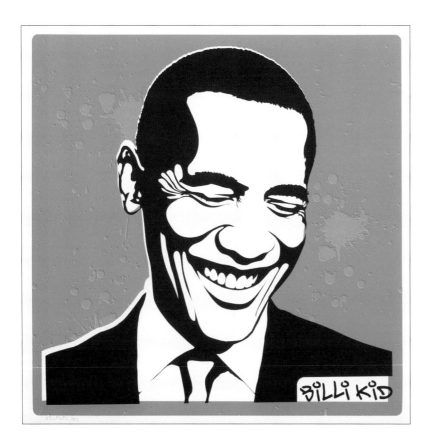

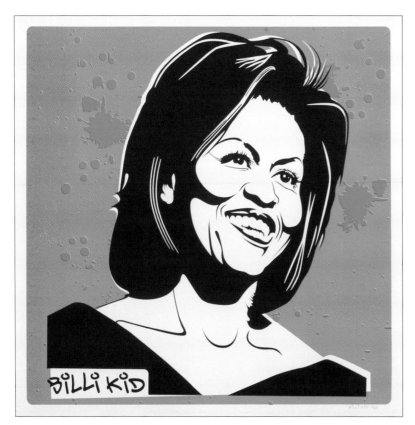

278. Billi Kid, 2008

21" × 20¹³/₁₆", screen print
Courtesy of Billi Kid.

Billi Kid says that his work "blurs the lines between graffiti, pop culture, and art." During the campaign, in guerilla art actions, he constructed outdoor street art sticker collages in and around New York City, and he used stencils to create a number of spray-painted pieces on wood panels. His pencil-signed and numbered screen printed editions of fifty of Barack Obama are examples of the best of the hip-hop, skateboarder, street-art style.

279. Billi Kid, 2008

21" × 20 ¹³/₁₆", screen print
Courtesy of Billi Kid.

First Lady Michelle Obama's warmth is captured in this Billi Kid screen print, which is also a pencil-signed and numbered edition of fifty.

280. Peter Max, 2008

24" × 18", offset lithography

To commemorate the forty-fourth president of the United States, Peter Max painted what he called "a quilt of forty-four portraits laid out in a four-by-eleven-foot grid." The poster that followed used the forty-four portraits but sized them differently and arranged them around a painting of the White House. Max has painted portraits of the last five presidents and did a number of inaugural pieces for Clinton, often using repeated images. Hugo Gellert has the honor of having created more campaign posters than any other artist, but Peter Max is in a close second.

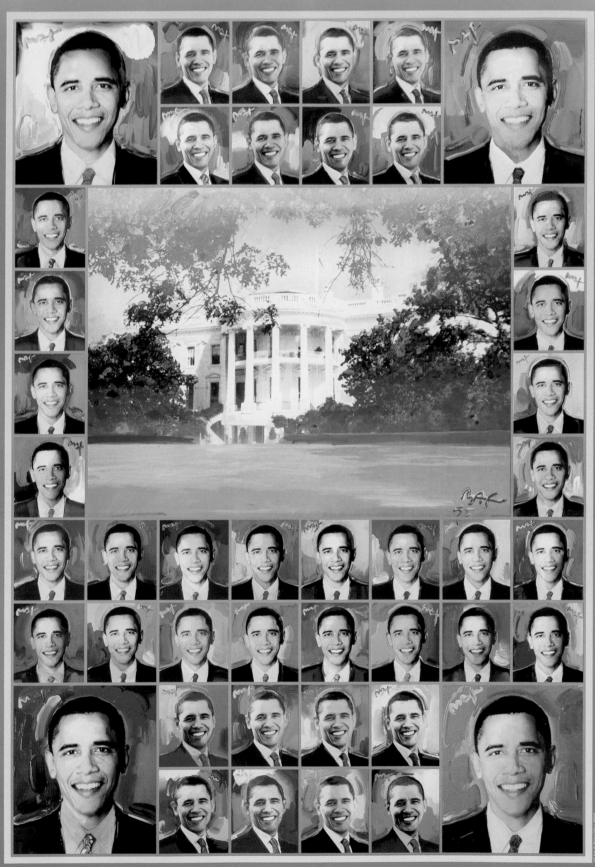

For Tim —
love

Peter Max Paints
44 Portraits of President Obama
A Tribute to the 44th U.S. President

2009

peter max©
www.petermax.com

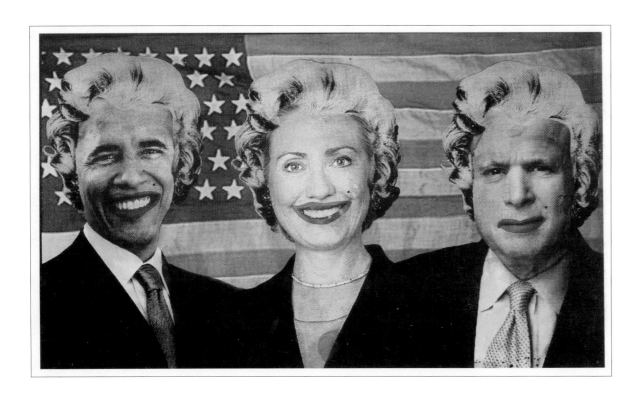

281. Mr. Brainwash, 2008

4" × 6", offset lithography

Thierry Guetta, aka Mr. Brainwash, is a French-born
filmmaker turned street artist based in Los Angeles.
His parodies on the world in which we live and the
people who inhabit our world are often hilarious.
Marilyn Obama, Marilyn Clinton, and Marilyn McCain
posed in front of the American flag are a case in
point. The pencil-signed, limited edition screen
prints of Marilyn Obama, Obama as Superman, and
a boxing-style poster of Obama vs. McCain sold
quickly. Mr. Brainwash's use of art to good-naturedly
satirize art is insightful and fun. Cheap slapper runs
of his Obama prints, which he and his crew pasted
up around Los Angeles, were a delight to the eye.
This postcard is a souvenir that was given out at his
art opening. A large pink-faced version graced the
corner of Sunset and El Centro in LA and daily
brought smiles to people's faces.

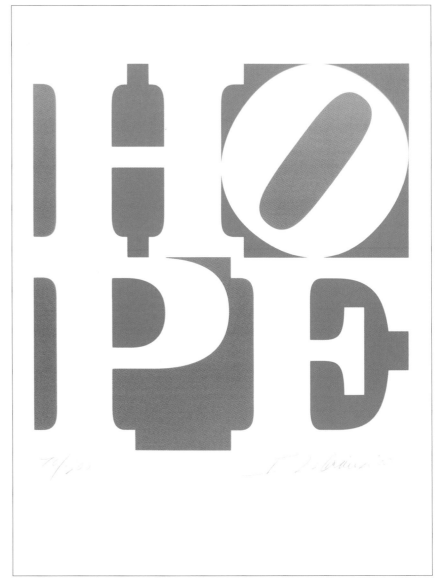

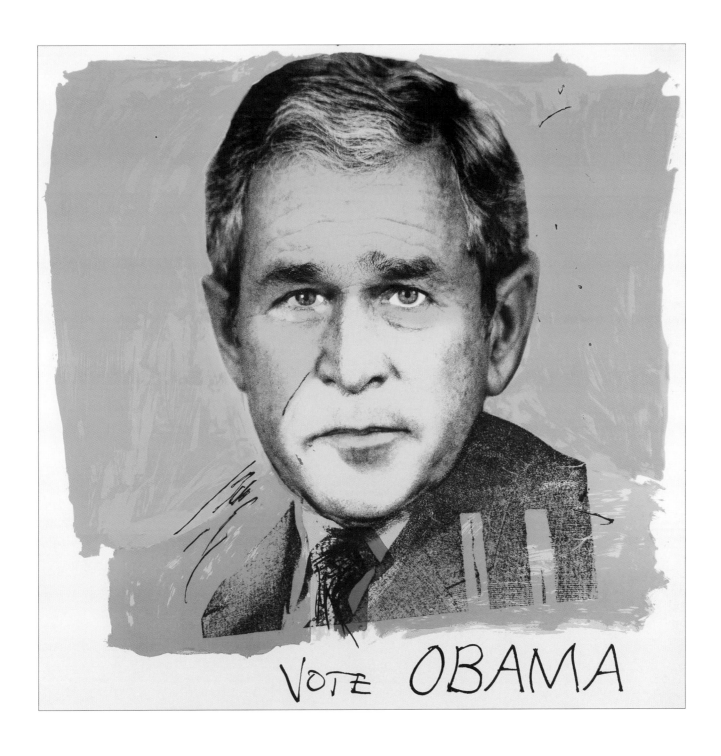

VOTE OBAMA

282. Robert Indiana, 2008

26" × 19", screen print

From the Artists for Obama series of ten prints available online through the Obama headquarters in 2008, Robert Indiana created this screen print in a pencil-signed, limited edition of two hundred. *Hope*, much like the artist's earlier work, *Love*, was printed in different colors and was also done as metal sculptures of various sizes.

283. R. J. Berman and John Calao, 2008

42" × 42", screen print

Californians R. J. Berman and John Calao were true to the colors and style of Andy Warhol's famous *Vote McGovern* (fig. 159) in their updated appropriated version, *Vote Obama*.

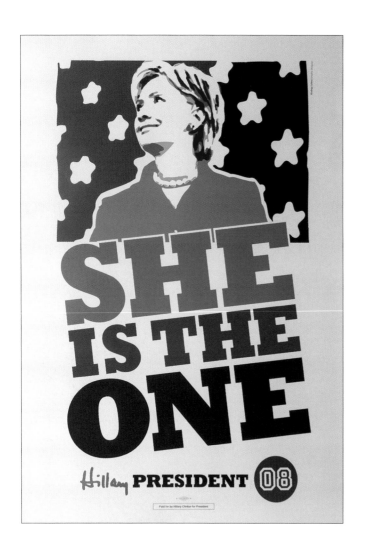

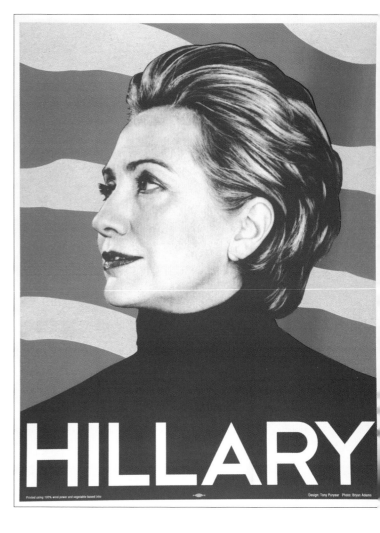

284. Unknown artist, 2008
35" × 24", offset lithography
Hillary Clinton did not win the hearts and minds of
the art crowd, who flocked to the Obama standard,
and her campaign did not rely heavily on posters in
her effort to win the nomination. Nevertheless, the
campaign produced a few fine posters. *She Is the
One*, a series of six different-colored, eye-grabbing
posters from Cincinnati, were very well designed
and used color in a fascinating way—the deep red

and black to suggest the flag avoided the standard
use of red, white, and blue. Another well-done Clin-
ton poster was created by Fred Hosman, Hosco
Design and Print Studio, in Omaha, Nebraska, who
turned out a triptych print of Clinton, Obama, and
John Edwards for the state's February 9 caucus in a
pencil-signed, limited edition screen print of thirty-
five. Individual posters in the same design were
printed for each candidate, and they too were in an
edition of thirty-five signed prints.

**285. Tony Puryear design, Eryan Adams
photo, 2008**
31" × 24", offset lithography
Courtesy of Tony Puryear.
Two versions of this attractive, powerful
poster were done by Tony Puryear, a Los
Angeles writer and artist. Printed on heavy
stock, both prints were for sale on Clinton's
website.

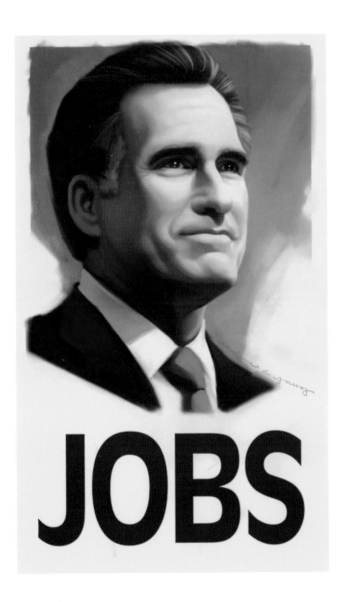

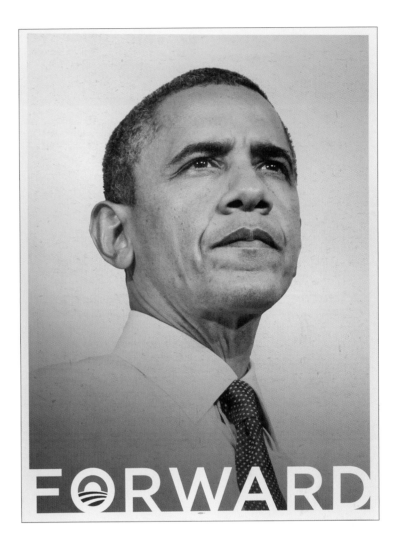

286. Andrew Redford Young, 2012

26" × 18", giclee print

The Romney campaign produced even fewer posters than did the Obama folks, but *Jobs* portrays a serious candidate up to the job. The poster has the 2008 Shepard Fairey touch and would be much stronger graphically if it had not been made to look airbrushed.

287. Unknown artist, 2012

24" × 18", offset lithography

This splendid photo poster of the president is one of the best 2012 posters and differs significantly from the image of Obama fostered in 2008. President Obama is no longer the hip, cool candidate but rather the confident, mature leader you can trust. The poster design directly appeals to young people who would immediately think the designer used photo filters from Instagram.

BRUCE ★ SPRINGSTEEN

AT **IOWA** STATE UNIVERSITY

OCTOBER 18, 2012 | OFA.BO/BRUCEISU

A **CAMPUS TAKEOVER** EVENT / DOORS OPEN AT 1:00PM / HILTON COLISEUM, IOWA STATE UNIVERSITY / AMES, IOWA

 PAID FOR BY OBAMA FOR AMERICA

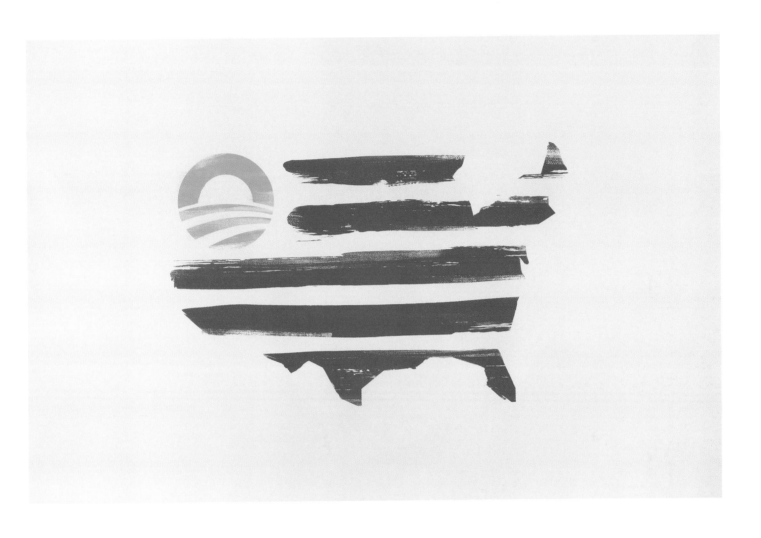

288. Unknown artist, 2012

22½" × 14", offset lithography

Bruce Springsteen, who performed his first political fund-raising gig in 1972 for McGovern, set out on an October tour for Obama that started on October 13, 2012, in Cleveland, Ohio; then to Iowa State University in Ames on October 18; Charlottesville, Virginia, on October 23; and Pittsburgh on October 28. These four concerts used this good-looking, yellow-tinted poster, changing only the date and the location of the events.

289. Ross Bruggink and Dan Olson, 2012

24" × 36", screen print

This dynamic design duo came up with two limited edition screen prints for the Obama campaign for sale on the website. Picturing the U.S. map with the Obama logo in a flag motif caused a stir, mostly among conservatives, as did the other print that was just the flag motif. The kerfuffle was not as great as the controversy over the '72 McGovern poster *Four More Years?* (fig. 79) that featured a photo of the My Lai Massacre; but the complaints faded slowly, the posters were not withdrawn, and attitudes hardened on both sides. The designers' intent was to use the flag to graphically demonstrate that the country was united behind Obama, a tradition that stretches back to the mid-nineteenth century. Both prints sold out.

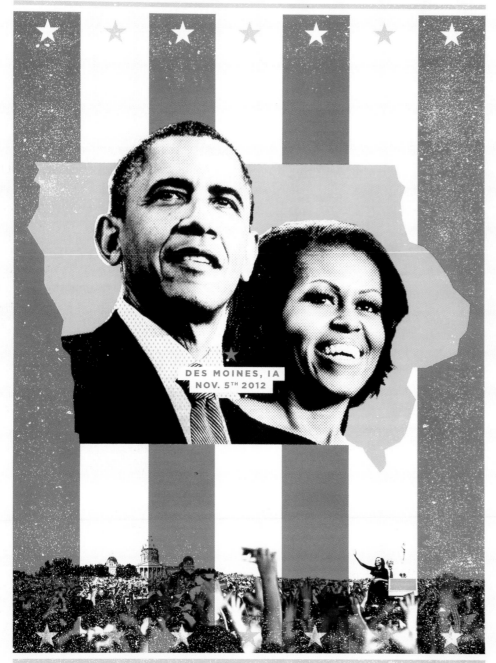

290. Unknown artist, 2012

22" × 14", offset lithography

The Obamas and Bruce Springsteen traveled from an afternoon rally in Madison, Wisconsin, to an evening event in downtown Des Moines, Iowa, on November 5, 2012. Obama's road to the White House began with his victory in the Iowa caucuses on January 3, 2008, when he surprisingly garnered 38 percent of the vote. The rally was appropriately titled Finish Where We Started, and the Obamas were pleased with the support they had received from Iowans. The well-designed photomontage event poster is one of the last Obama campaign items.

Acknowledgments

First of all, thank you to those artists who created the posters that appear in this volume. I made every effort to discover who they were and to learn more about their work. Sadly, I was often unable to accomplish my goal, and I offer my apologies. I am as well profoundly grateful to those artists who gave me their permission to include images of their work and who shared with me their high-resolution files or loaned original posters to be photographed. Thank you, Billi Kid, Emek Golan, Ron English, Chas Fleischman, Earl Newman, and Tony Puryear. Special thanks are owed to Ann McGovern, and thanks to Frank Mankiewicz who kindly agreed to write the foreword to this book. Aside from family, no one knew Senator McGovern better than Frank Mankiewicz, who served as McGovern's 1972 campaign manager along with Sen. Gary Hart.

Once again I am indebted to Robert Heishman, an aspiring and talented young Chicago artist, with whom I spent many an hour photographing a large number of posters in this book, all at between 300 and 600 ppi, and then debating with him about which images to select. Robert has worked as my research assistant for the last six years, and he shot the photographs for my last book, *Hope: A Collection of Obama Posters and Prints,* which won the Benjamin Franklin Award given by the Independent Book Publishers Association for the best book in Politics/Current Affairs.

For the third time, I am indebted to Mary Anne Demeritt for proofreading the entire manuscript, for suggesting changes, and for cheerfully helping me meet many deadlines. My close friend, Carl Kurtz, who has taught me how to see more clearly and has nurtured in me a love of visual literacy, was always ready to answer complicated questions on printing techniques, poster layout and construction, and interpretation of complex images. Carl, a calligrapher with a deep love of paper and ink, has taught for nearly forty years in the Foundation Program of the Kansas City Art Institute and has built an international reputation in his field. This year he decided to retire and he will be missed. Carl also read the manuscript and clarified several of my aesthetic judgments. My agent, Fritz Heinzen, has without fail sold my book proposals and has spent much time with me on the phone attempting to keep past projects in print and to pitch new ones.

Many thanks go as well to Bridget Barry, acquisitions editor at the University of Nebraska Press, who has been excited about this project from our first conversation more than two years ago. Erika Kuebler Rippeteau, grant development specialist with the University of Nebraska Press, persistently sought funding for this project. Thanks as well to Sabrina Ehmke Sergeant, editorial assistant, who oversaw the large number of necessary permissions and Joeth Zucco, senior project editor, who undertook the copy editing of the manuscript.

To Ken Harman of the online Obama Art Report, thank you for publishing my first article on George McGovern's campaign posters. Thank you to Raechell Smith, the director of the Kansas City Art Institute's H&R Block Artspace, and her staff: Beverly Ahern, Michael Schonhoff, and Molly Kaderka, who have been supportive of my poster projects since hosting an Obama poster show in the Upper Gallery in 2009. Kansas City Art Institute president Jacqueline Chanda, the board, and Vice President for Academic Affairs Bambi Burgard have made possible several critical faculty development grants. Phyllis Moore, my department chair, has continuously encouraged and supported my efforts to publish lavish poster books and to teach Prints of Persuasion. Marc Deckard, photo/digital film technician, has on several occasions skillfully printed posters from high-resolution files. Deborah Tinsley, associate librarian for visual resources, and her assistant, Dustin Johnson, have photographed many posters for me over a long number of years. Invitations from a number of faculty, especially Reed Anderson, to speak to their classes on poster art were much appreciated.

Daniel Joseph Watkins, author of the deeply researched book, *Thomas W. Benton, Artist/Activist*, winner of the Colorado 2012 book prize, asked me to write the introduction to his book, which I was pleased to do. Since publication, the intrepid Mr. Watkins has tracked down a number of Benton's political posters, and some of Eugene McCarthy and Jesse Jackson, which he has graciously shared with me and allowed me to publish for the first time. Ted Wilson, professor of history at the University of Kansas and director of the Hall Center's Peace, War and Global Change Seminar and longtime friend, has on several occasions invited me to deliver papers on propaganda art. The feedback from those in attendance has been important in shaping my views and on several occasions resulted in publications.

Richard Michael Marano in his book *Vote Your Conscience: The Last Campaign of George McGovern* succinctly analyzed McGovern's horrific defeat in his 1972 campaign and captured the senator's steadfast commitment to a vision of a better America. He generously sent me a number of 1984 McGovern campaign posters to be photographed.

Special thanks to Laurie Langland, university archivist, Dakota Wesleyan University, and her staff. Laurie listed the posters in the McGovern Library collection and welcomed my research assistant and me to Mitchell, South Dakota, to photograph them. Knowing that Senator McGovern was at his home across the street from the library, she arranged for us to meet with him and photograph additional material. Later, she went the extra mile and measured the posters selected from the library collection. Connie Duffett, director of Development Operations at Dakota Wesleyan, passed on my emails to Senator McGovern at his winter home in Florida.

Alex Winter, president of Hake's Americana and Collectibles was most cooperative in providing a number of poster images. Lisa Marine, image reproduction and licensing manager, Wisconsin Historical Society, provided key images as did Elizabeth LaBeard, digitization specialist, McCain Library and Archives, University of Southern Mississippi. Carol Wells, founder and executive director for the Center for the Study of Political Graphics, made a special effort to search the collection's seventy thousand posters for pertinent material. Joy Novak, archivist for the Center for the Study of Political Graphics, worked closely with me to ensure high-quality digital images of selected posters. Lincoln Cushing, author and art historian, was extremely helpful in locating poster artists, tracking down copyright owners, and sharing images. Lincoln has also written extensively on psychedelic and protest posters, Cuban political propaganda posters, and posters from the Chinese Cultural Revolution. Alida Post responded enthusiastically to my request to use one of John Van Hamersveld's terrific psychedelic posters. John, founder of Pin-

nacle Productions in Los Angeles, generously sent me the image of one of his most famous poster creations, *Indian,* and shared with me a story associated with its reception.

Thanks as well to Gilbert Shelton, former art director of the Vulcan Gas Company in Austin, Texas, for use of two poster images. Colin Turner, president of Last Gasp Press, was instrumental in my locating Gilbert through his agent, Lora Fountain. Victor Moscoso was kind enough to grant me permission to use images of two of his fine psychedelic posters, including the famous *Chamber Brothers* Neon Rose. Laura Grimshaw, wife of the late Gary Grimshaw, the king of the Detroit psychedelic posters, kindly consented to allow the use of two of his outstanding poster images. Grant Feichtmeir and Karen Rogers made possible the use of two fine Fillmore posters: one by Bonnie MacLean and the other by David Singer. Grant also provided two images of very rare McCarthy posters. Sara Miller of Mouse Studios granted permission for use of two Stanley Mouse and Alton Kelley poster images. Nathan Kerr, intellectual property coordinator, Rights and Reproduction Imaging at the Oakland Museum of California was very helpful in my obtaining the use of three images from the museum's extensive collection of political posters. Kelly Spinks, vice president of Business and Legal Affairs, Rhino Entertainment Company, arranged for my use of the first hand-colored Family Dog Avalon Ballroom poster by Wes Wilson.

Alan Schaefer, lecturer, Department of English, Texas State University, enabled me to contact Jim Franklin while working on a show of Austin music posters that opened in the spring of 2015. Jim Franklin was kind enough to respond to my request for use of his Vulcan Gas Company Janis Joplin poster, and Aryn Glazier of the Dolph Briscoe Center for American History at the University of Texas at Austin provided the Franklin poster image and the Gilbert Shelton images. Maria Fernanda Meza, Artists Rights Society, arranged an image of a Black Panther poster by Panther Minister of Culture Emory Douglas and permission for Andy Warhol's Vote McGovern print.

Stacey Sherman, senior coordinator, Rights and Reproduction Imaging Services, Nelson-Atkins Museum of Art, helped secure the permission of Kerry James Marshall for the use of his painting *What a Time. What a Time. Memento #5.* Joe R. Armstrong, a Californian who has amassed one of the finest collections of rock posters, many from the sixties, took time from his busy schedule to ensure that images of some of his rarest Bob Dylan CORE and SNCC posters, as well as an image of the first psychedelic poster drawn by the Charlatans, arrived on time. Thank you, Barbara Sedlock, for making it possible to obtain a poster housed in Pilgrim Library at Defiance College. Your timely persistence made possible the poster's inclusion in the book. If I have forgotten anyone, I apologize. Any mistakes that occur are solely my responsibility.